DANCERS

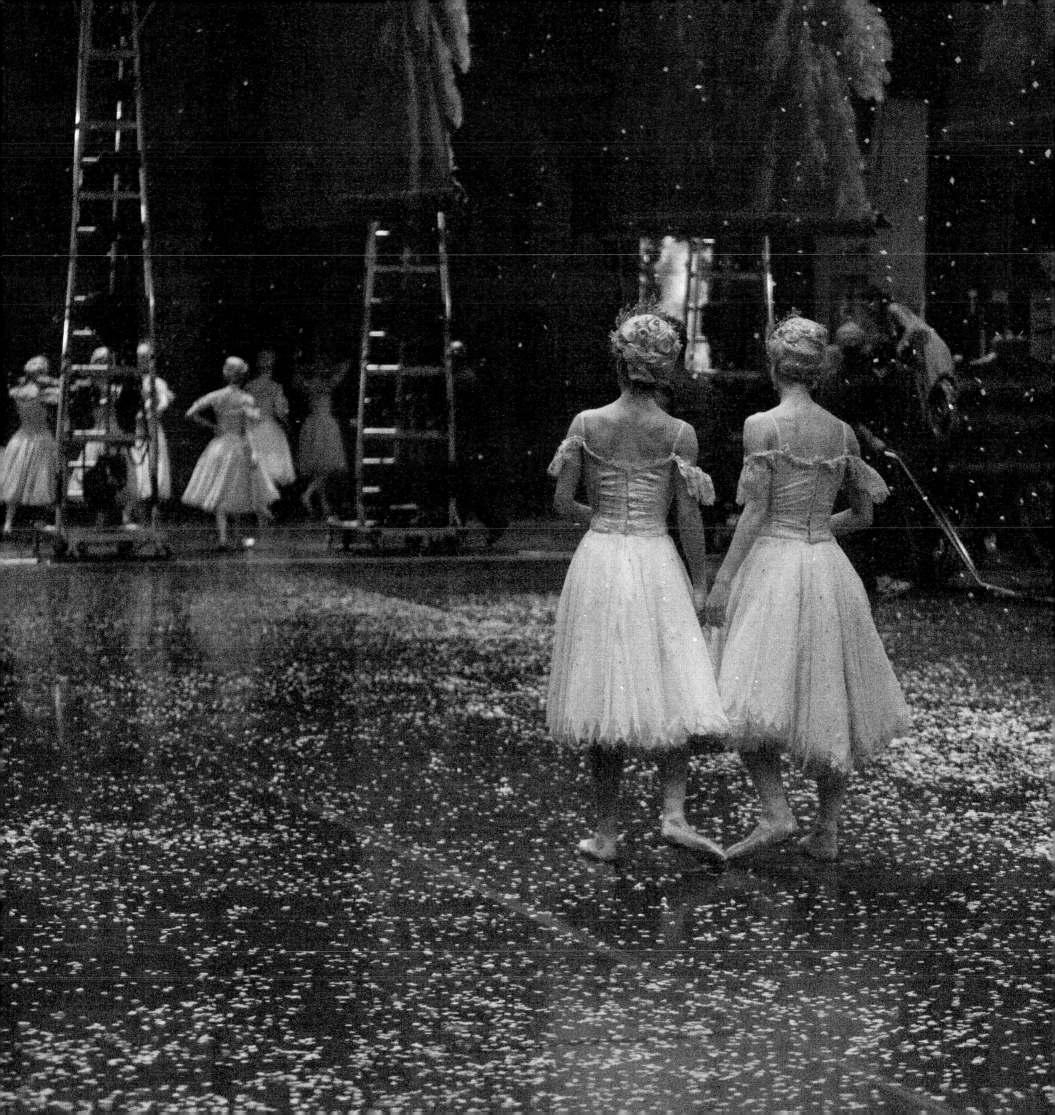

ROYAL
BALLET

DANCERS

BEHIND THE SCENES WITH THE ROYAL BALLET

ANDREJ USPENSKI

OBERON BOOKS

LONDON

First published in 2013 by the Royal Opera House
in association with Oberon Books Ltd

Oberon Books
521 Caledonian Road, London N7 9RH
Tel +44 (0)20 7607 3637
info@oberonbooks.com
www.oberonbooks.com

Text © Royal Opera House, 2013

Photographs by Andrej Uspenski © Royal Opera House, 2013

Compilation © Oberon Books Ltd and Royal Opera House, 2013

The Royal Opera House/Andrej Uspenski are hereby identified as
the author of this Work and the relevant photographs in accordance
with section 77 of the Copyright, Designs and Patents Act 1988.

Cover and book design: James Illman

A catalogue record for this book is available from the British Library.

ISBN 978-1-84943-388-4

Printed and bound by Replika Press Pvt Ltd, India

Royal Opera House
Covent Garden
London WC2E 9DD
Box Office +44 (0)20 7304 4000
www.roh.org.uk

Acknowledgements

Special thanks to Kevin O'Hare, Jeanetta Laurence
and James Hogan, and thanks to James Illman and
Kate Bettley, Ashley Woodfield, and Jane Latimer
and Máire Graham O'Hara.

Featuring

Carlos Acosta *Principal Guest Artist*

Alexander Agadzhanov *Senior Teacher and Répétiteur to the Principal Artists*

Alexandra Ansanelli *Former Principal*

Loipa Araujo *Guest Teacher*

Gary Avis *Principal Character Artist and Ballet Master*

Leanne Benjamin *Principal*

Tara-Brigitte Bhavnani *First Artist*

Sander Blommaert *Artist*

Federico Bonelli *Principal*

Camille Bracher *Artist*

Claire Calvert *Soloist*

Alexander Campbell *First Soloist*

Ricardo Cervera *First Soloist*

Deirdre Chapman *First Soloist*

Alina Cojocaru *Principal*

Leanne Cope *First Artist*

Jonathan Cope *Répétiteur*

Claudia Dean *Artist*

Anthony Dowell *Former Director of The Royal Ballet*

Tristan Dyer *Artist*

Wendy Ellis Somes *Guest Répétiteur*

Kevin Emerton *Artist*

Sorella Englund *Guest Répétiteur*

Mara Galeazzi *Principal*

Bennet Gartside *First Soloist*

Elsa Godard *Artist*

Meaghan Grace Hinkis *First Artist*

Melissa Hamilton *Soloist*

Nathalie Harrison *First Artist*

Elizabeth Harrod *First Artist*

Jonathan Howells *Soloist and Assistant Ballet Master*

Valeri Hristov *First Soloist*

Nehemiah Kish *Principal*

Johan Kobborg *Principal*

Sarah Lamb *Principal*

Emma Maguire *Soloist*

David Makhateli *Former Principal*

Roberta Marquez *Principal*

José Martín *Former First Soloist*

Kristen McNally *Soloist*

Steven McRae *Principal*

Pietra Mello-Pittman *First Artist*

Fernando Montaño *First Artist*

Laura Morera *Principal*

Yasmine Naghdi *First Artist*

Marianela Nuñez *Principal*

Ludovic Ondiviela *First Artist*

Natalia Osipova *Guest Artist*

Romany Pajdak *First Artist*

Rupert Pennefather *Principal*

Gemma Pitchley-Gale *Artist*

Sergei Polunin *Guest Artist*

Tamara Rojo *Guest Artist*

Christopher Saunders *Principal Character Artist and Ballet Master*

Liam Scarlett *Artist in Residence*

Thiago Soares *Principal*

Johannes Stepanek *First Soloist*

Beatriz Stix-Brunell *Soloist*

Michael Stojko *First Artist*

Dawid Trzensimiech *Soloist*

Jonathan Watkins *First Artist*

Edward Watson *Principal*

Sabina Westcombe *First Artist*

Thomas Whitehead *Soloist*

James Wilkie *First Artist*

Zenaida Yanowsky *Principal*

Miyako Yoshida *Former Principal*

Valentino Zucchetti *Soloist*

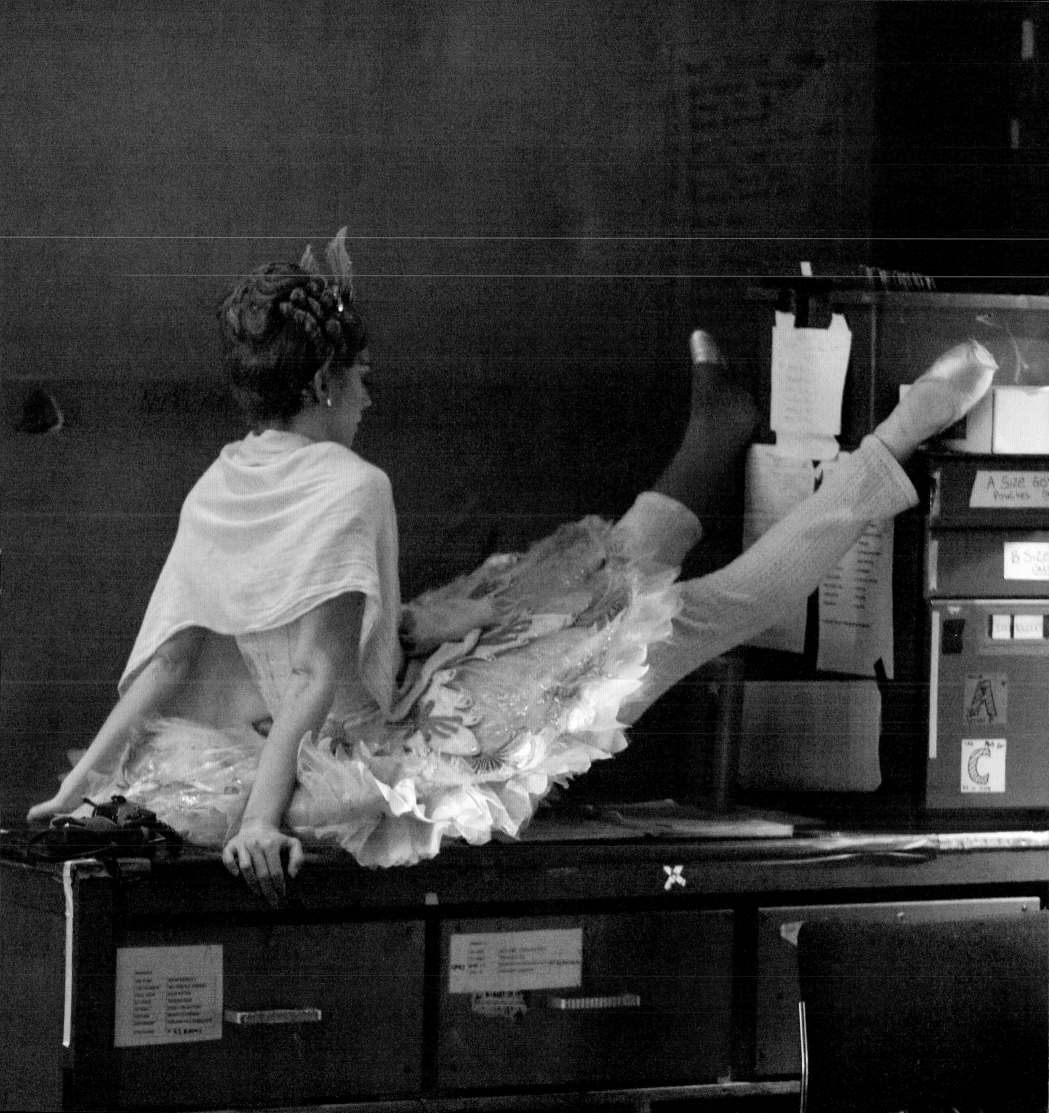

Andrej Uspenski has been a dancer with The Royal Ballet for over ten years. He performs with the Company at the Royal Opera House and on tour all over the world dancing in much of its wide-ranging repertory. Over the years a second passion has gradually taken hold and Andrej is now often to be seen in the rehearsal studios or in the wings with a camera in his hands. He grew up with photography, learning the basic skills as a child from his father as he watched him at work in his dark room. Andrej bought his first professional photographic equipment during our tour to Hong Kong several years ago and has gradually become more and more immersed in his second career.

Dancers are often said to have a very good eye for detail and design and, surrounded as he is on a daily basis by supremely talented dancers, Andrej has been inspired to capture the movement and artistry of his colleagues in the series of striking photographs that are seen in this book. He has taken great advantage of his situation to create a unique body of work which follows The Royal Ballet's world-class artists through their preparations and build up to performance. It is an intimate glimpse of life in a ballet company, on and off stage, brilliantly captured by one of its members and we are delighted with the results.

Kevin O'Hare
Director, The Royal Ballet

Jeanetta Laurence
Associate Director, The Royal Ballet

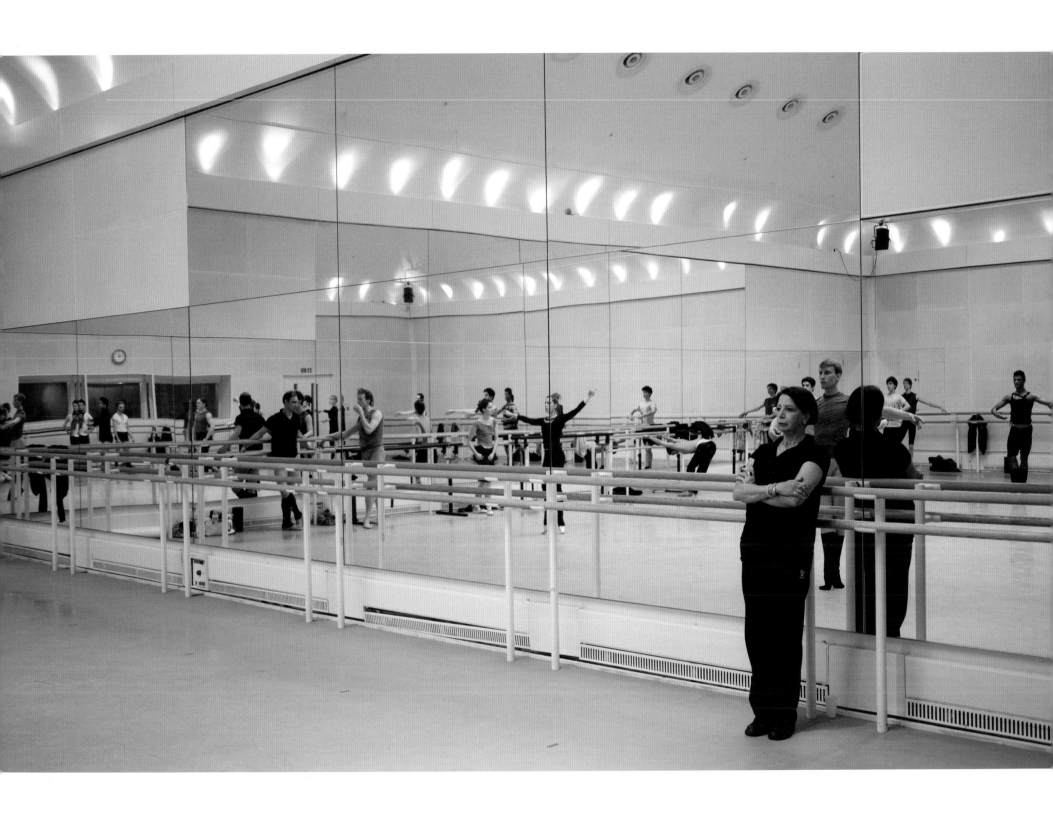

Loipa Araujo

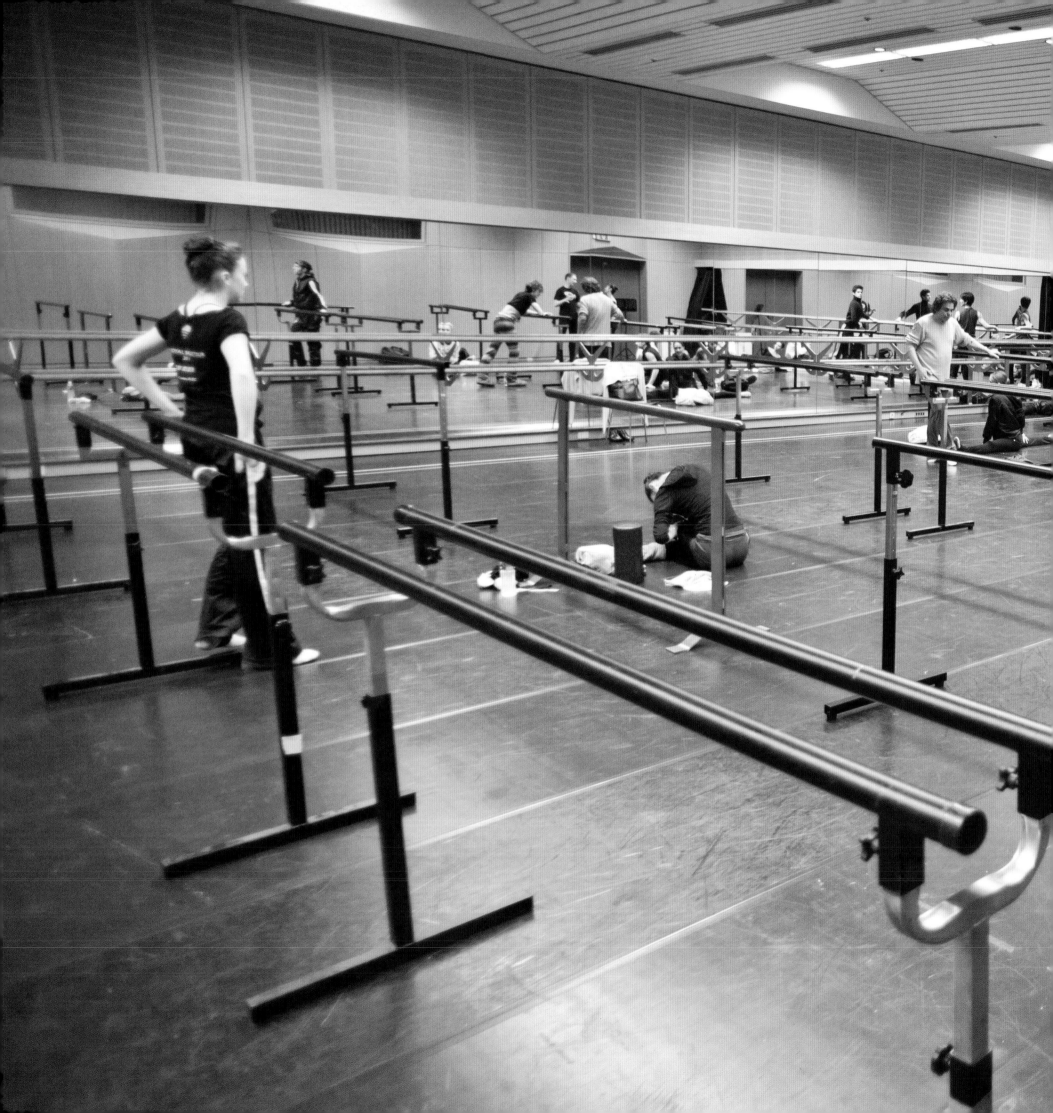

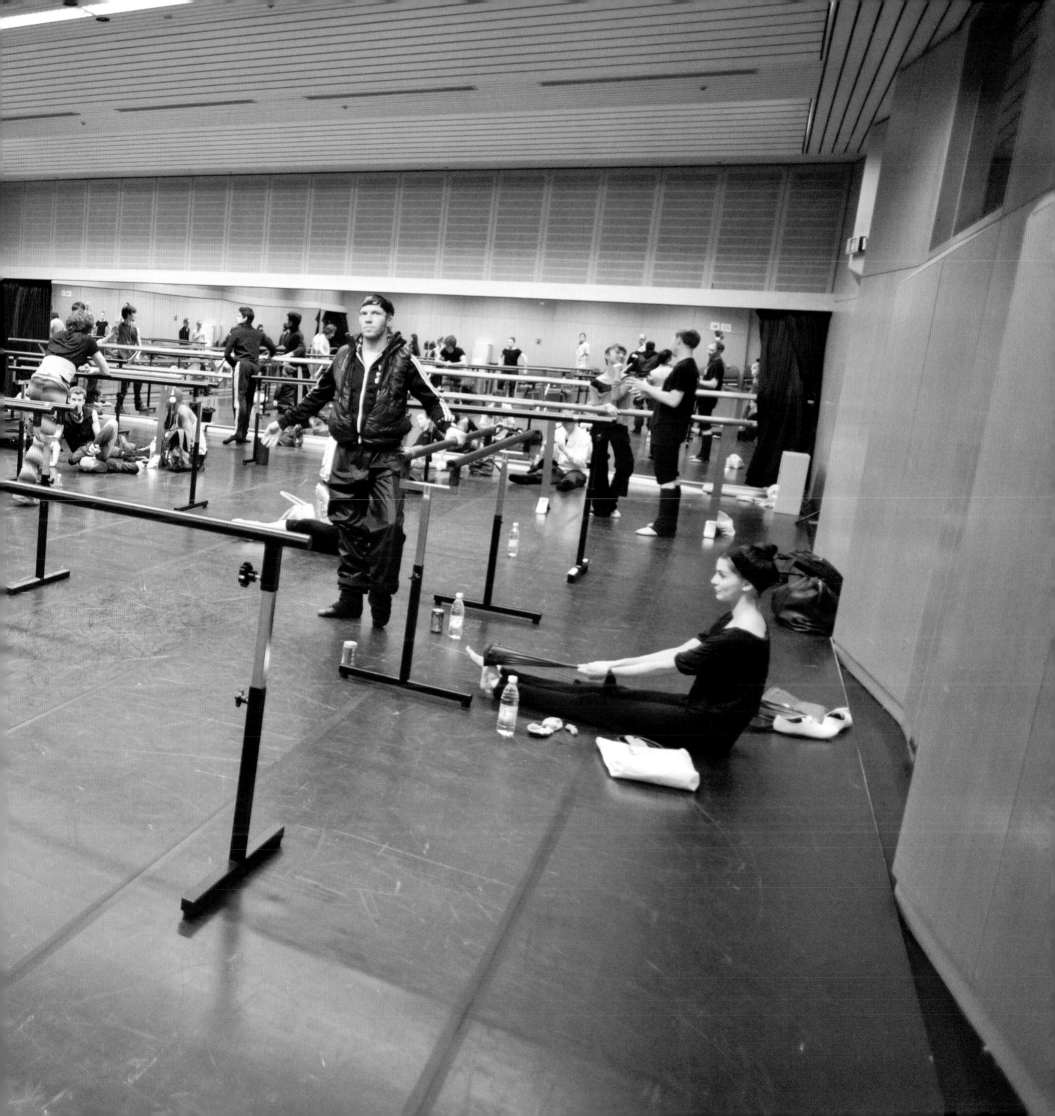

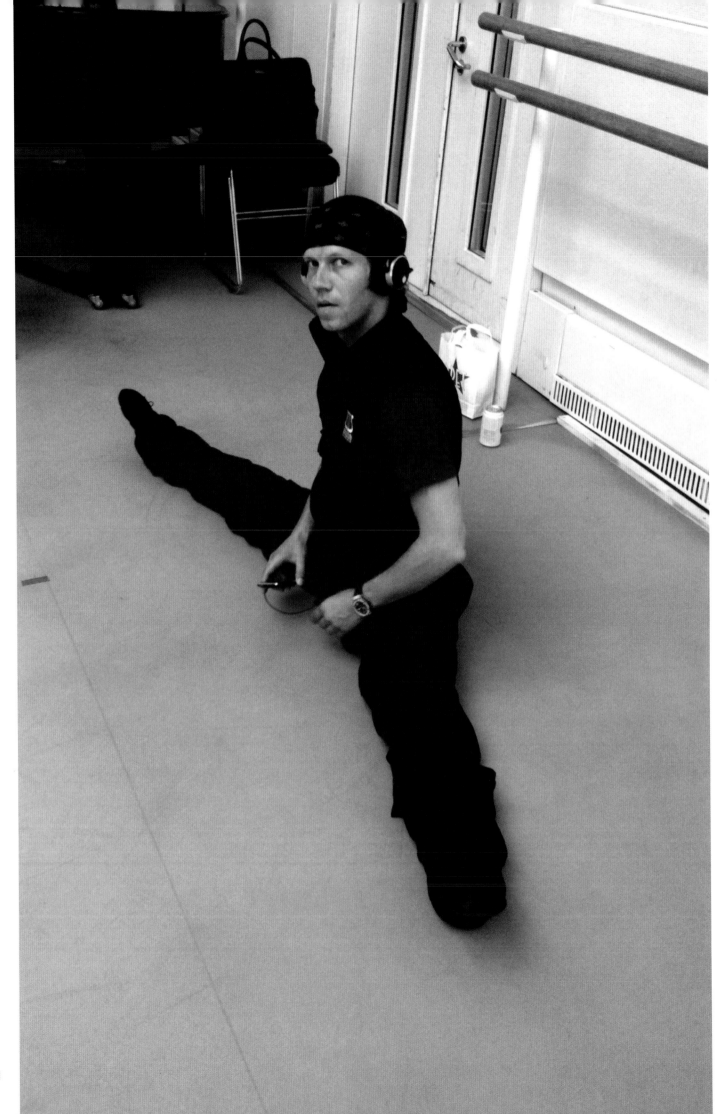

Johan Kobborg

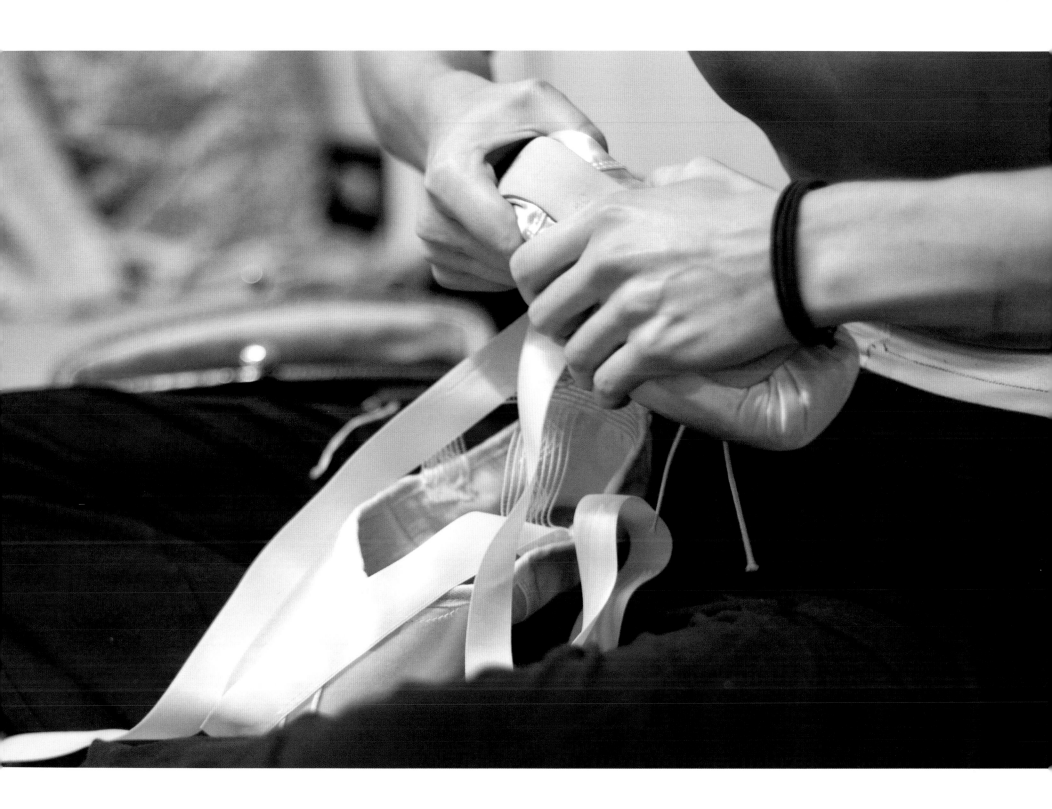

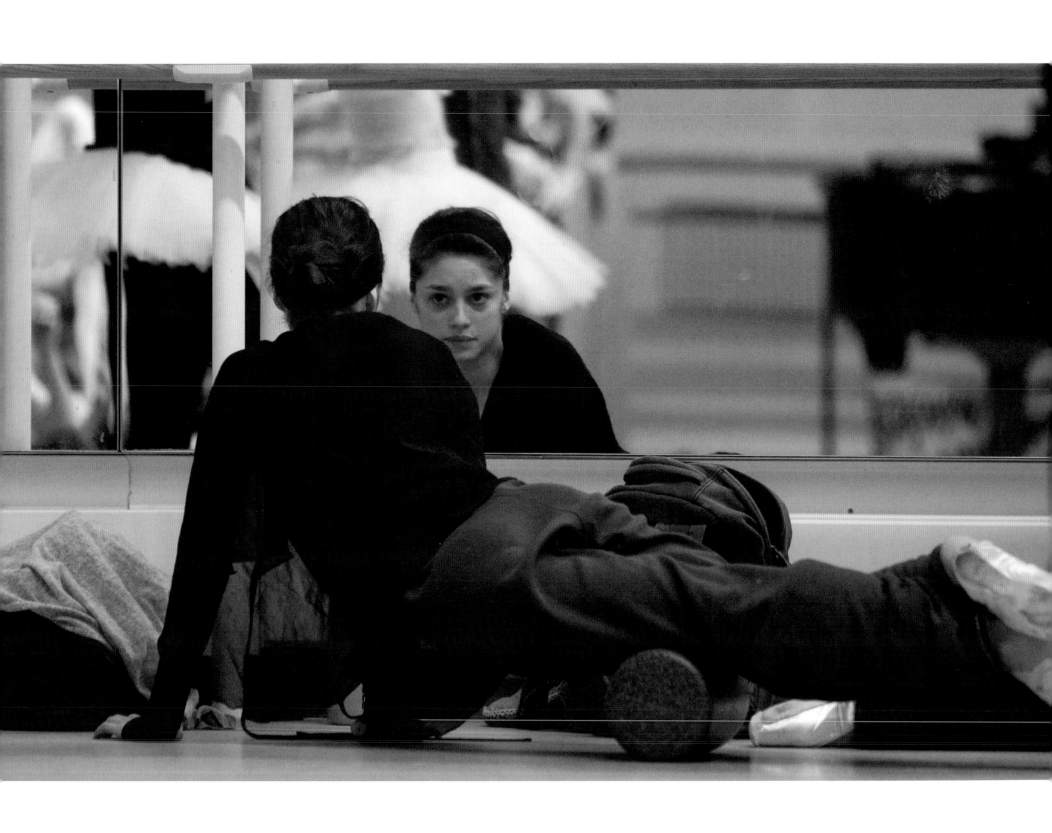

Romany Pajdak
Opposite **Deirdre Chapman**

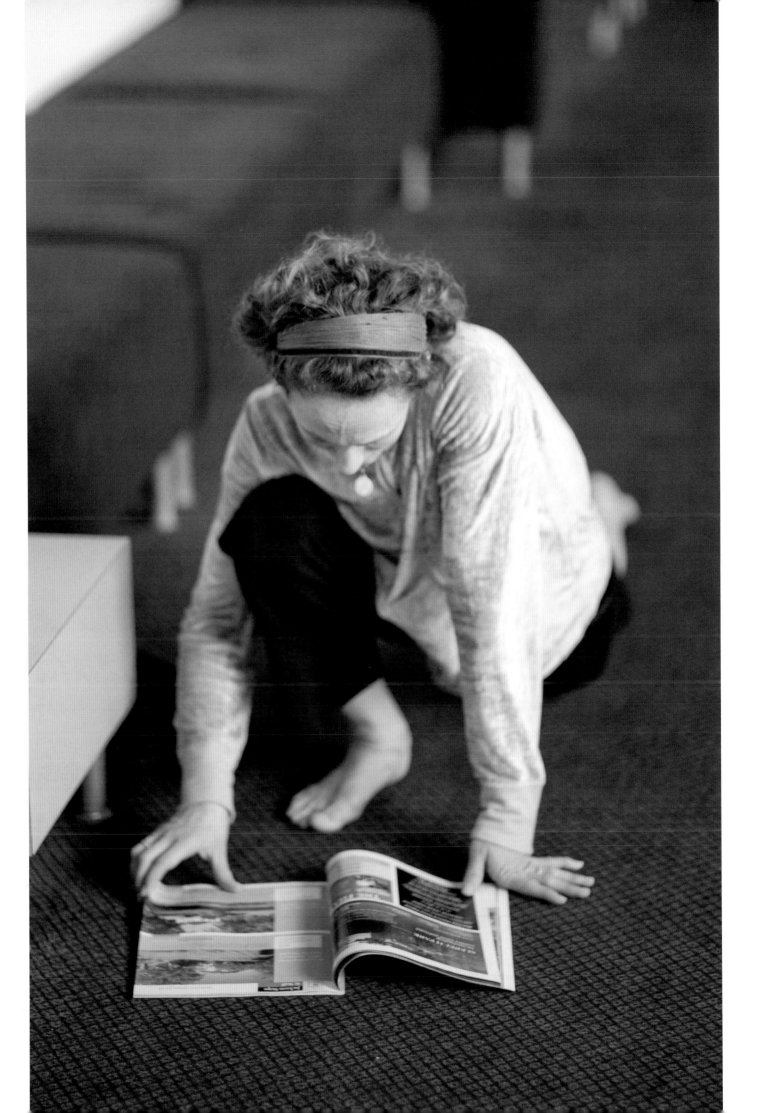

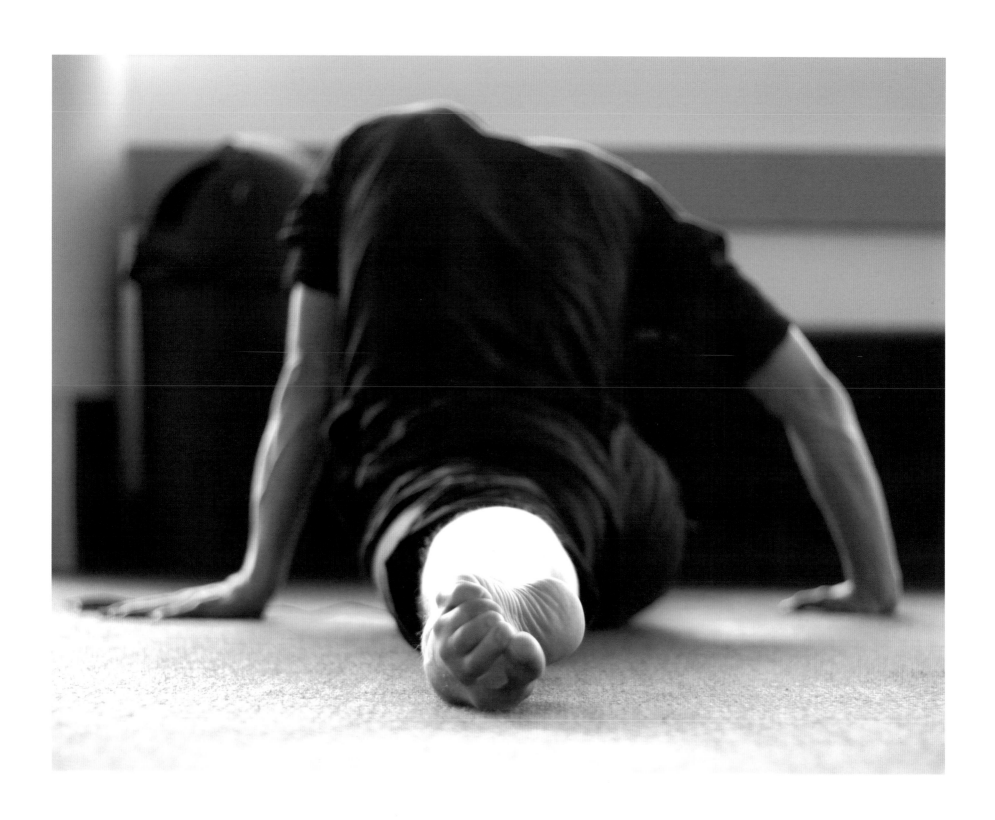

Johannes Stepanek

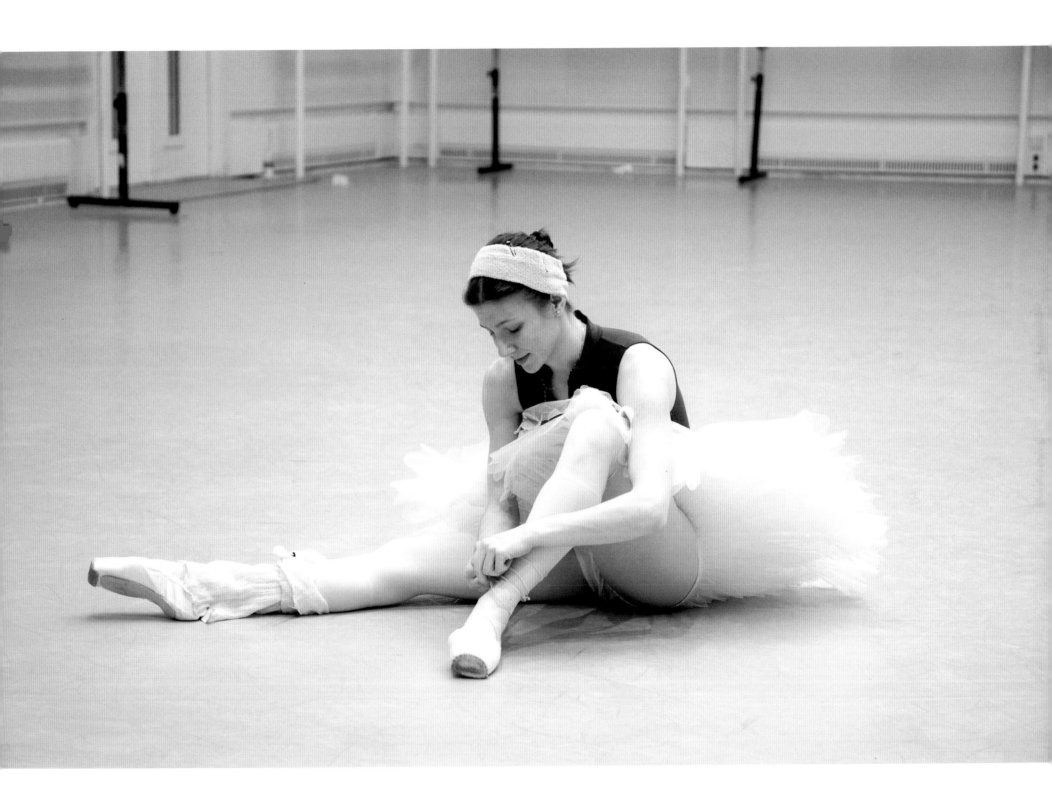

Alina Cojocaru

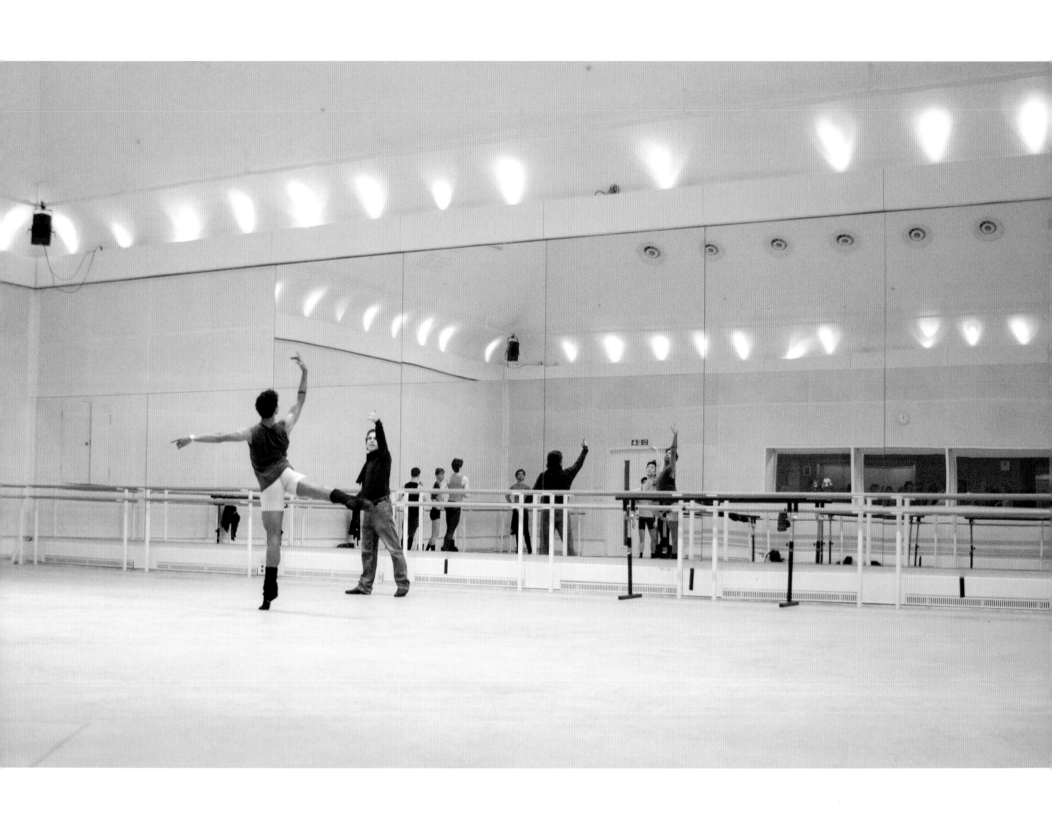

Carlos Acosta and **Alexander Agadzhanov**

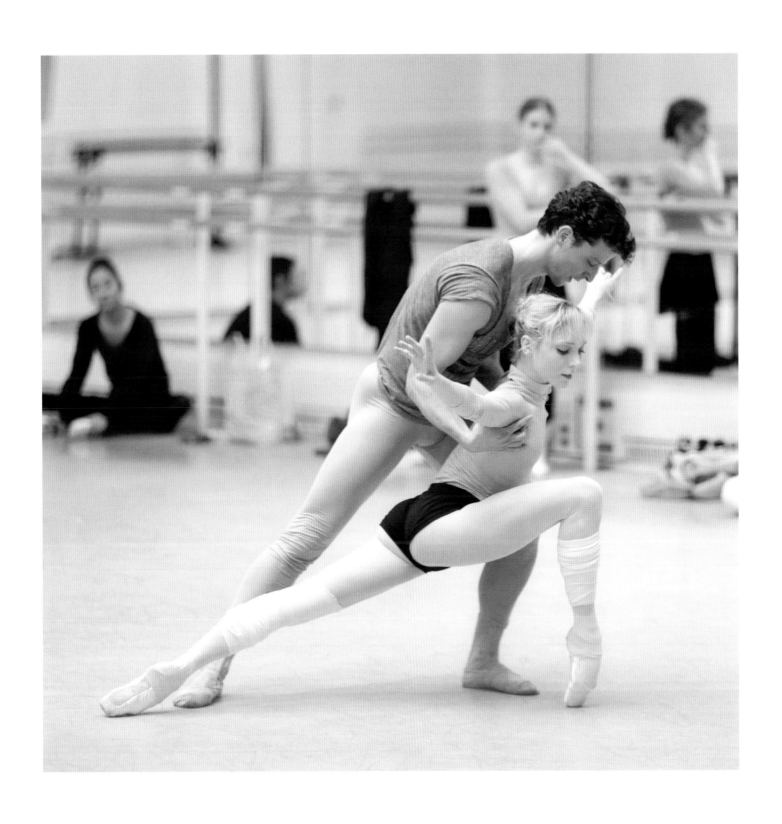

Johannes Stepanek and **Sarah Lamb**

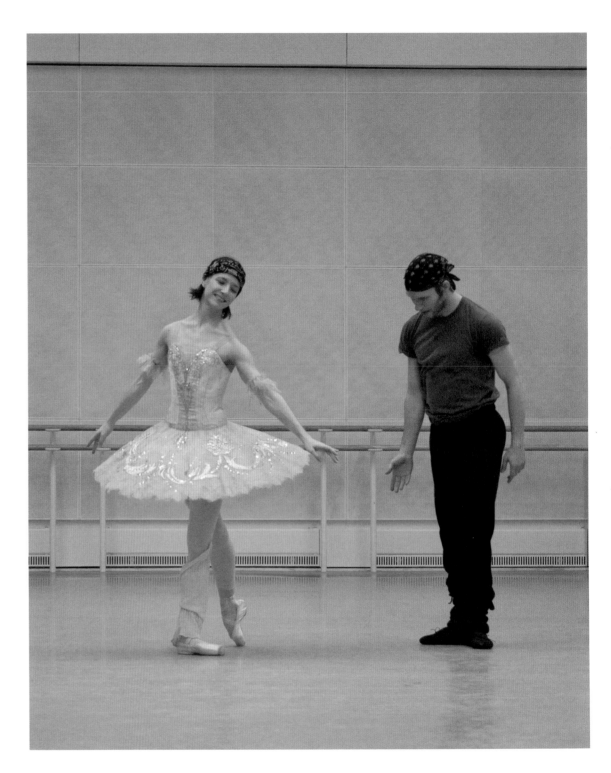

Johan Kobborg and **Alina Cojocaru**

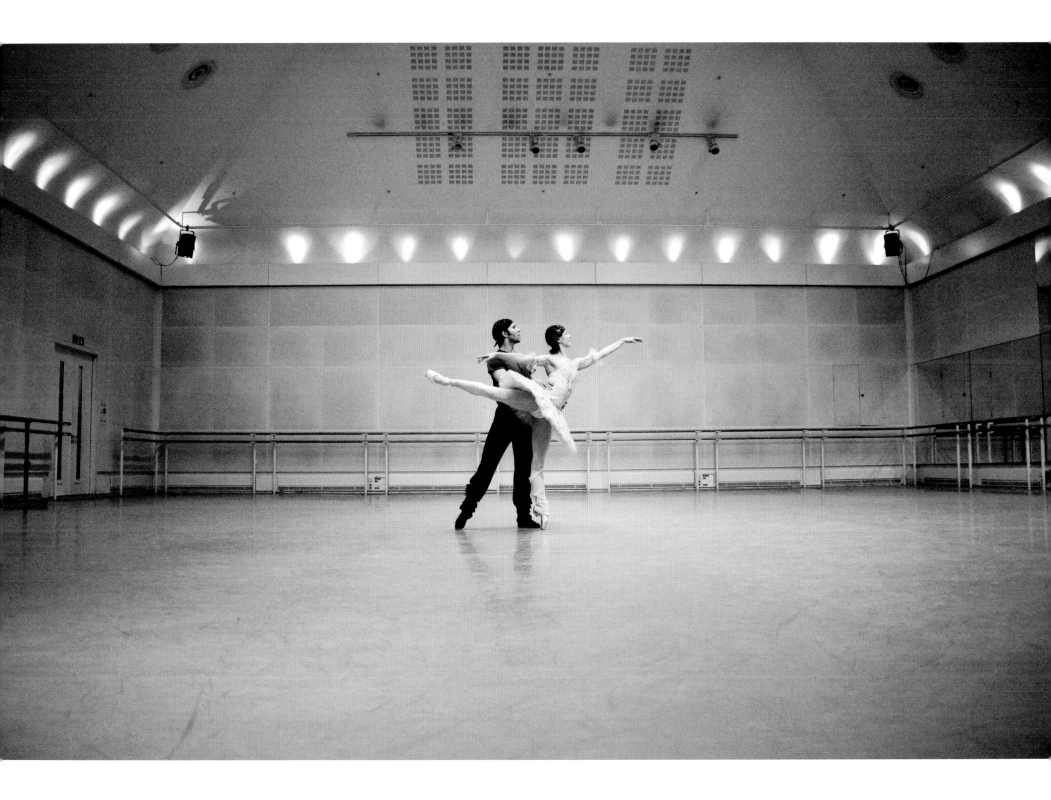

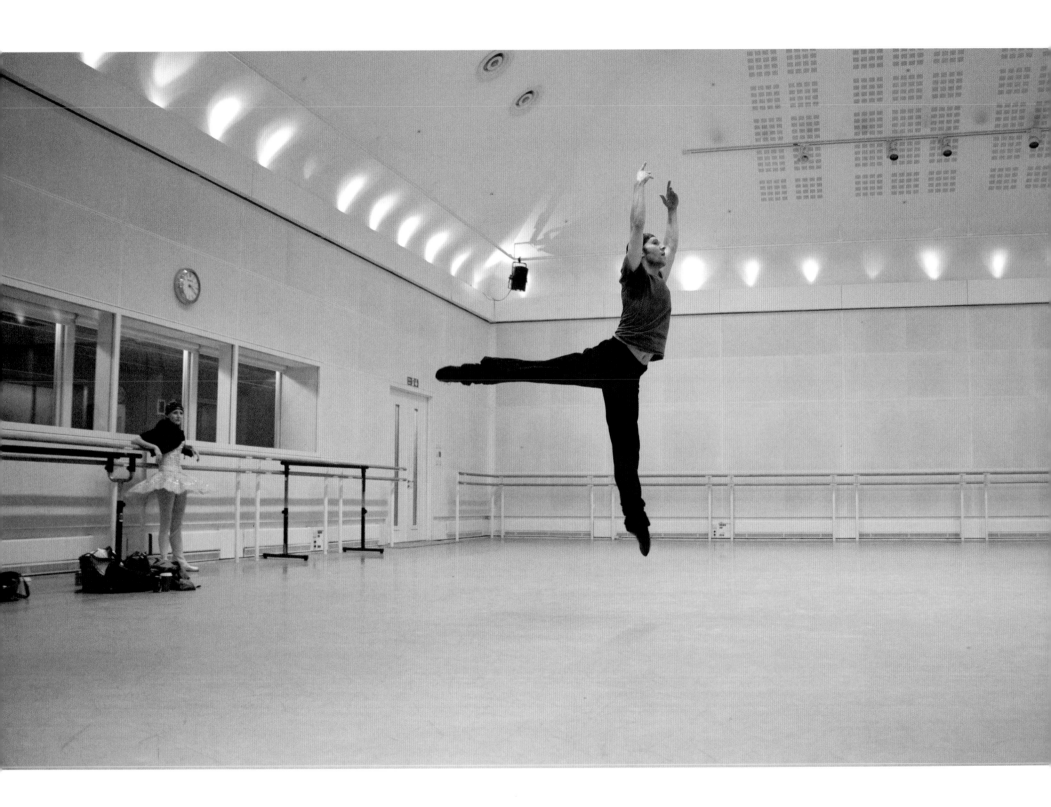

Johan Kobborg

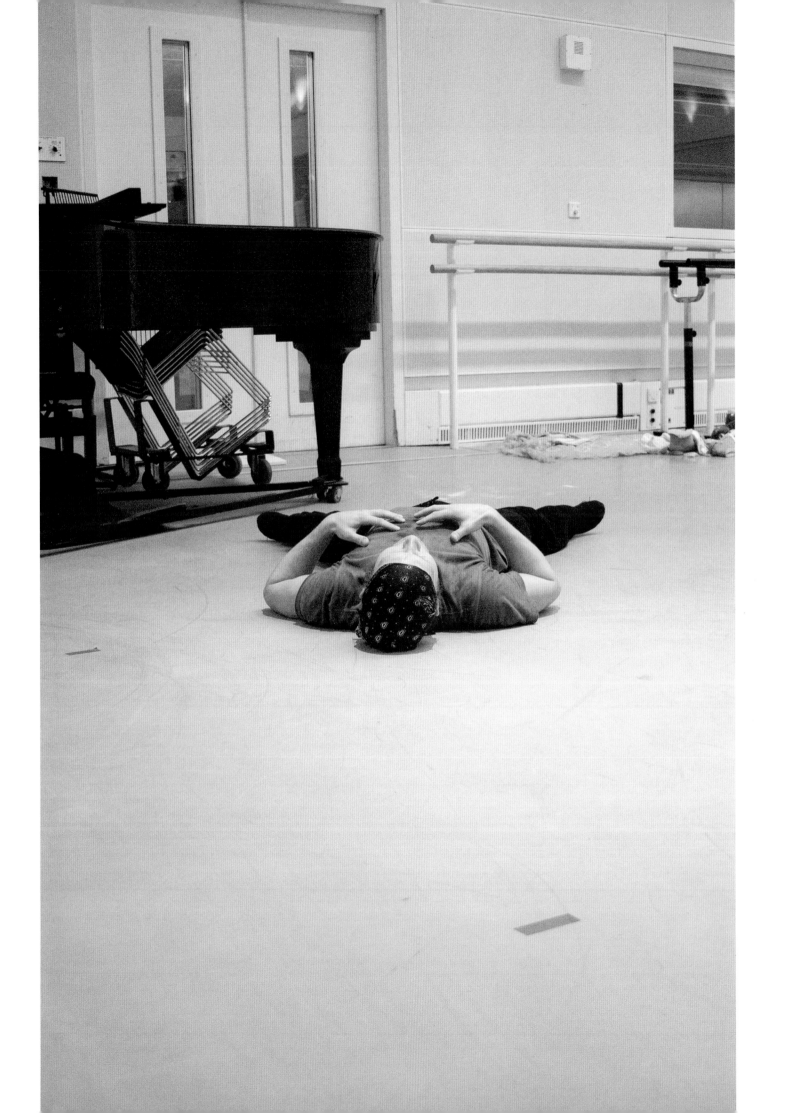

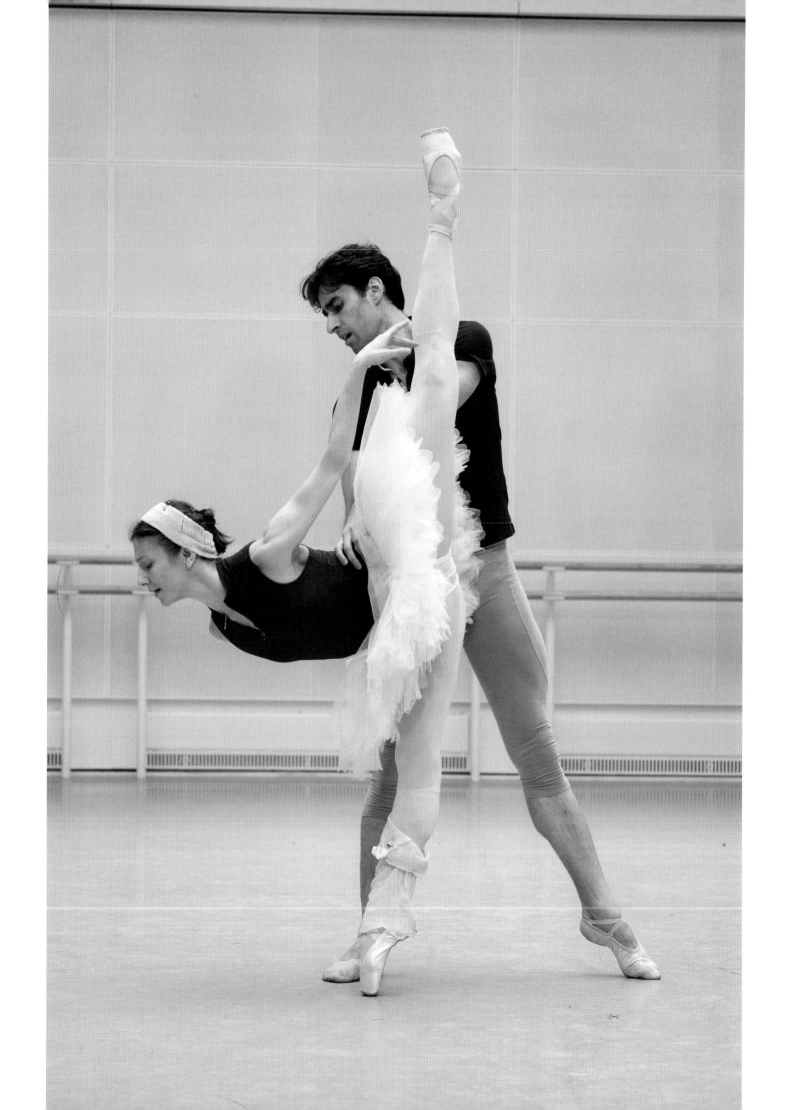

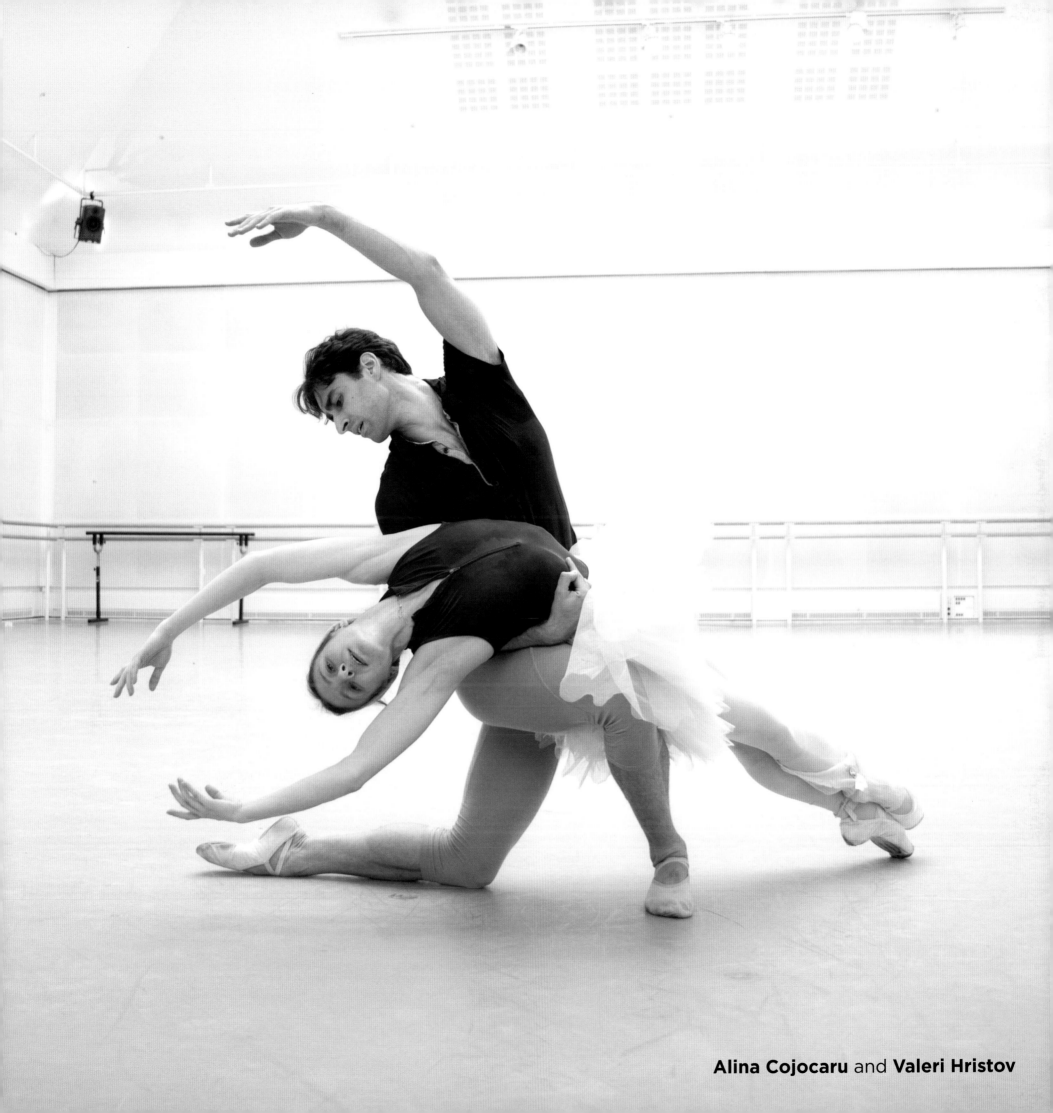

Alina Cojocaru and **Valeri Hristov**

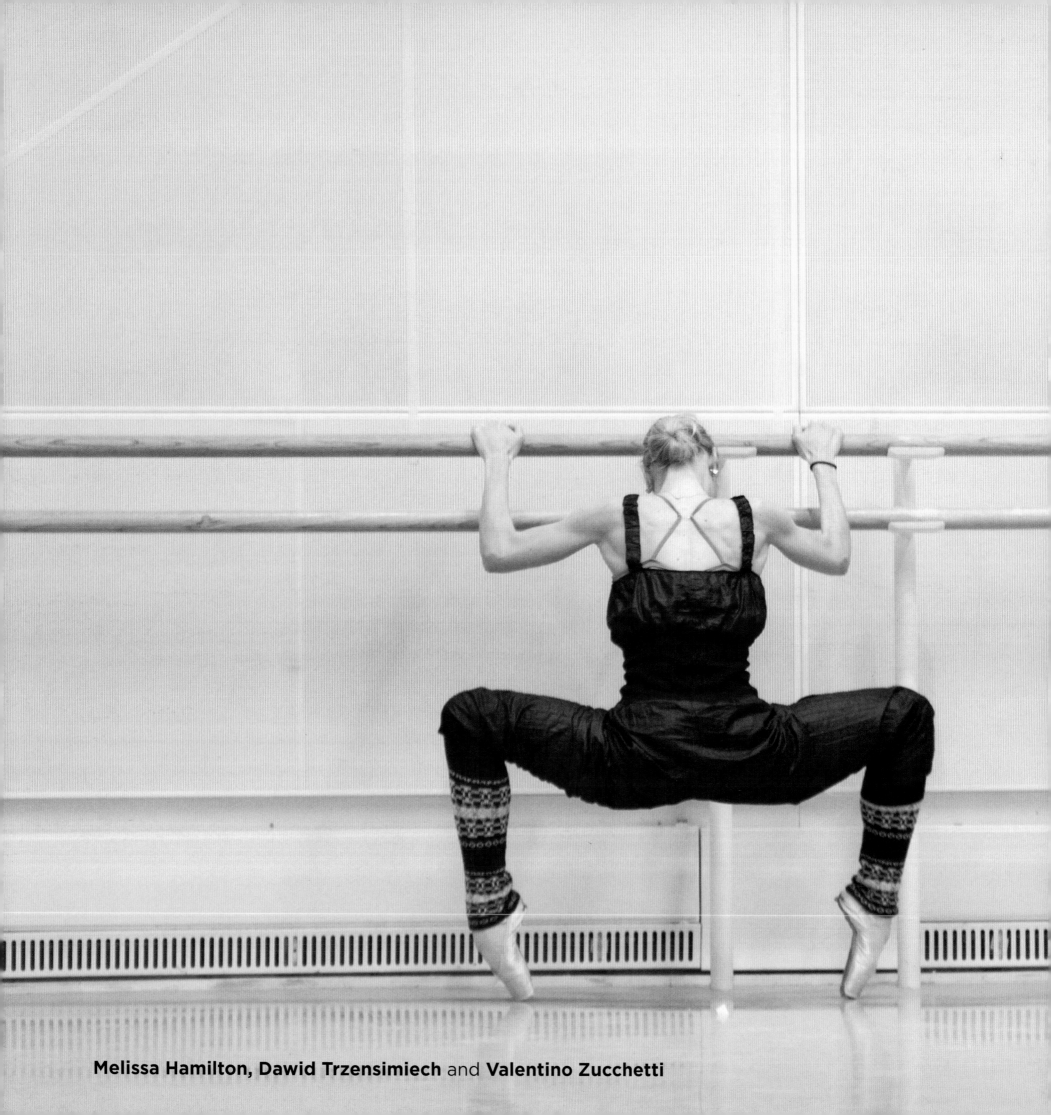

Melissa Hamilton, Dawid Trzensimiech and **Valentino Zucchetti**

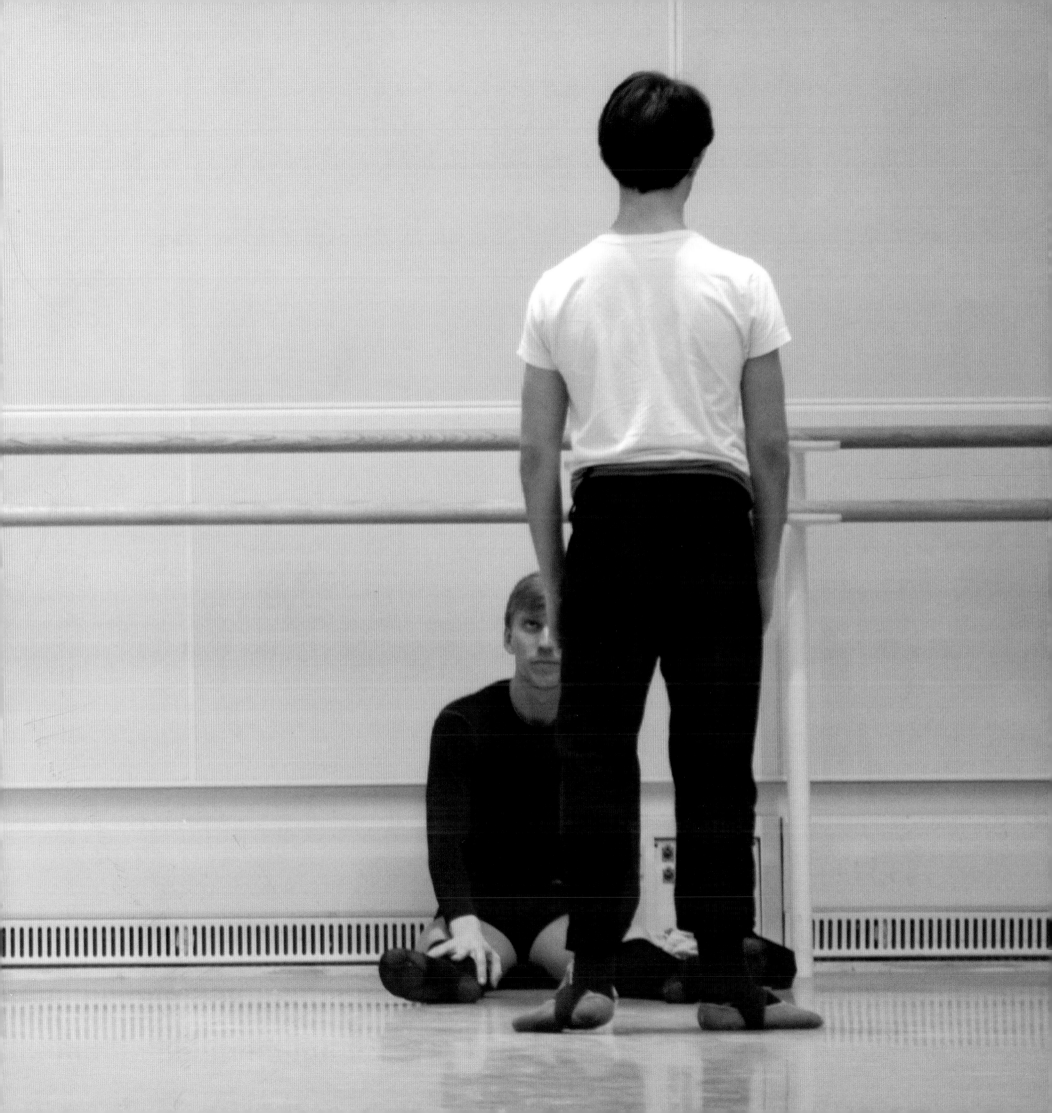

Natalia Osipova

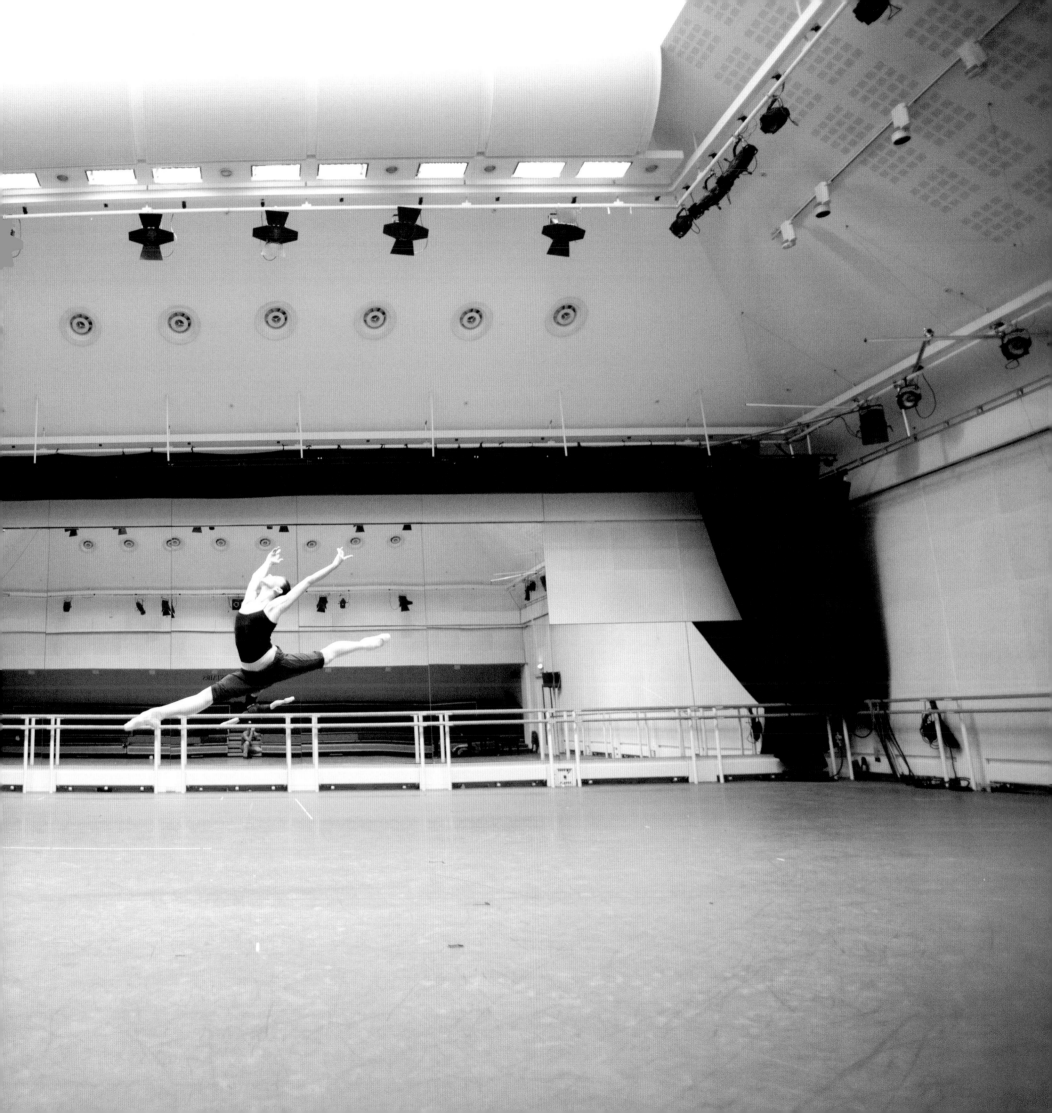

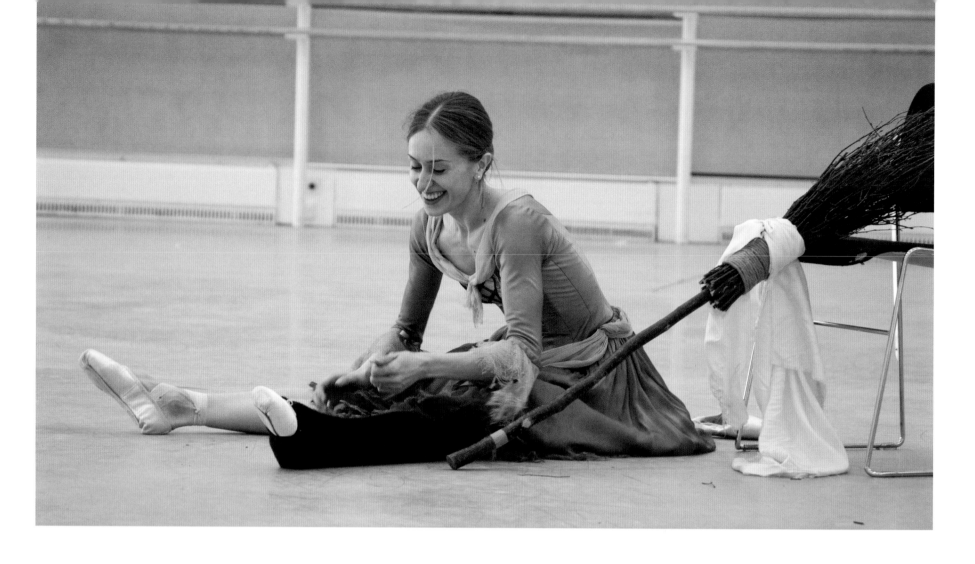

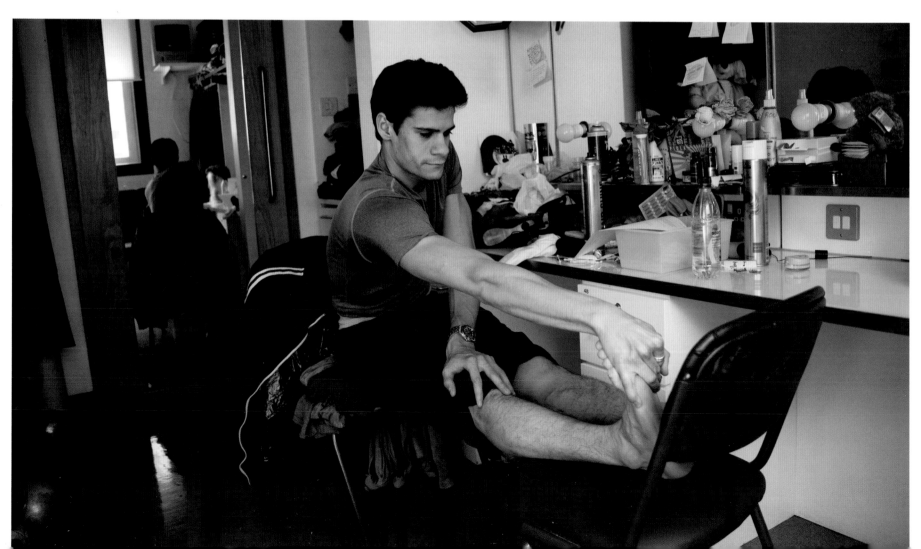

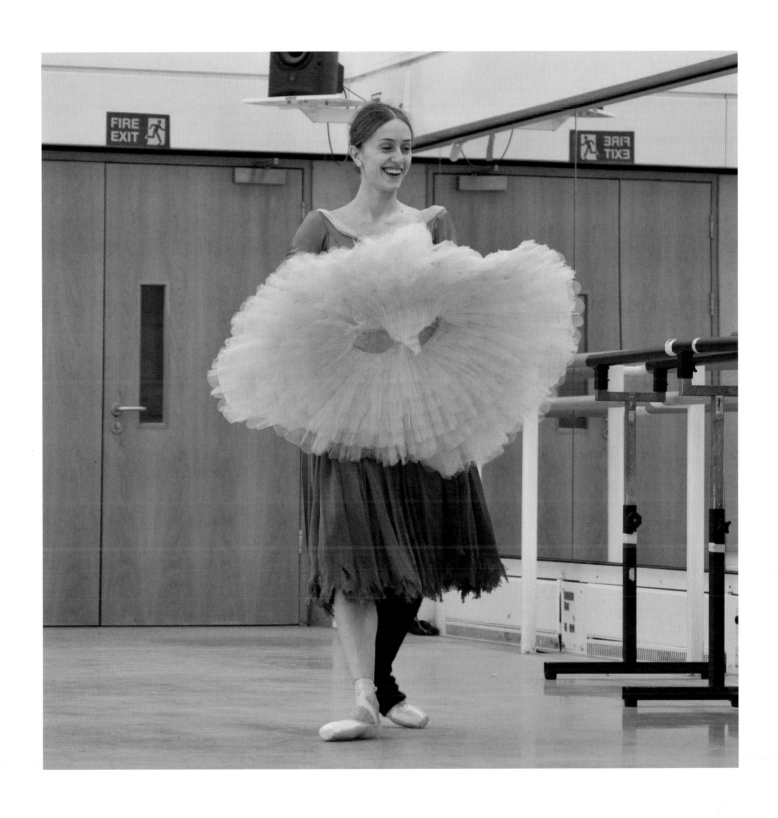

Marianela Nuñez and **Thiago Soares**

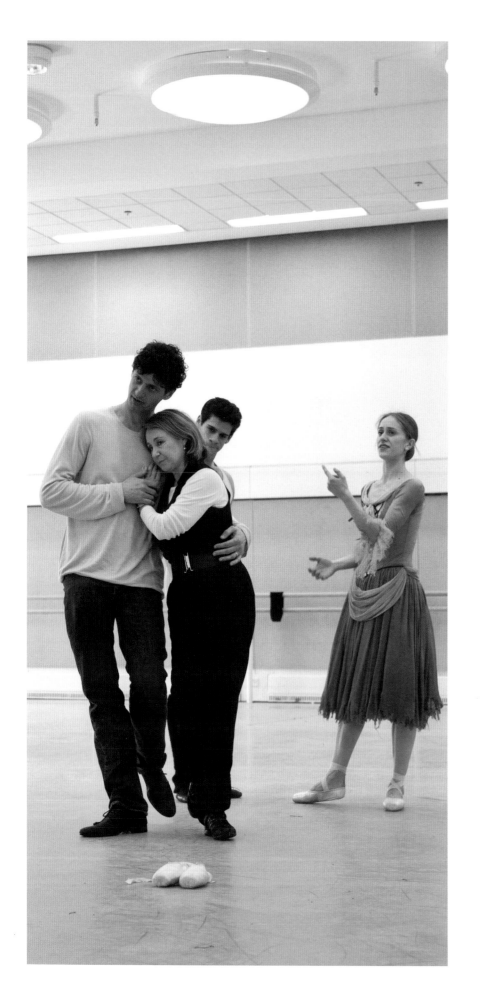

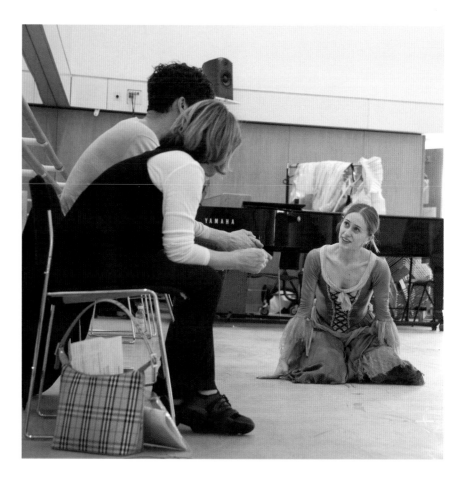

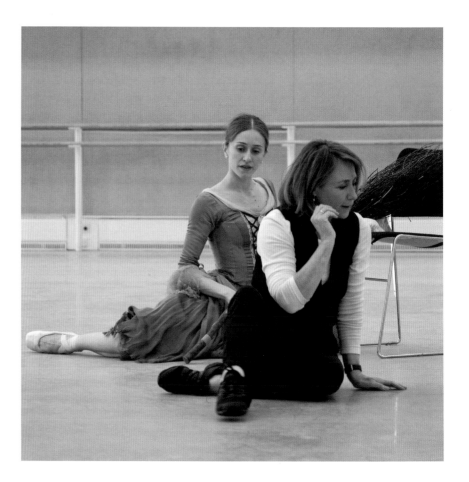

Left to right **Jonathan Cope, Wendy Ellis Somes, Thiago Soares** and **Marianela Nuñez**

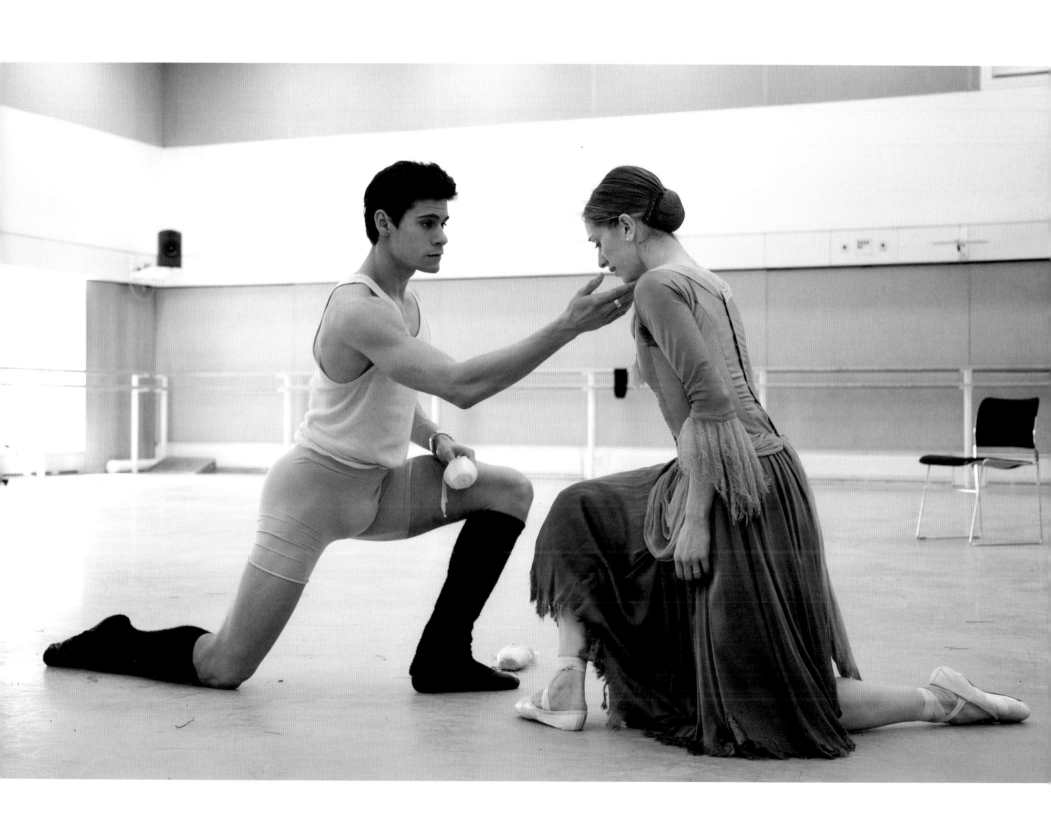

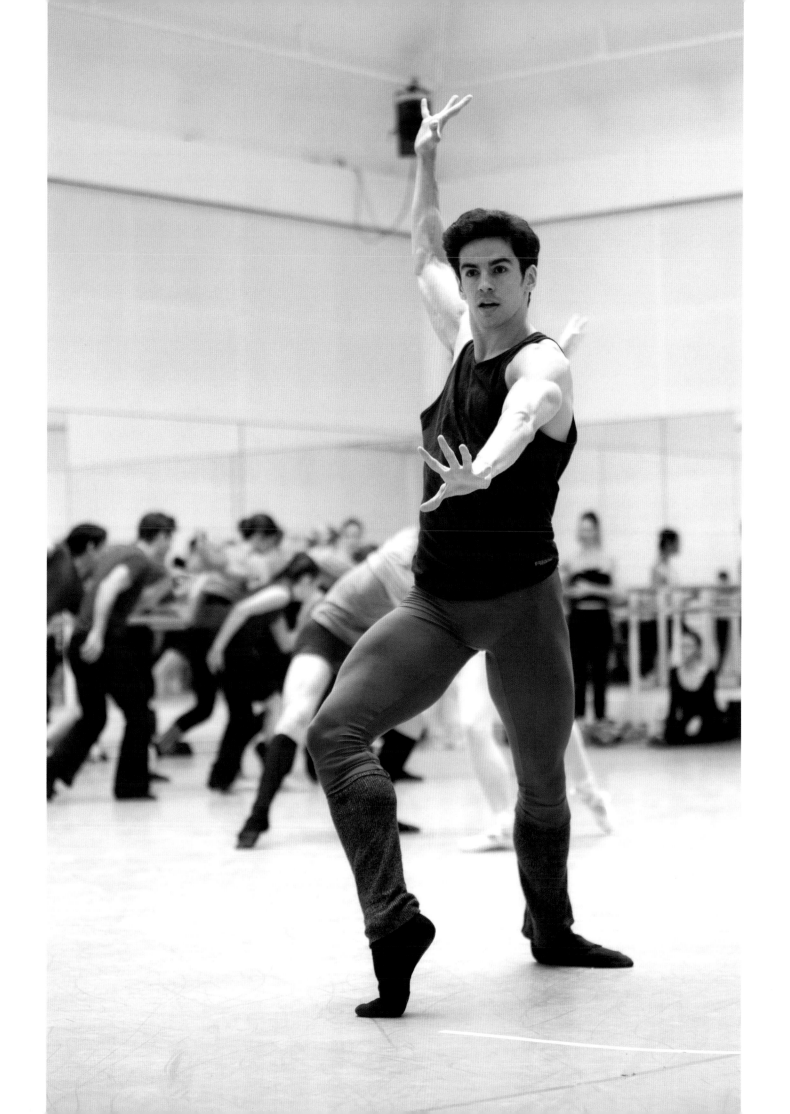

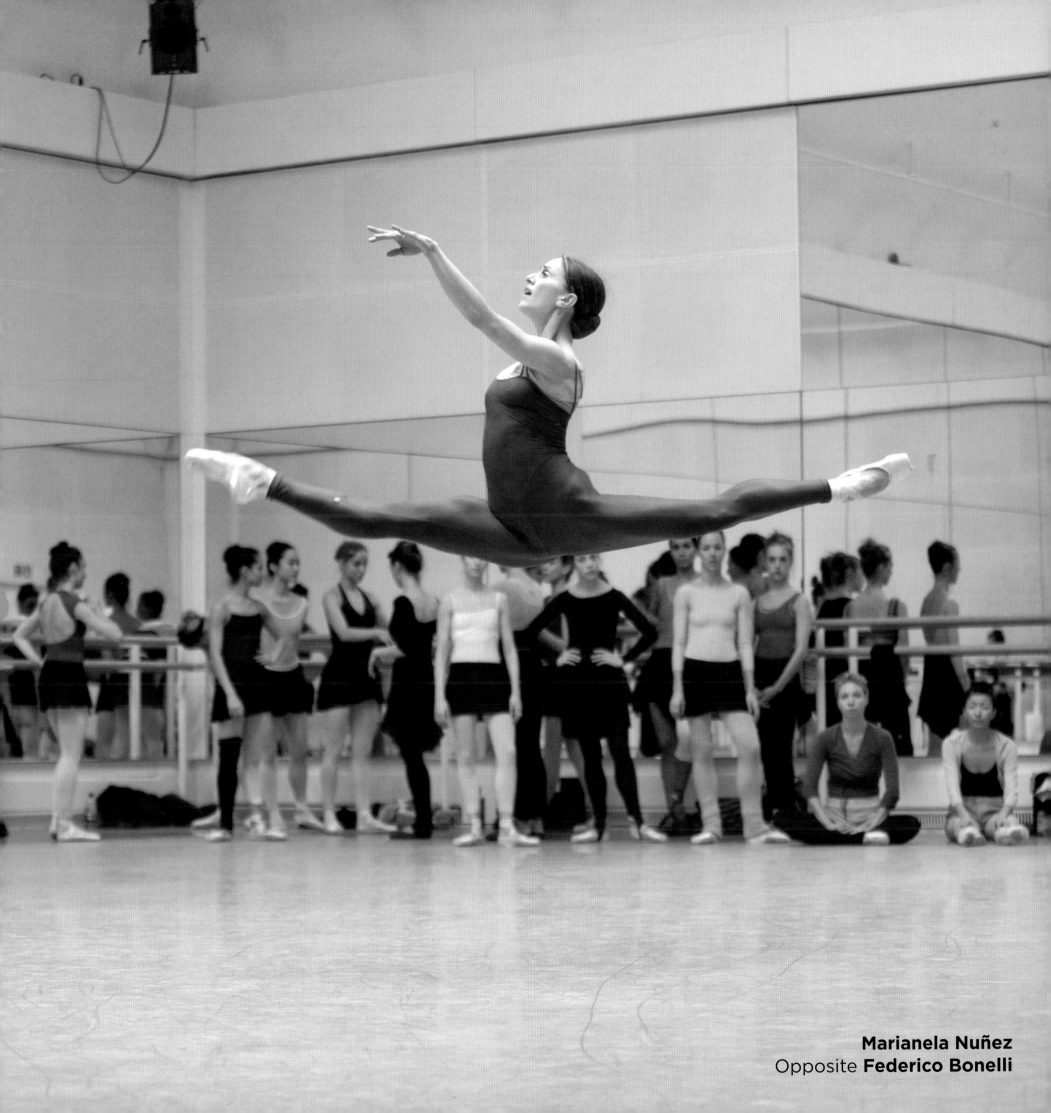

Marianela Nuñez
Opposite **Federico Bonelli**

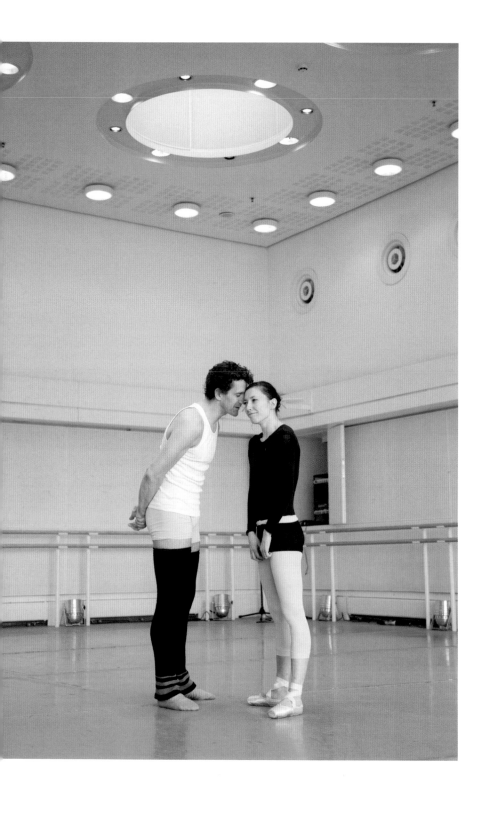

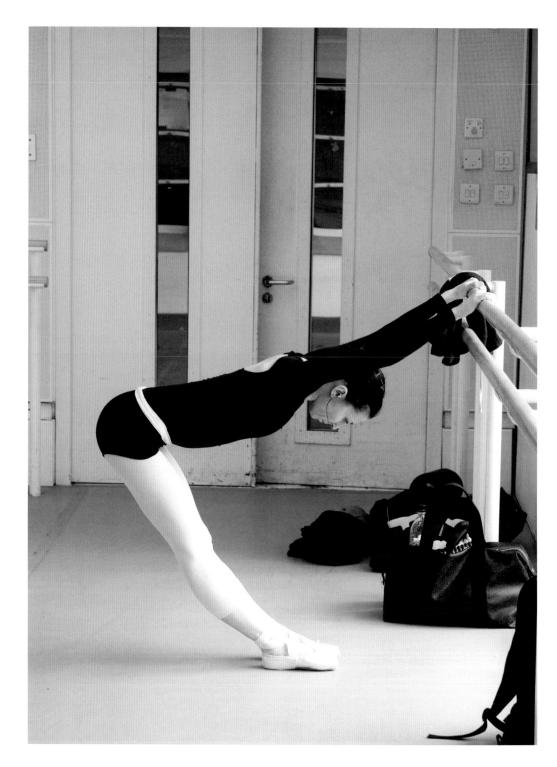

Gary Avis and **Mara Galeazzi**

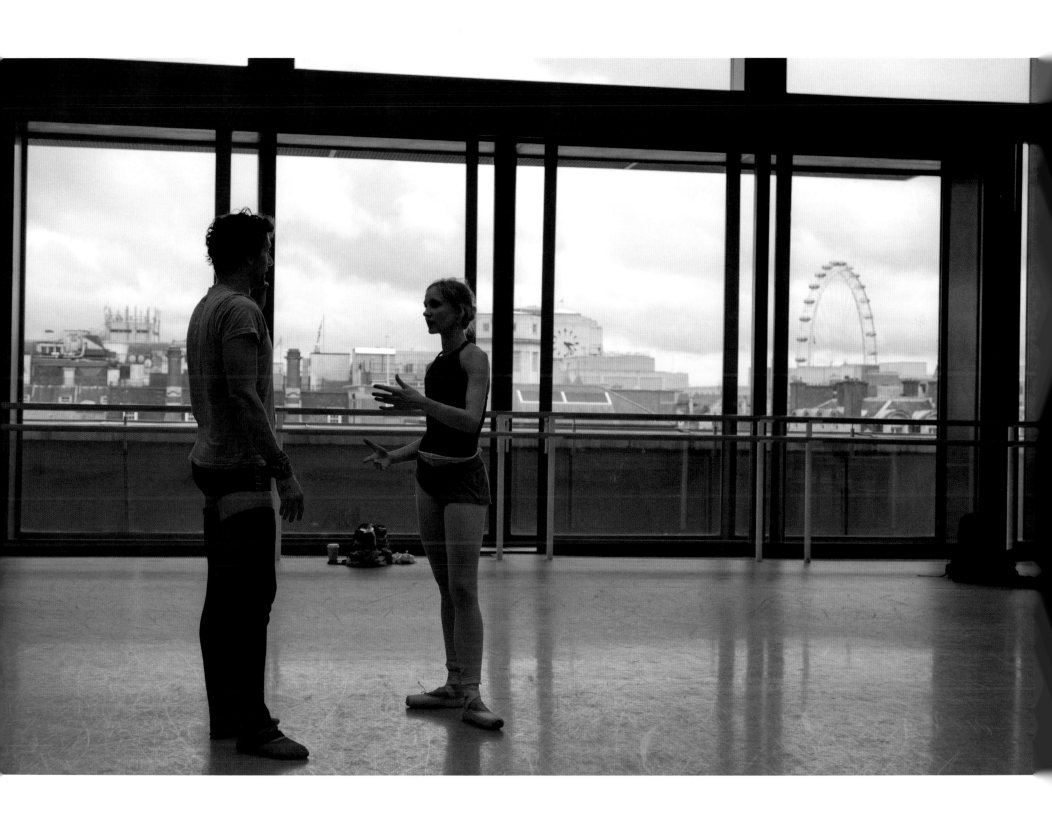

Gary Avis and **Melissa Hamilton**

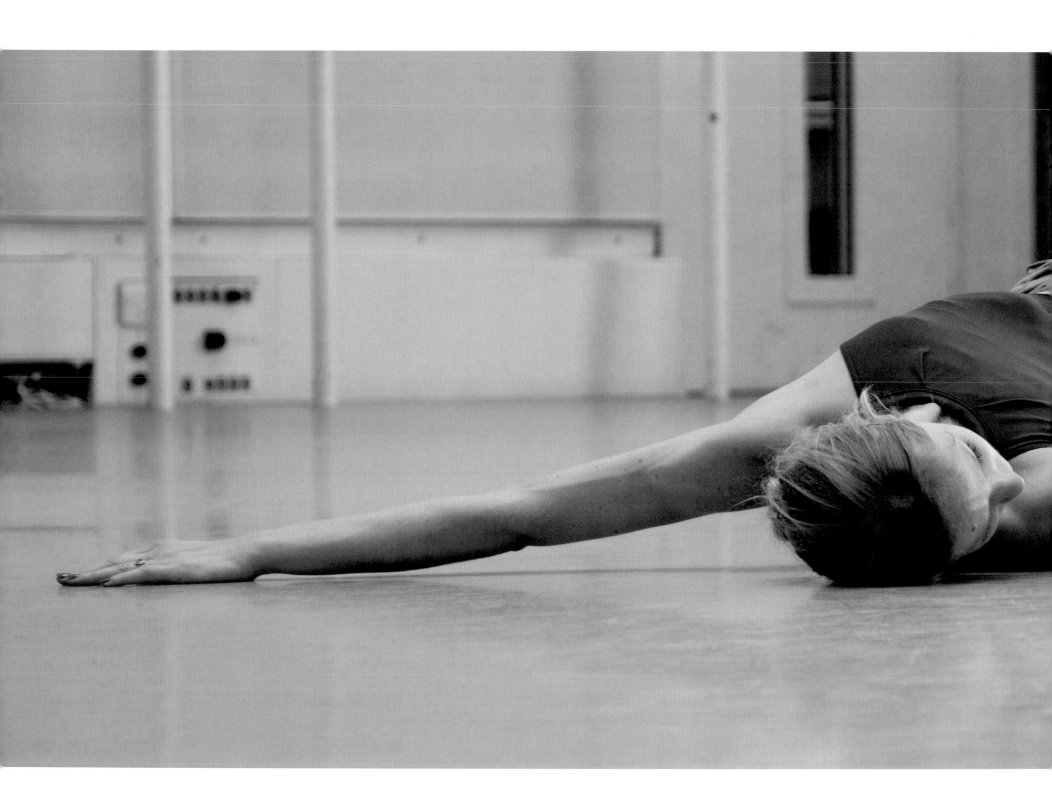

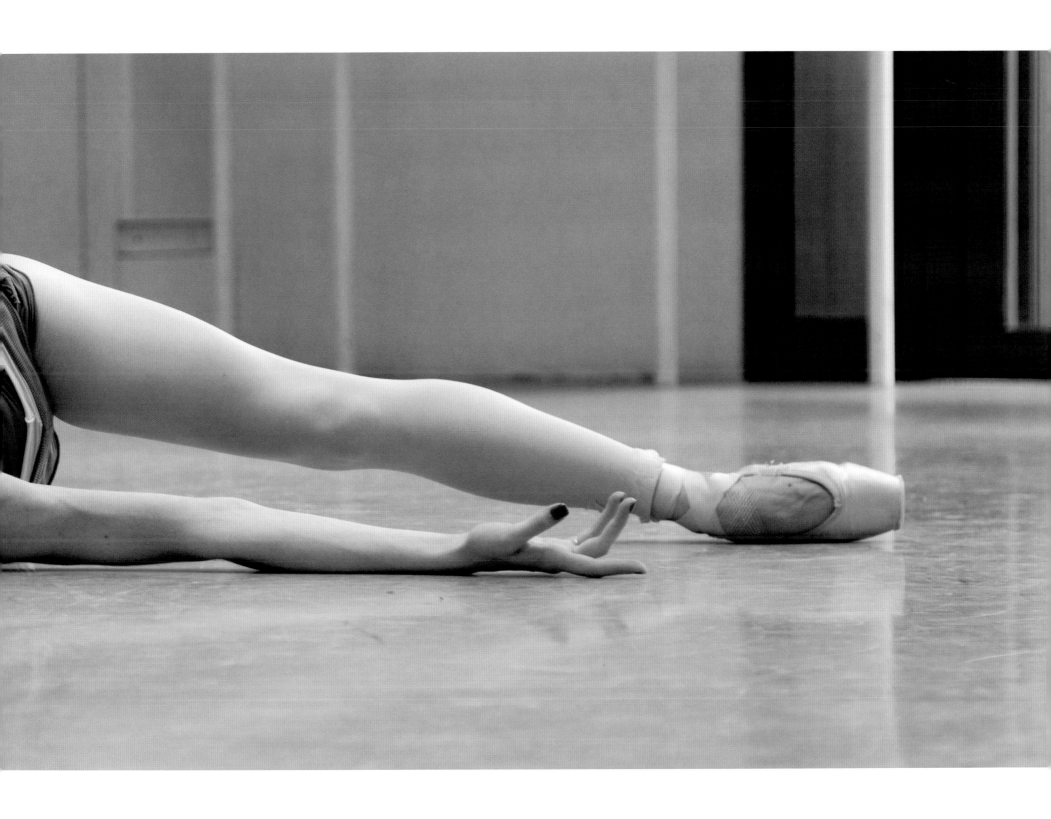

Melissa Hamilton

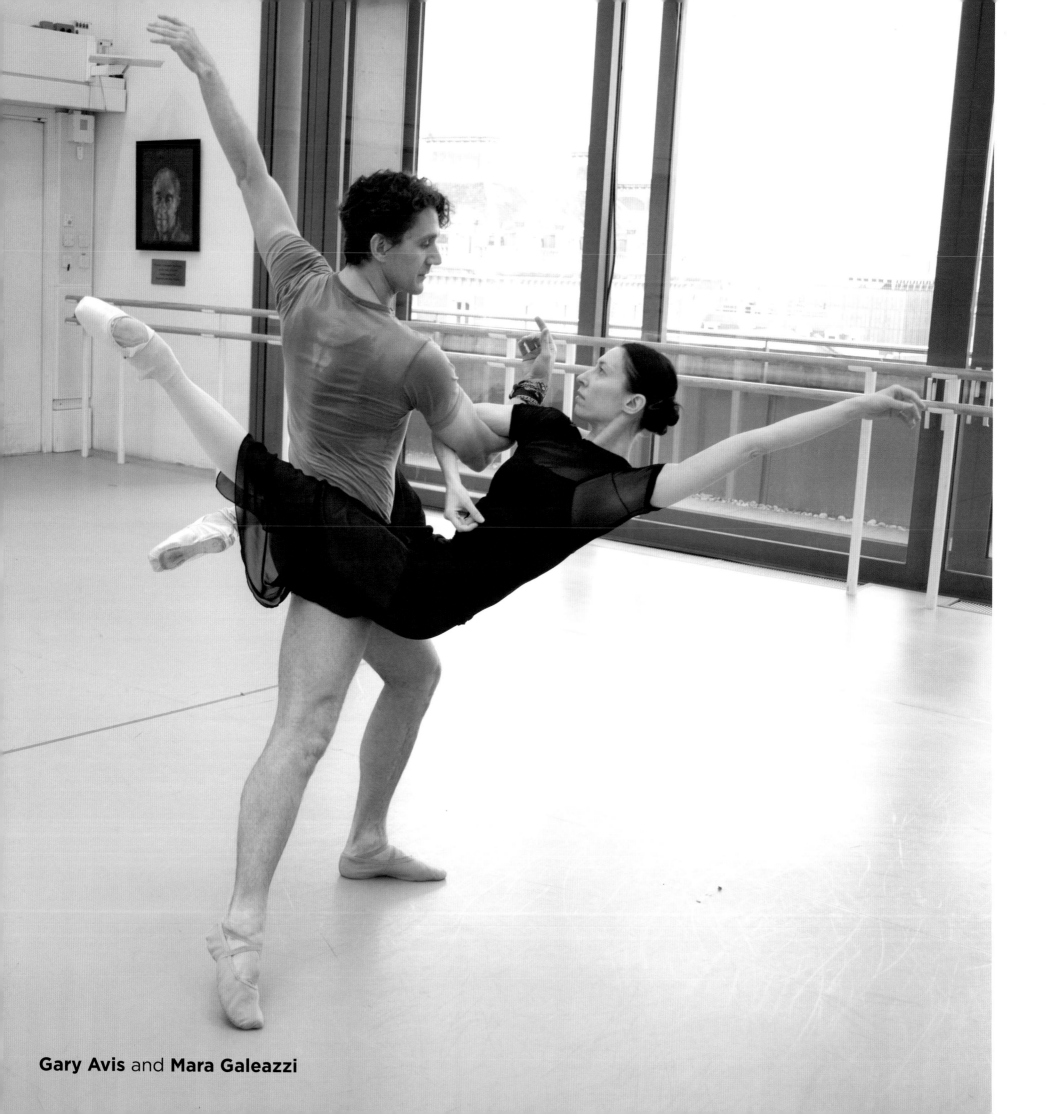

Gary Avis and **Mara Galeazzi**

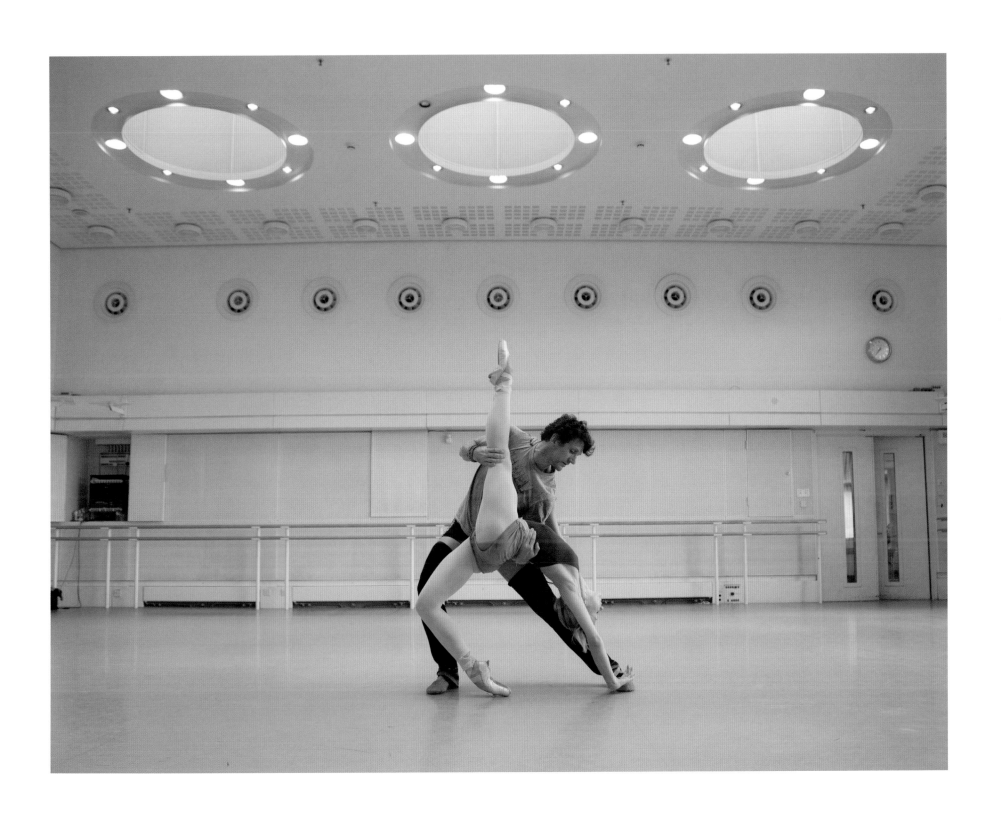

Gary Avis and **Melissa Hamilton**

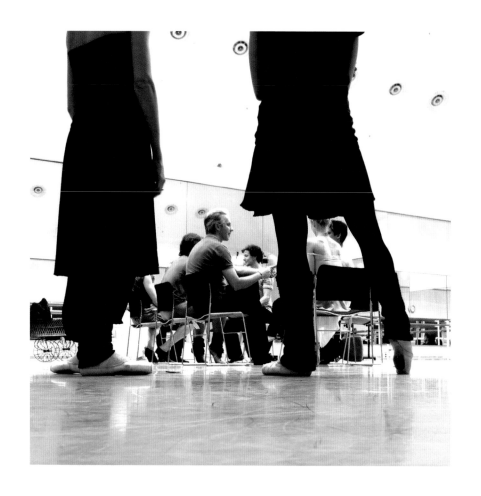

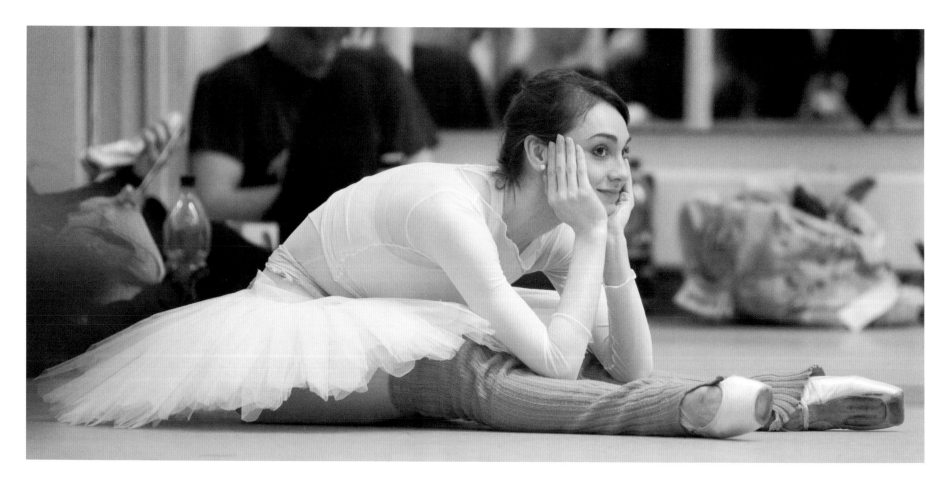

Clockwise from top left **Christopher Saunders**, **Tara-Brigitte Bhavnani** and **Elizabeth Harrod**

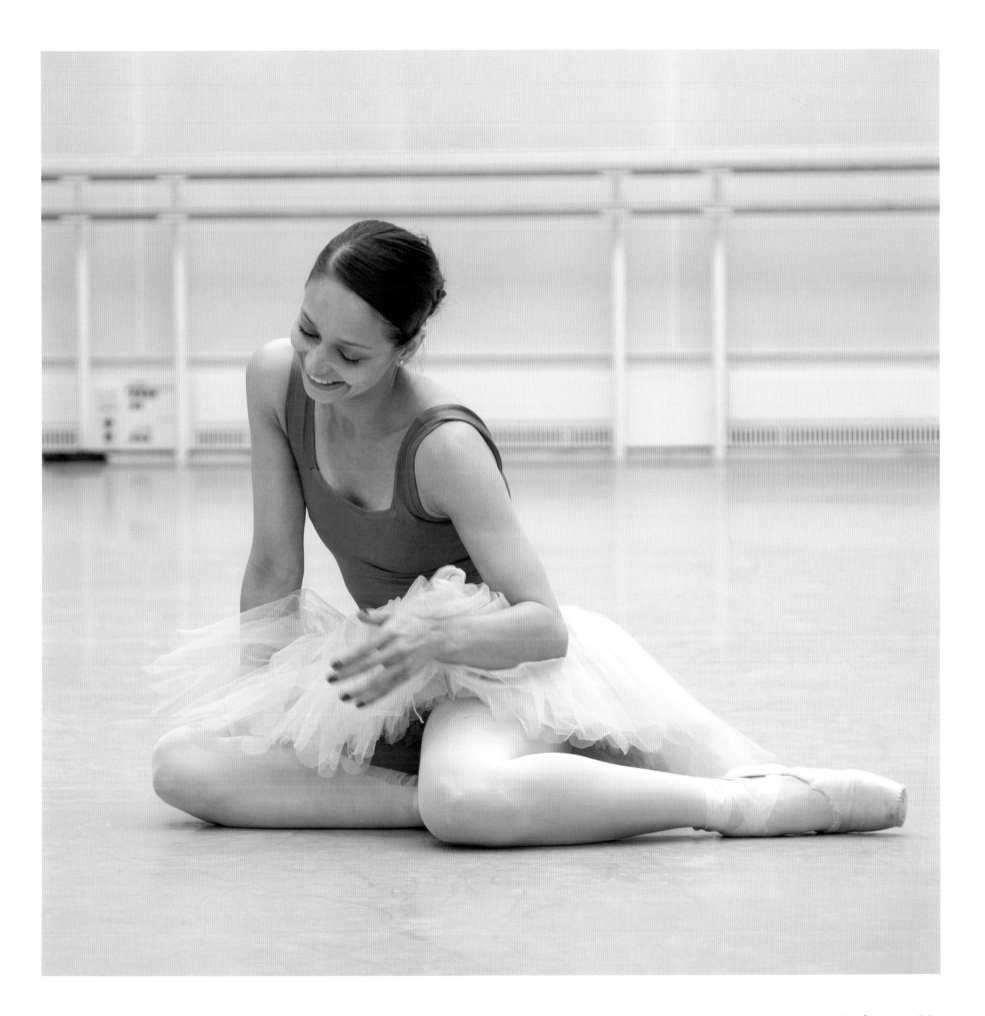

Roberta Marquez

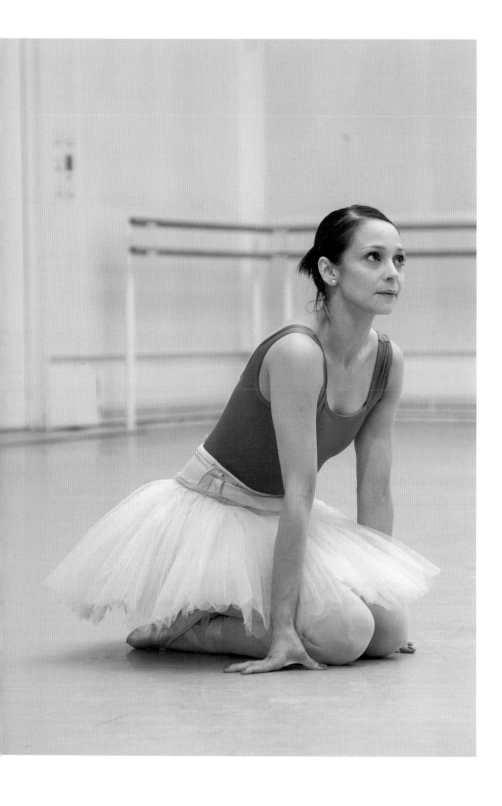

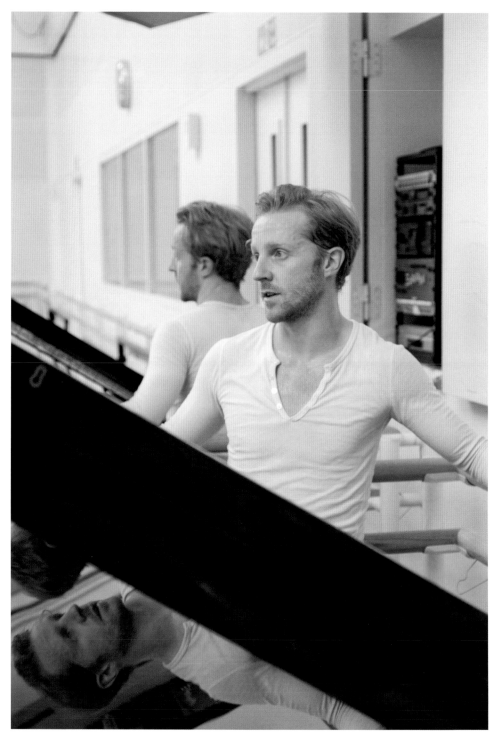

Roberta Marquez and **Steven McRae**

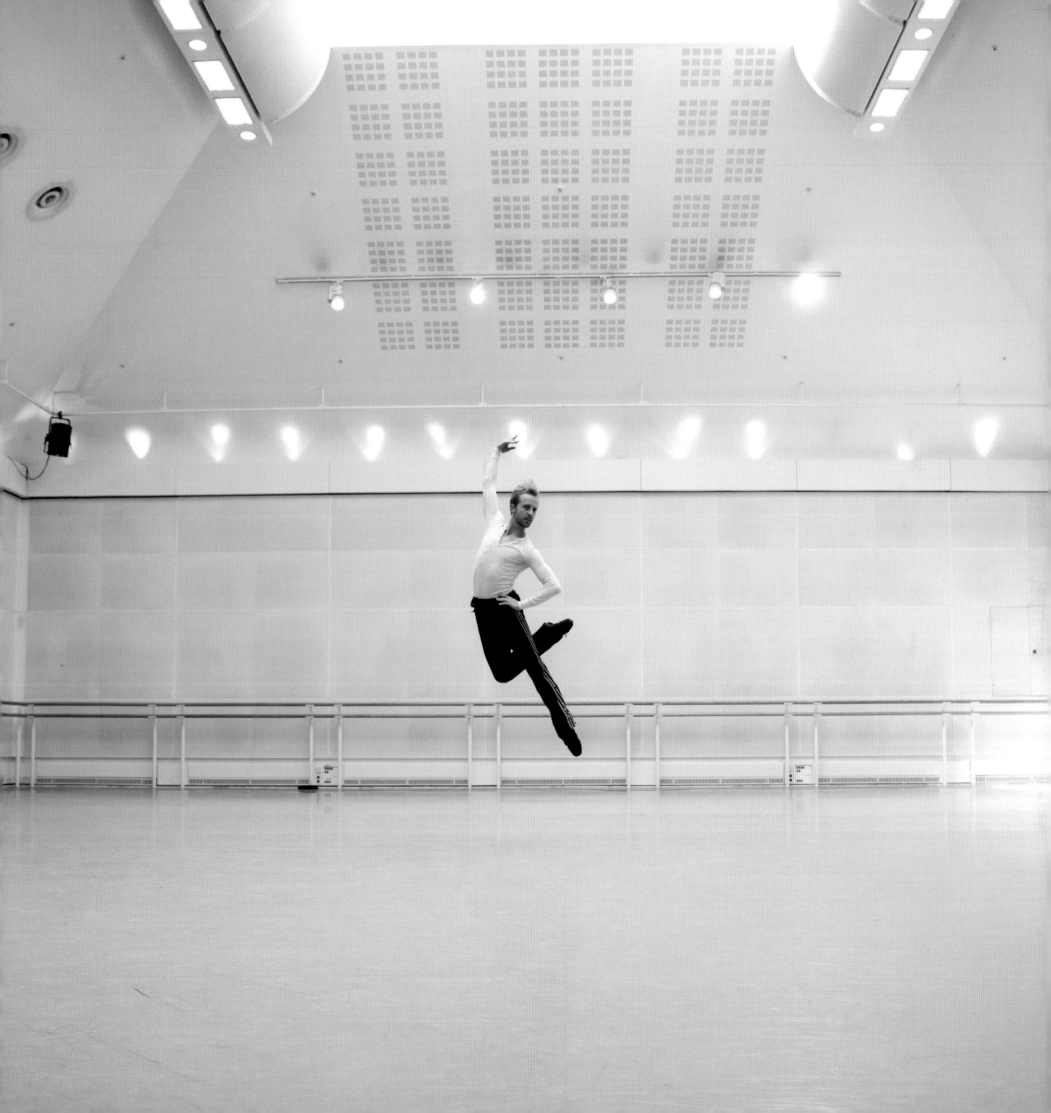

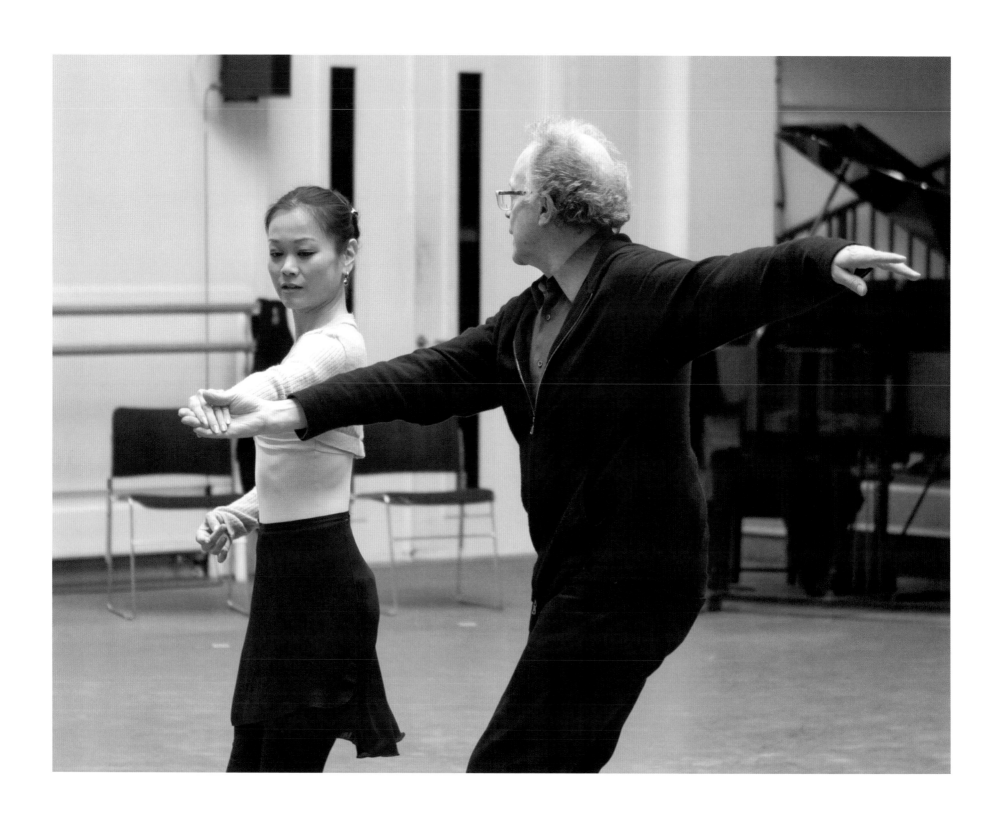

Miyako Yoshida and **Anthony Dowell**

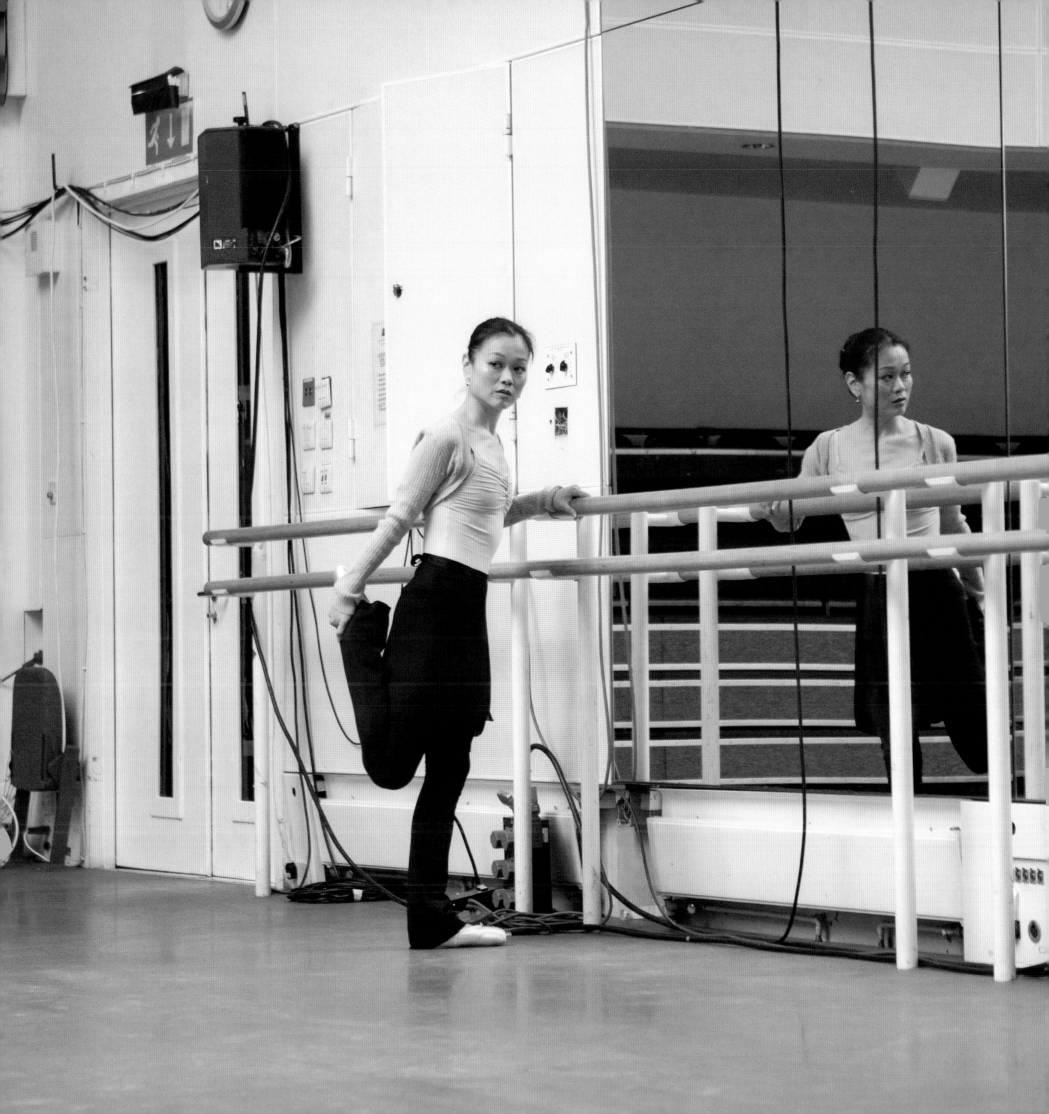

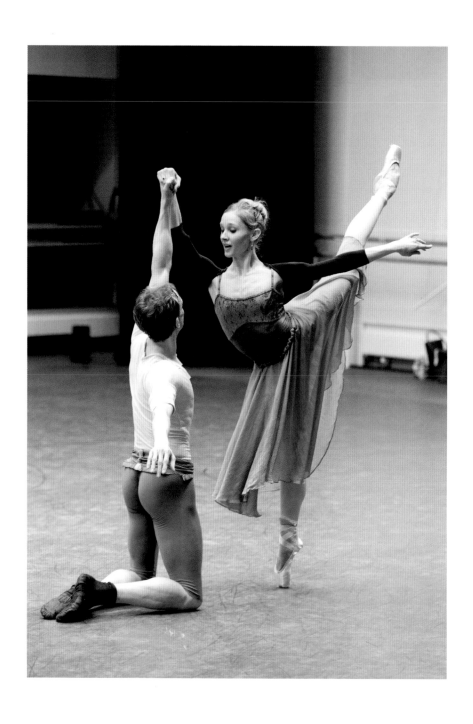

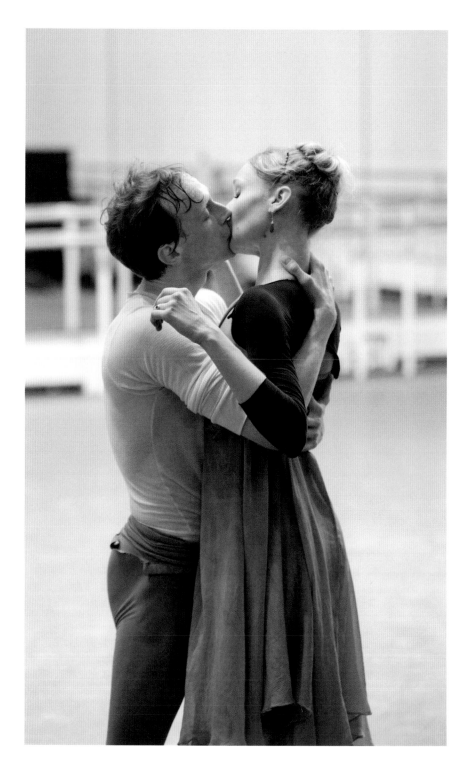

Edward Watson and **Melissa Hamilton**

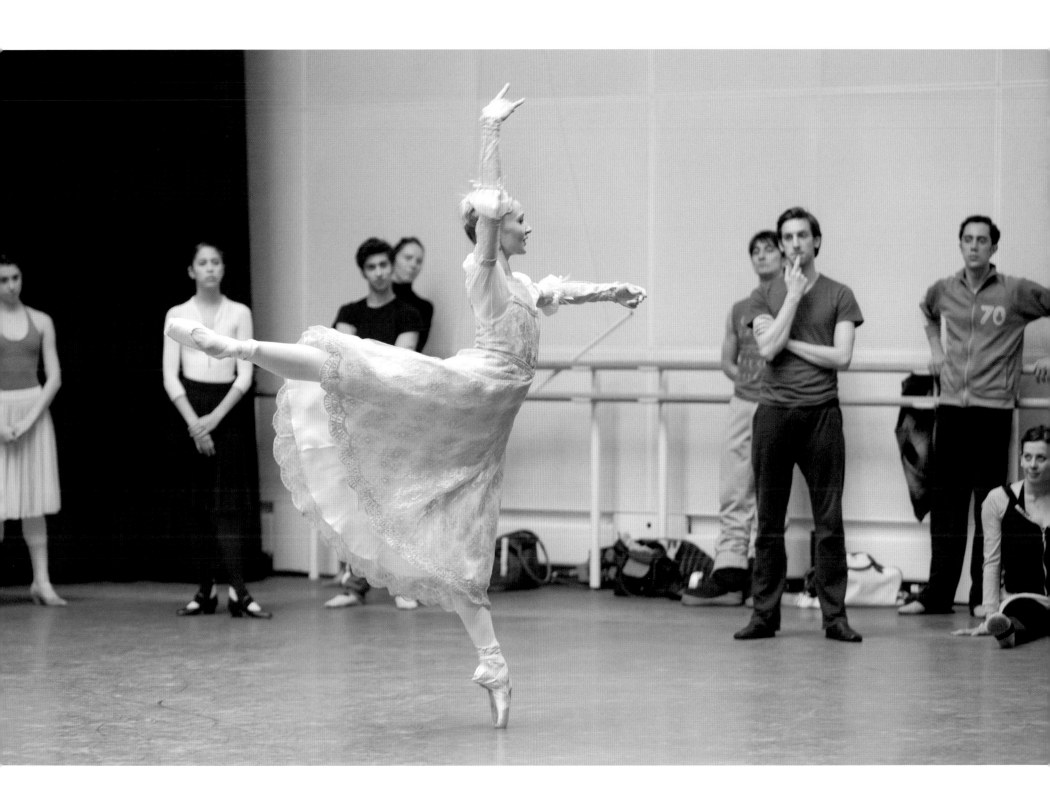

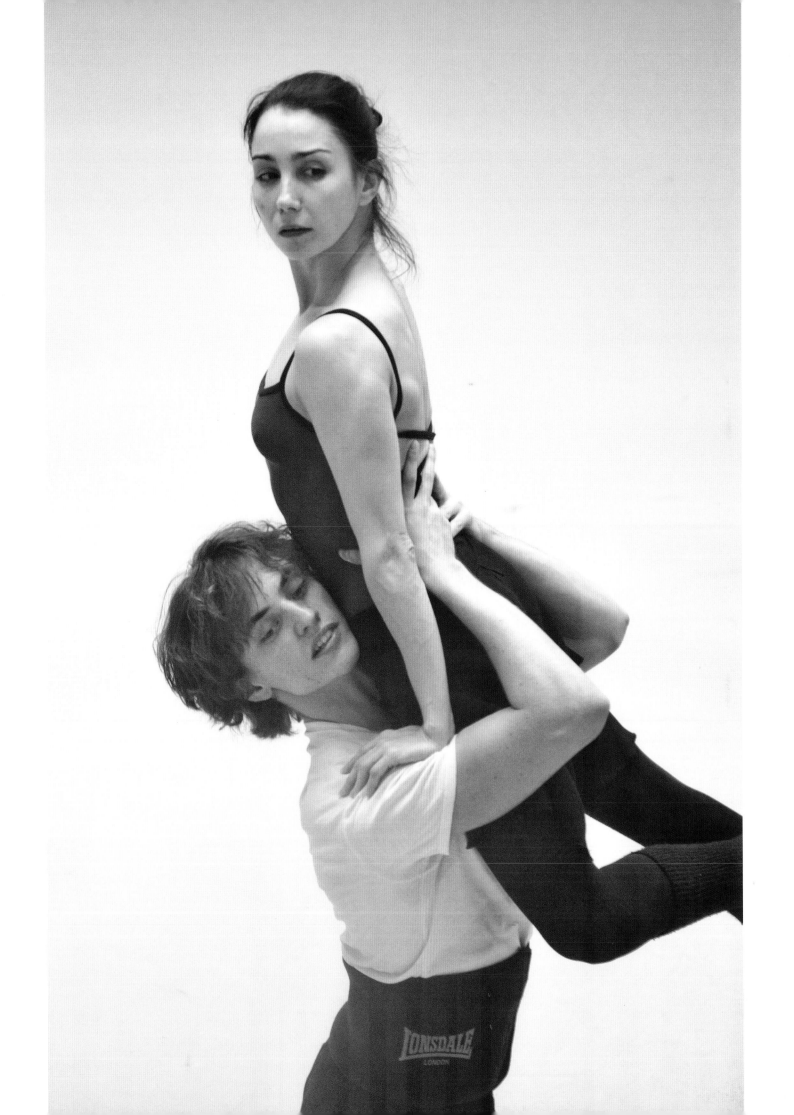

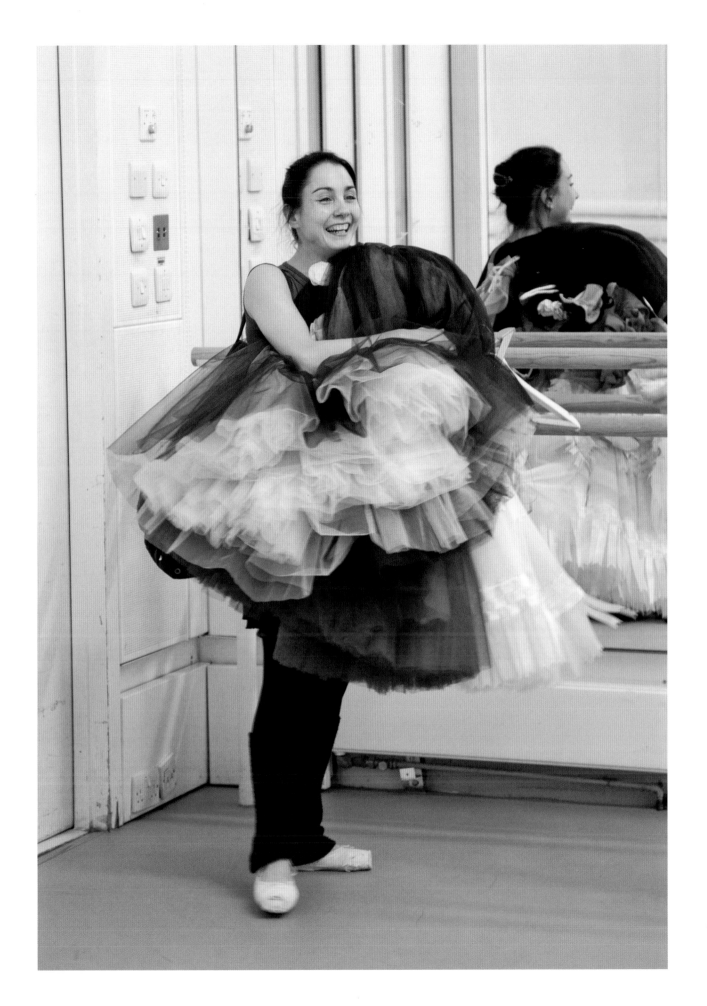

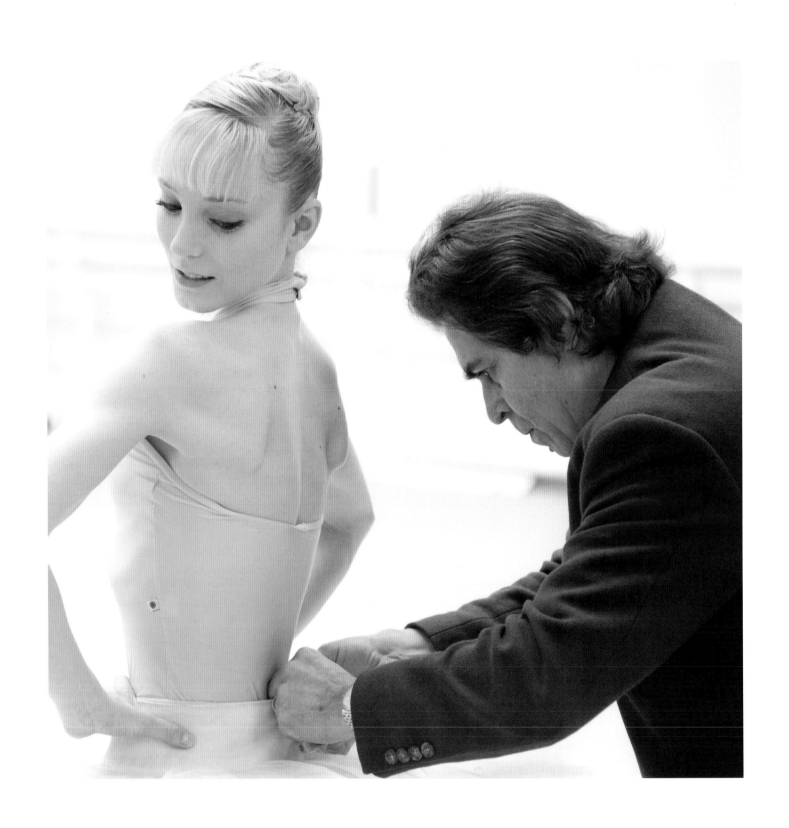

Sarah Lamb and **Alexander Agadzhanov**

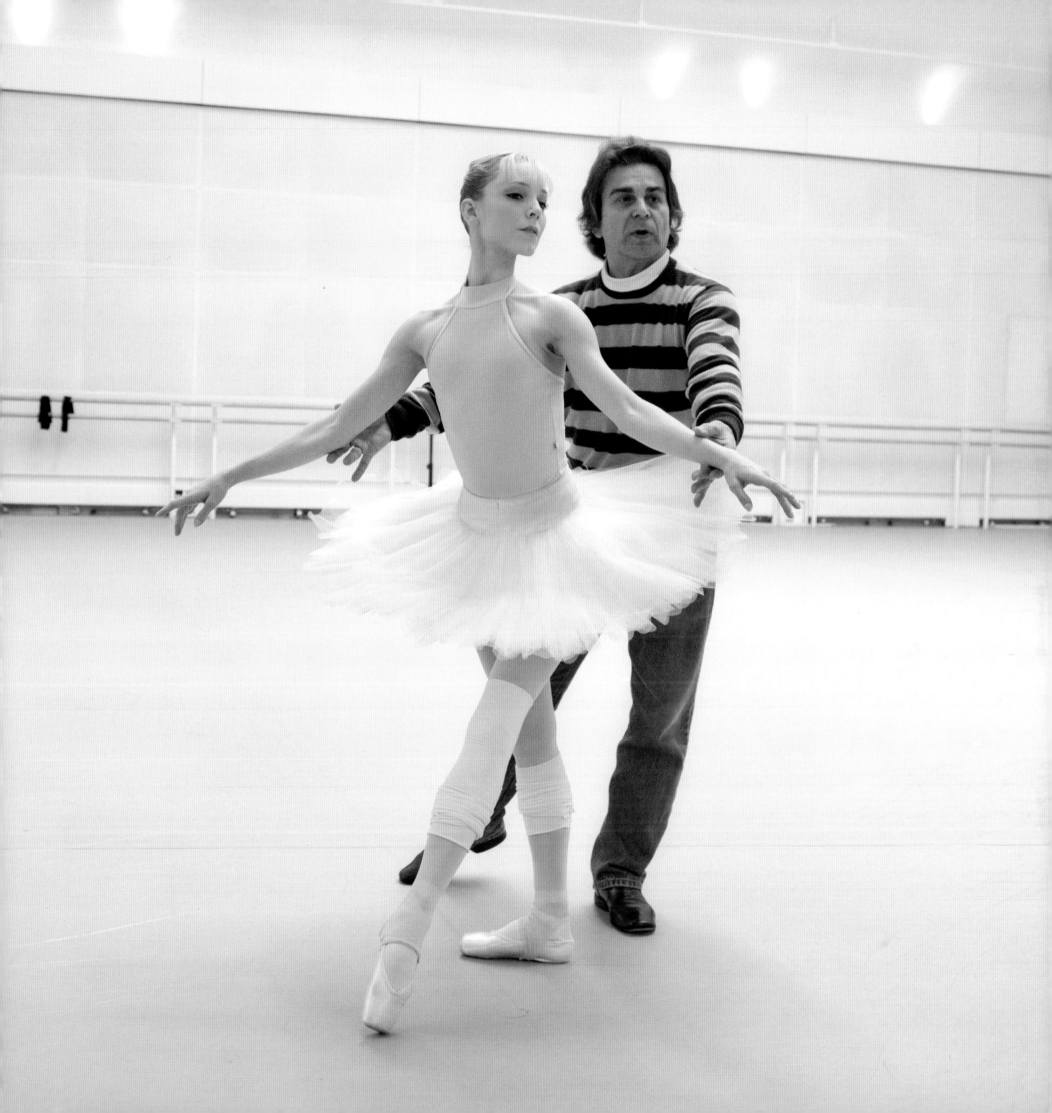

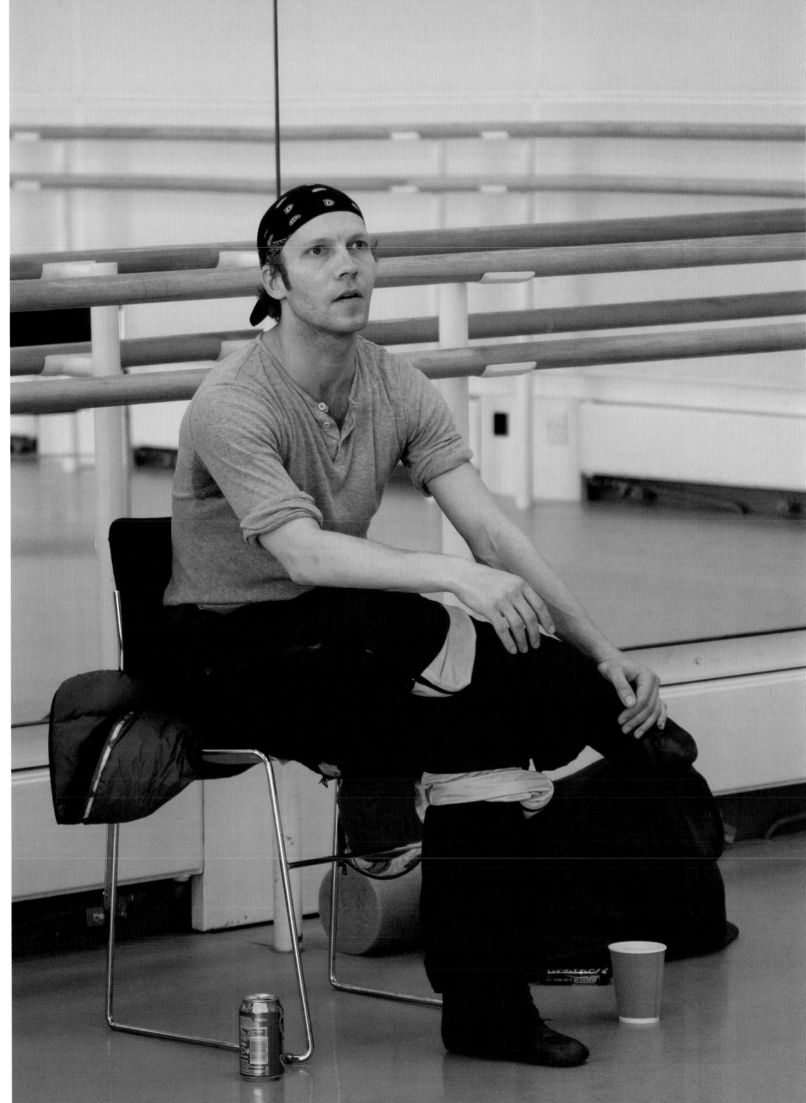

Johan Kobborg

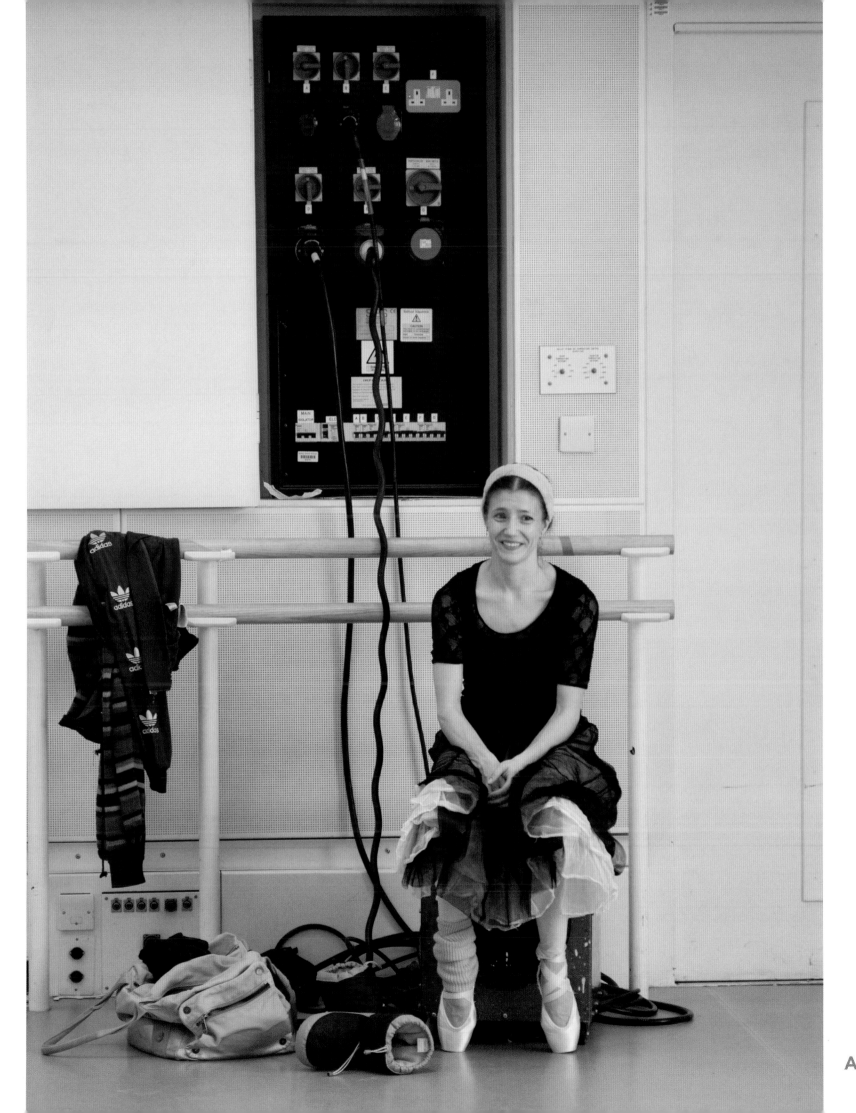

Alina Cojocaru

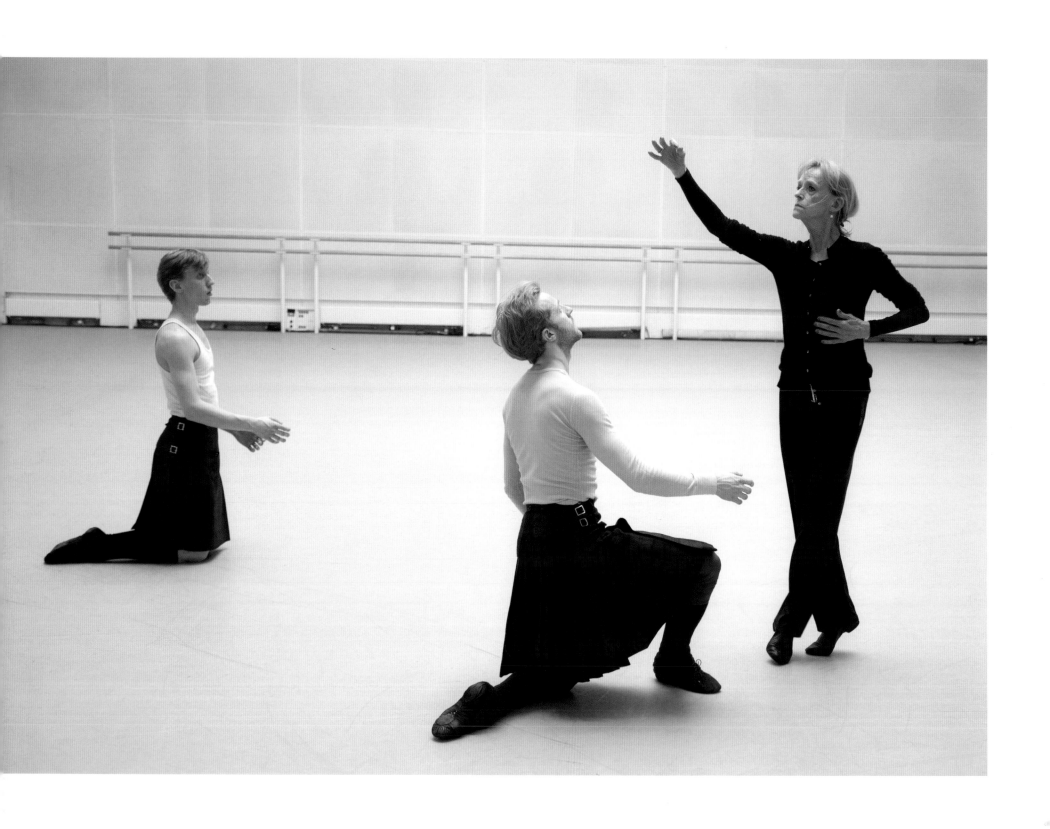

Dawid Trzensimiech, Steven McRae and **Sorella Englund**

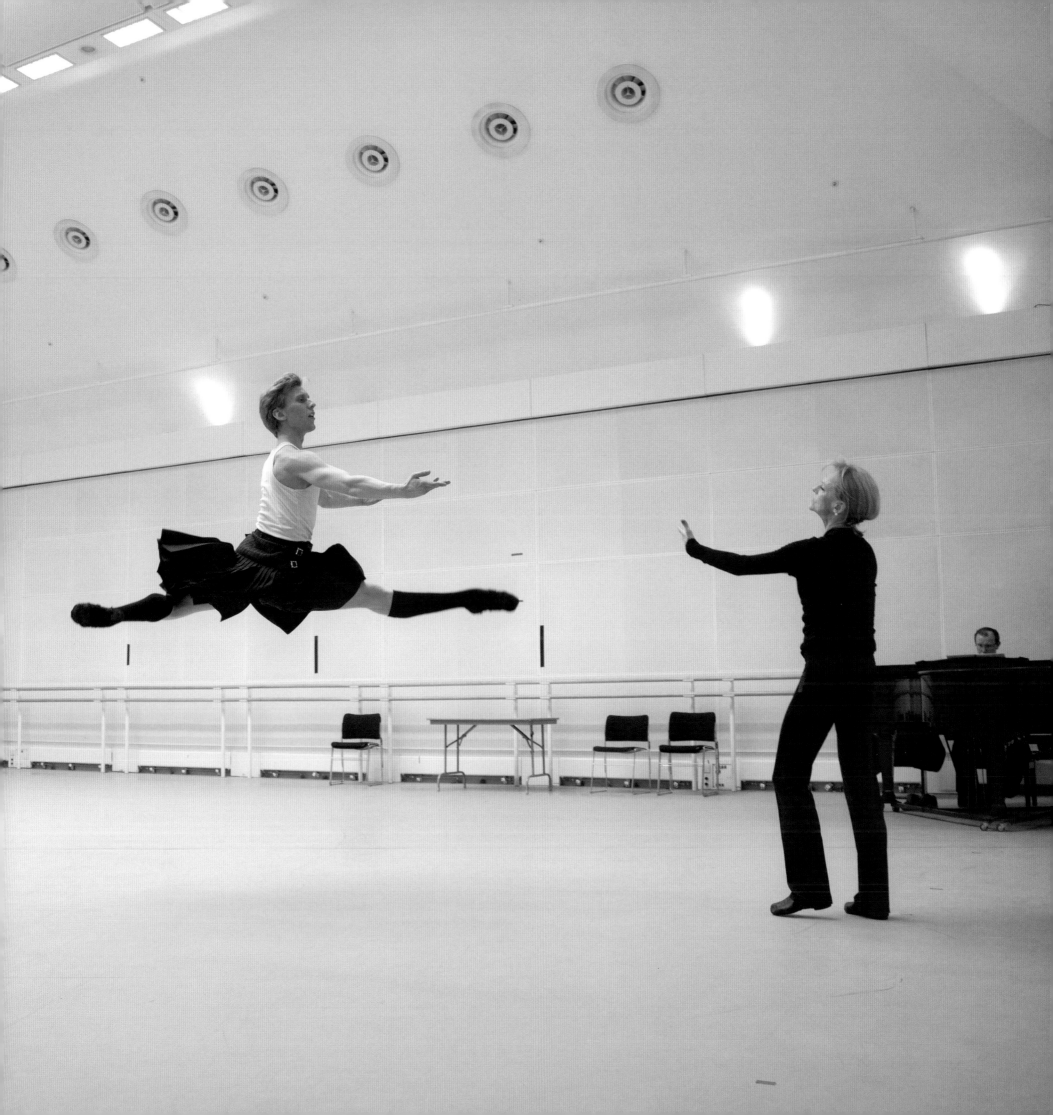

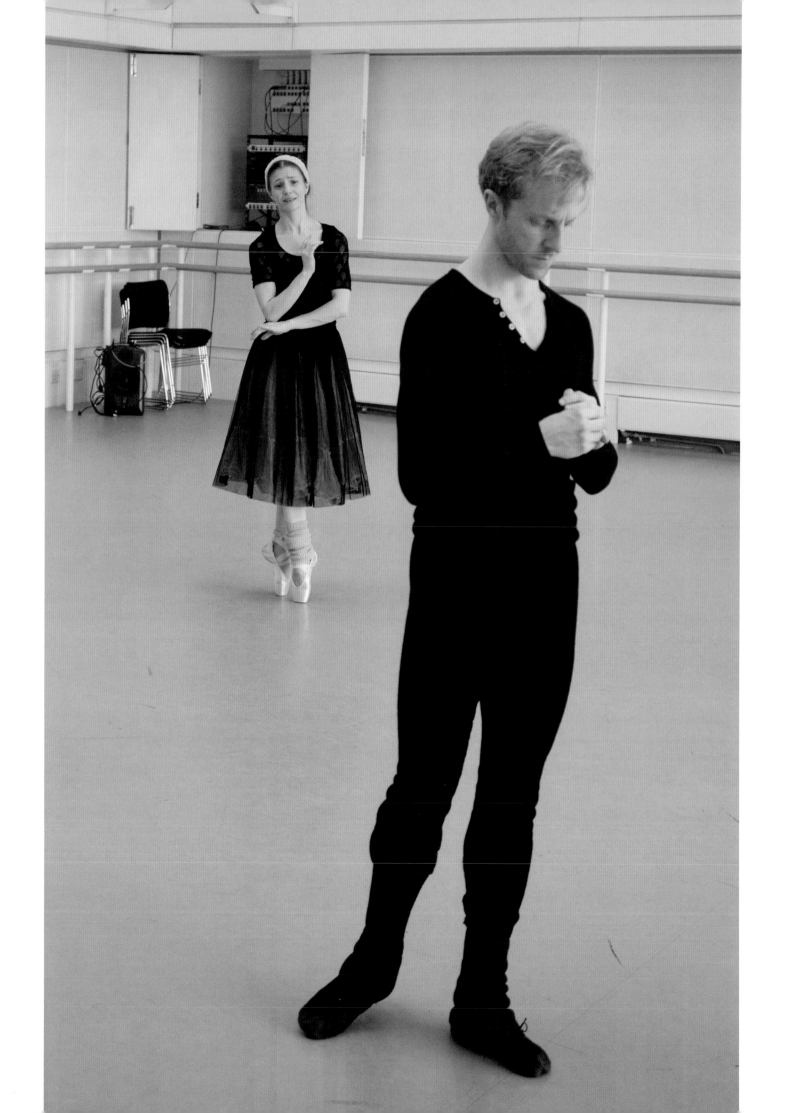

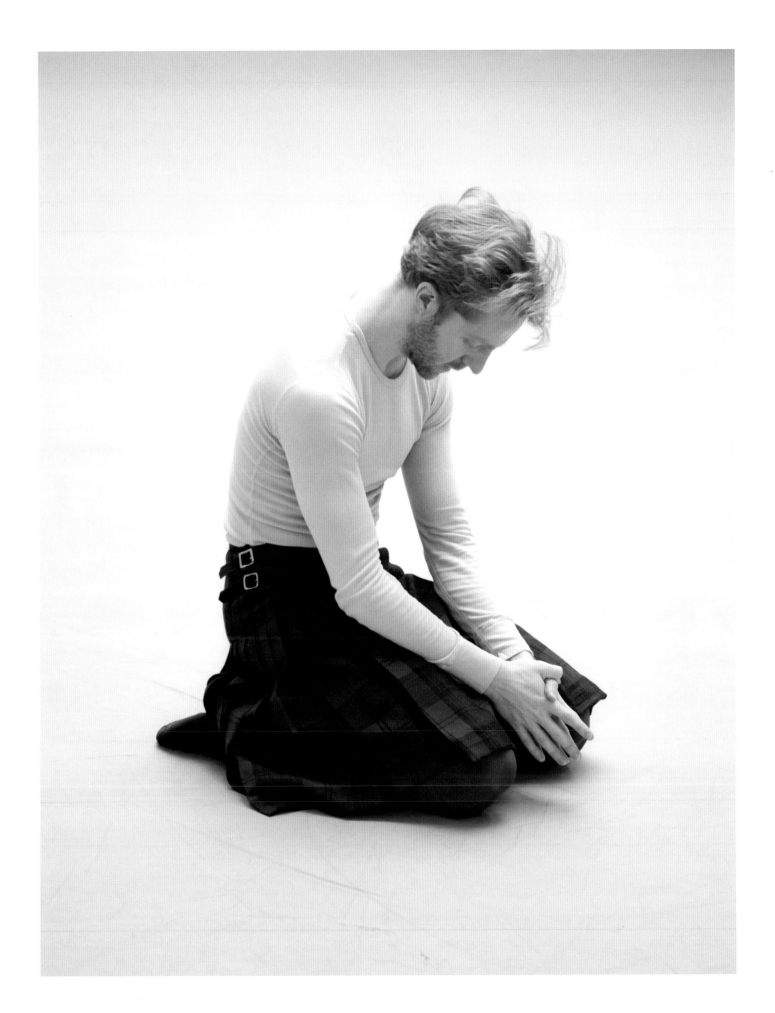

Alina Cojocaru and **Steven McRae**

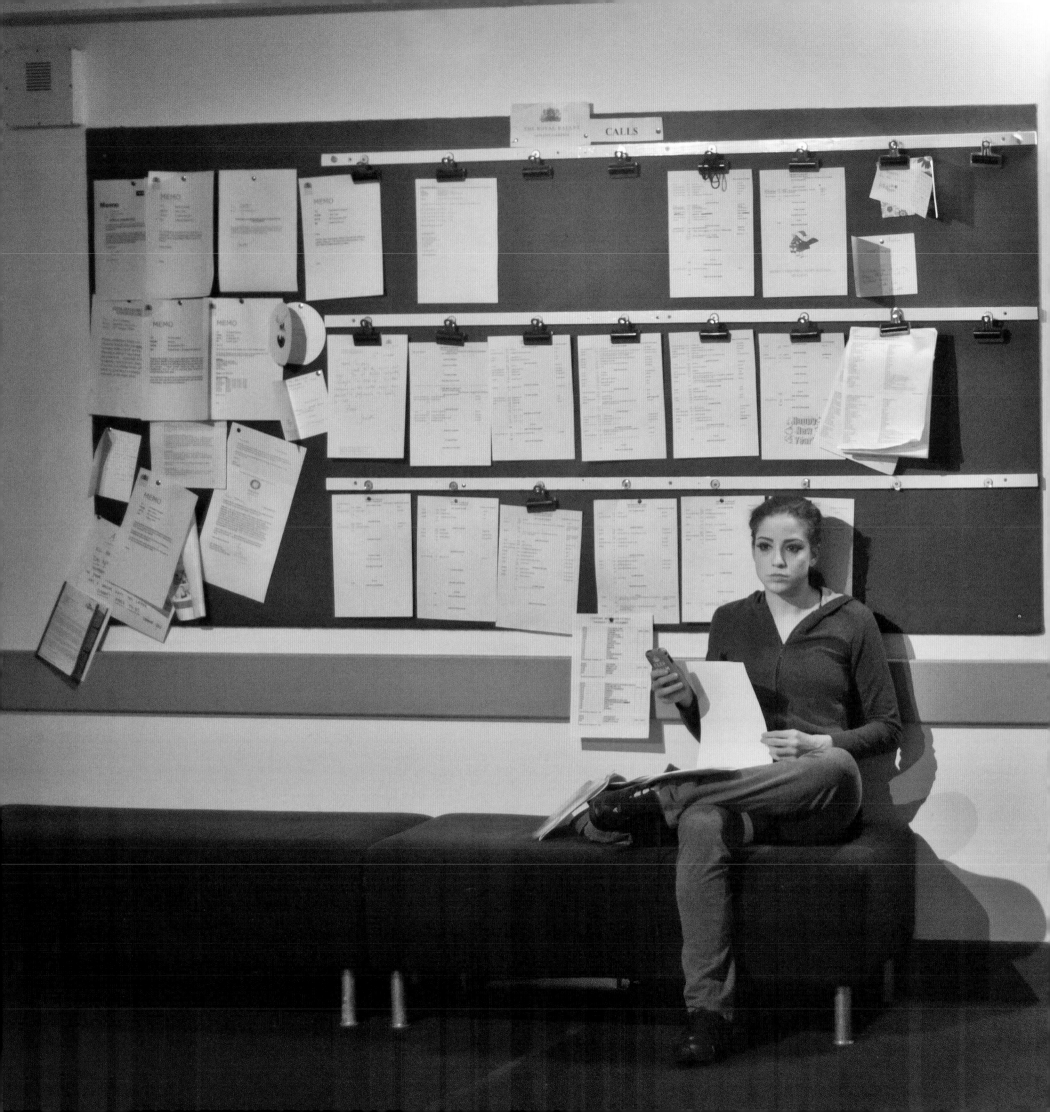

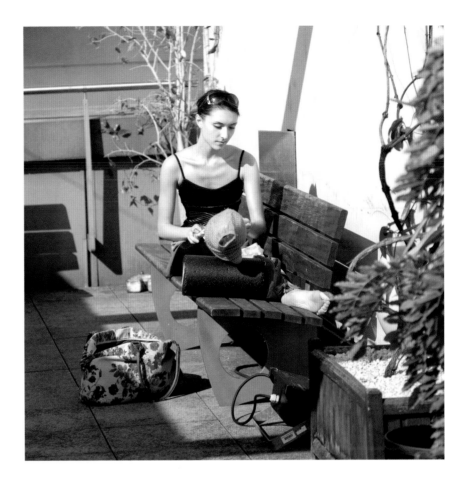
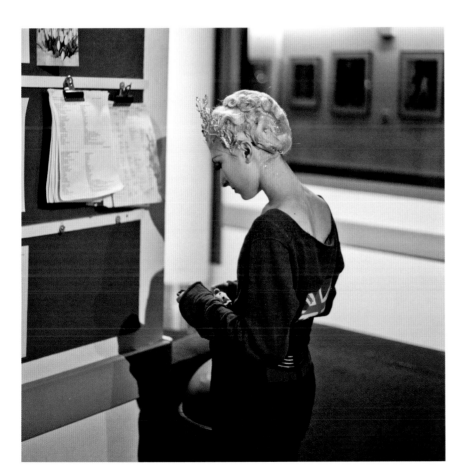
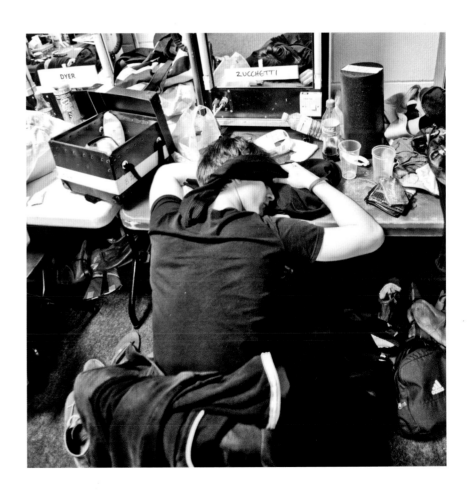

Clockwise from top left **James Wilkie, Elsa Godard, Valentino Zucchetti** and **Elsa Godard**
Opposite **Pietra Mello-Pittman**

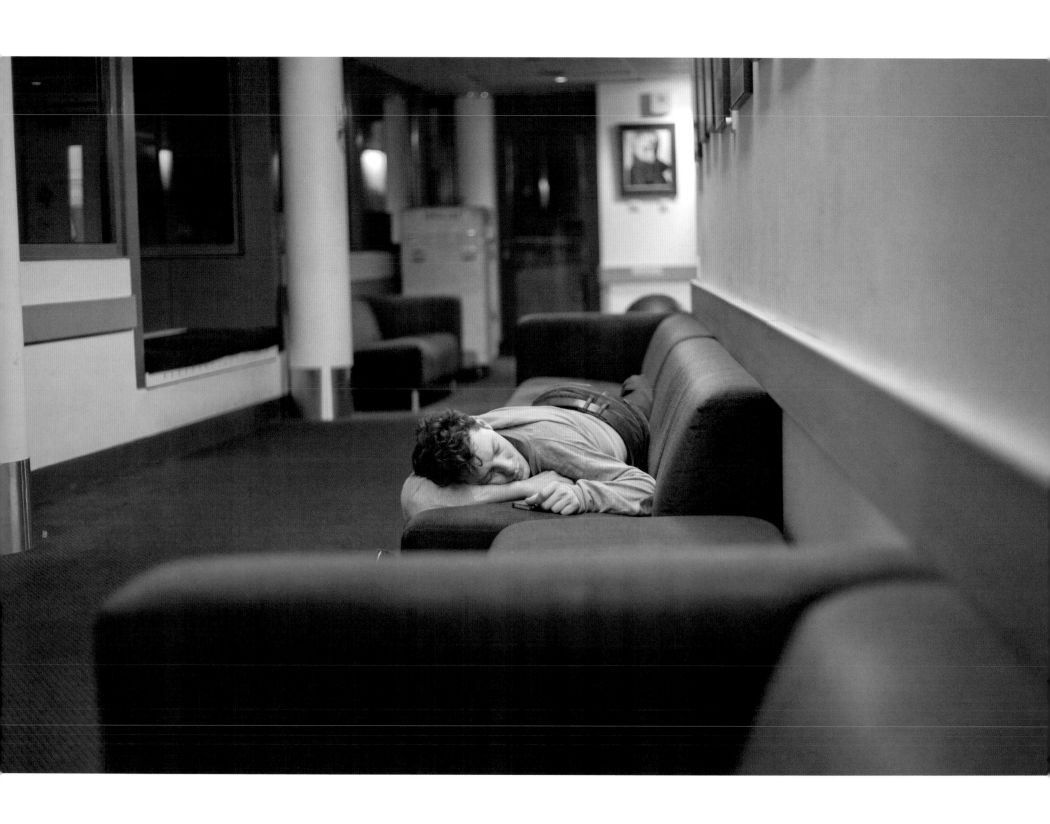

Johannes Stepanek
Opposite **Alina Cojocaru**

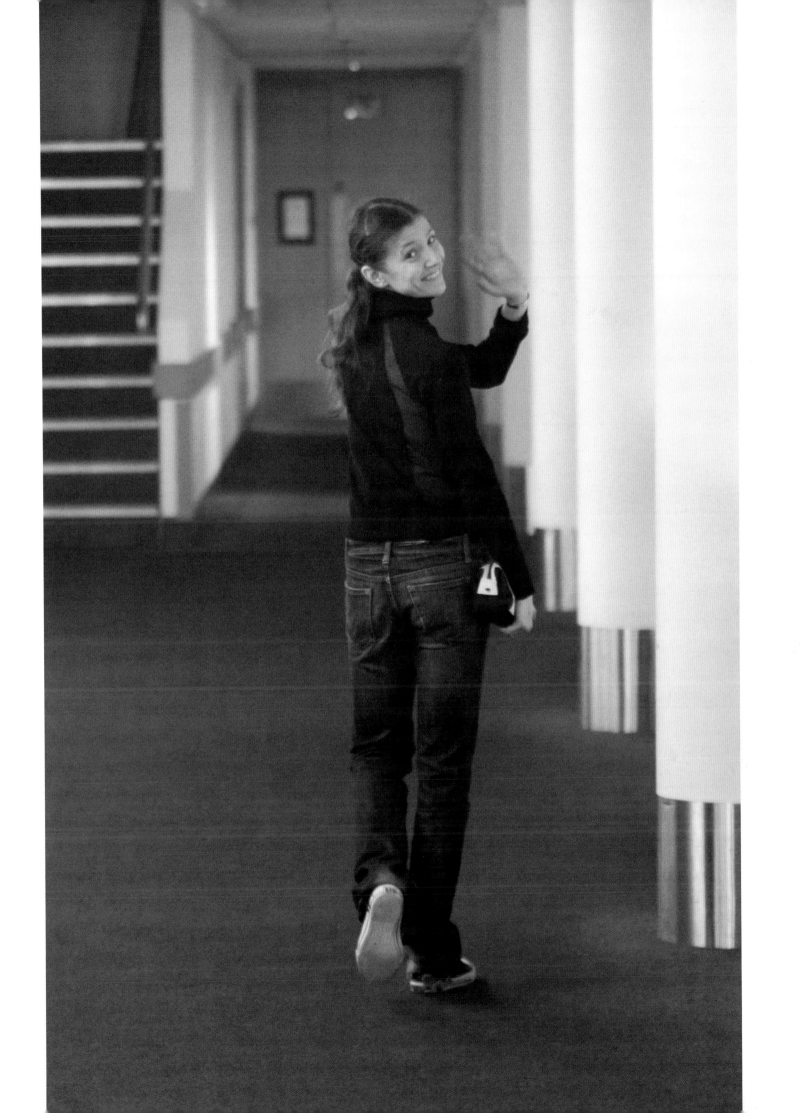

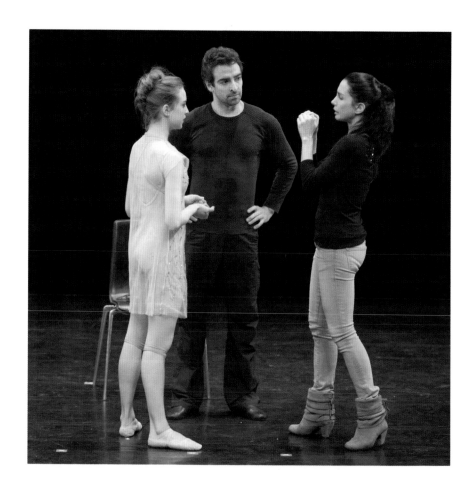

Clockwise from top left **Sergei Polunin**, **Leanne Benjamin** and **Thomas Whitehead,** **Camille Bracher, José Martín** and **Tamara Rojo,** and **Camille Bracher**

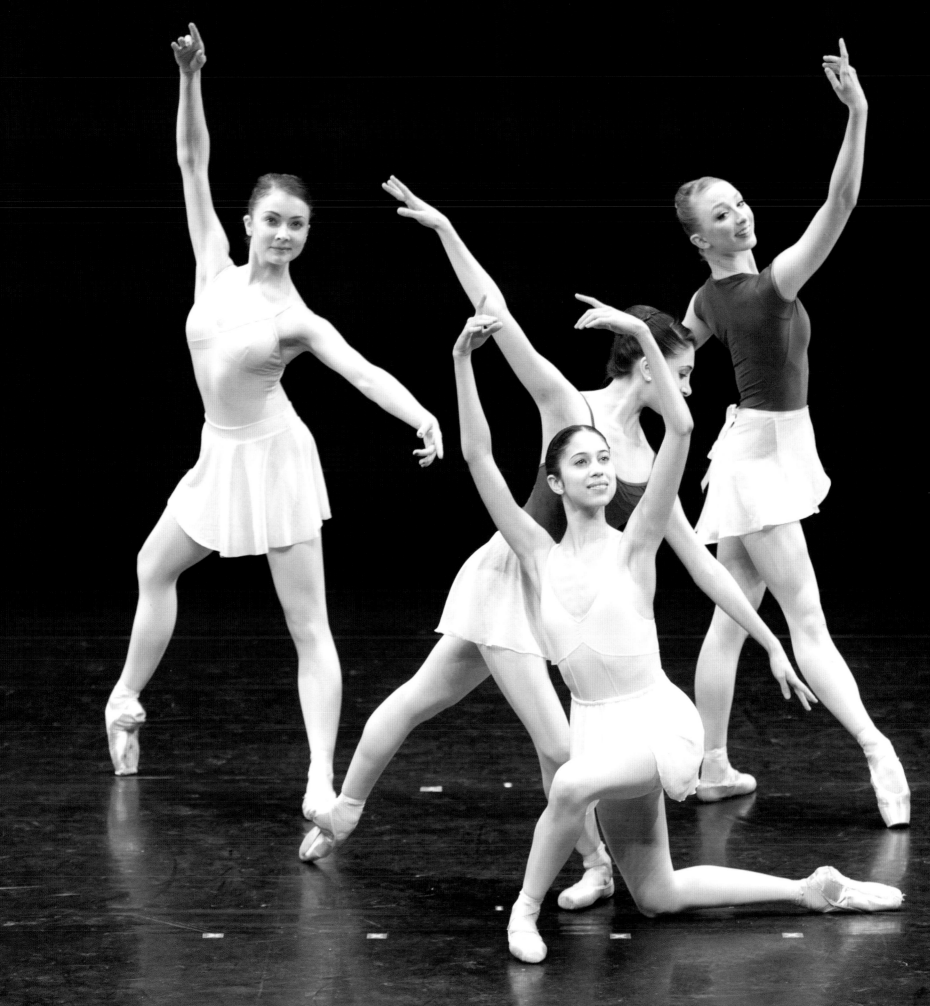

Clockwise from left **Claire Calvert**, **Yasmine Naghdi**, **Claudia Dean** and **Beatriz Stix-Brunell**

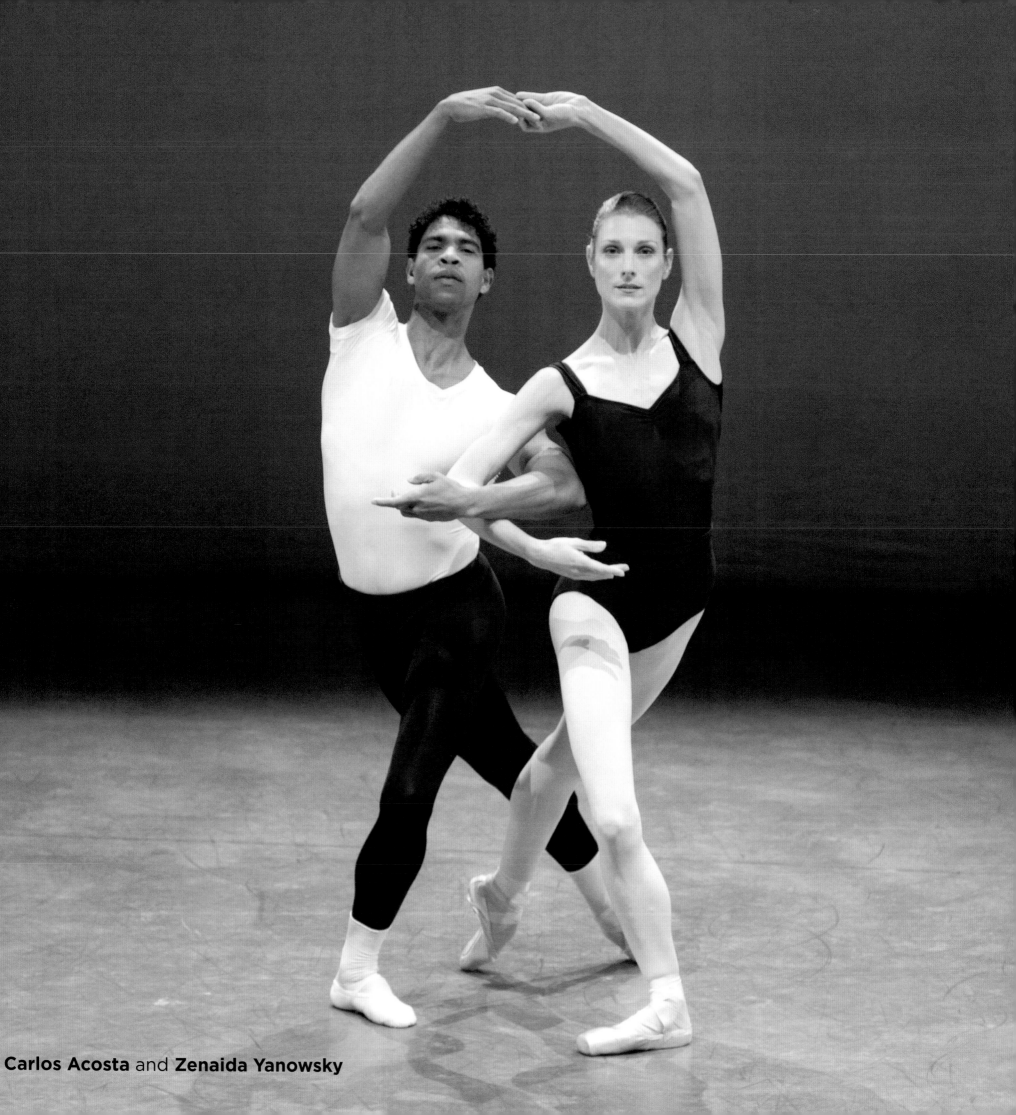

Carlos Acosta and **Zenaida Yanowsky**

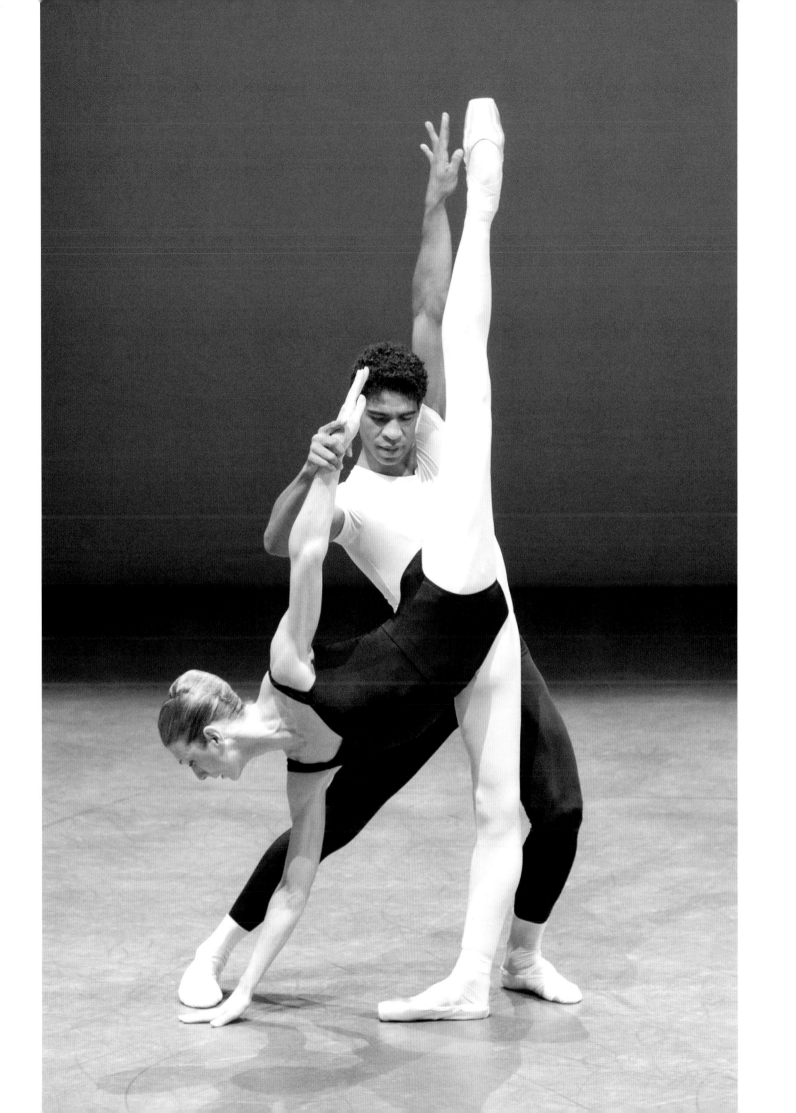

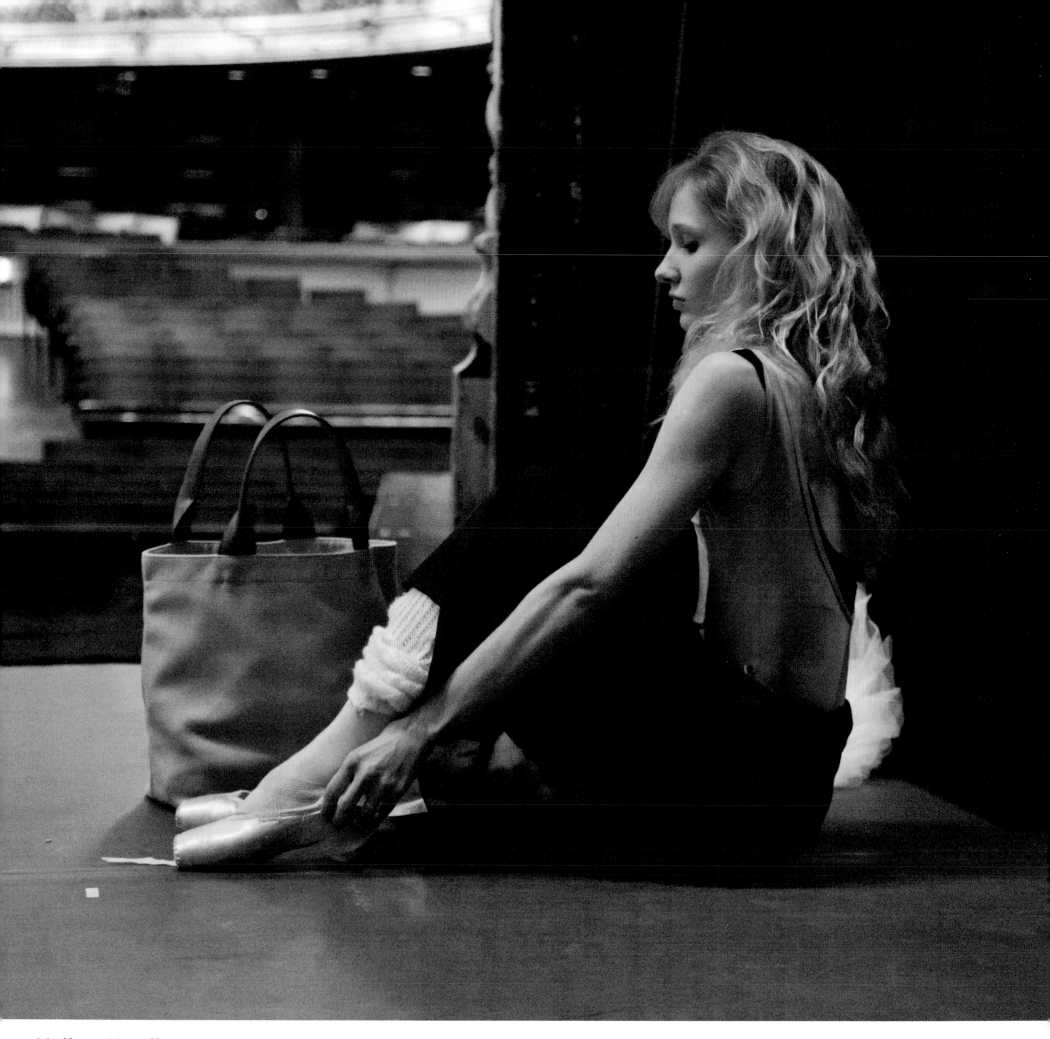

Melissa Hamilton
Opposite **Thiago Soares**

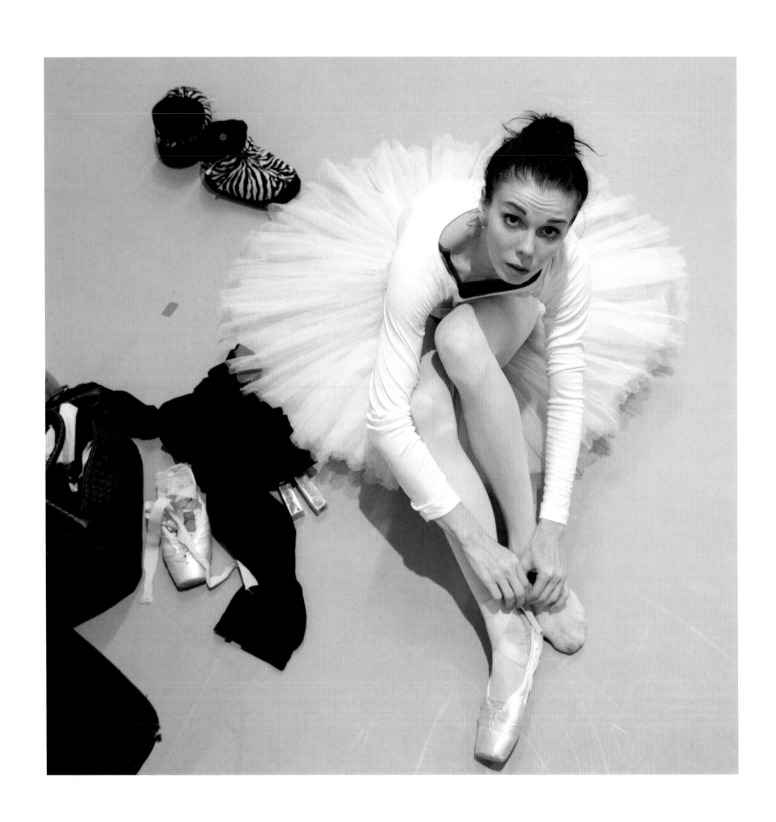

Natalia Osipova
Opposite **Corps de ballet**

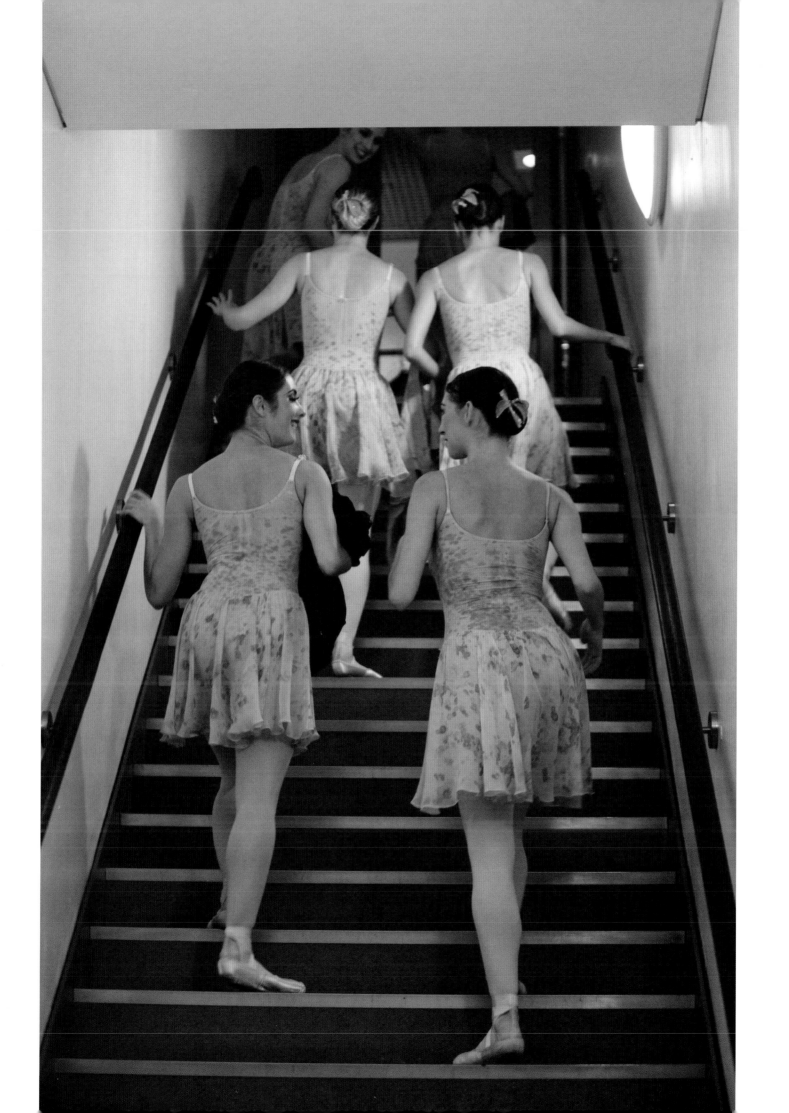

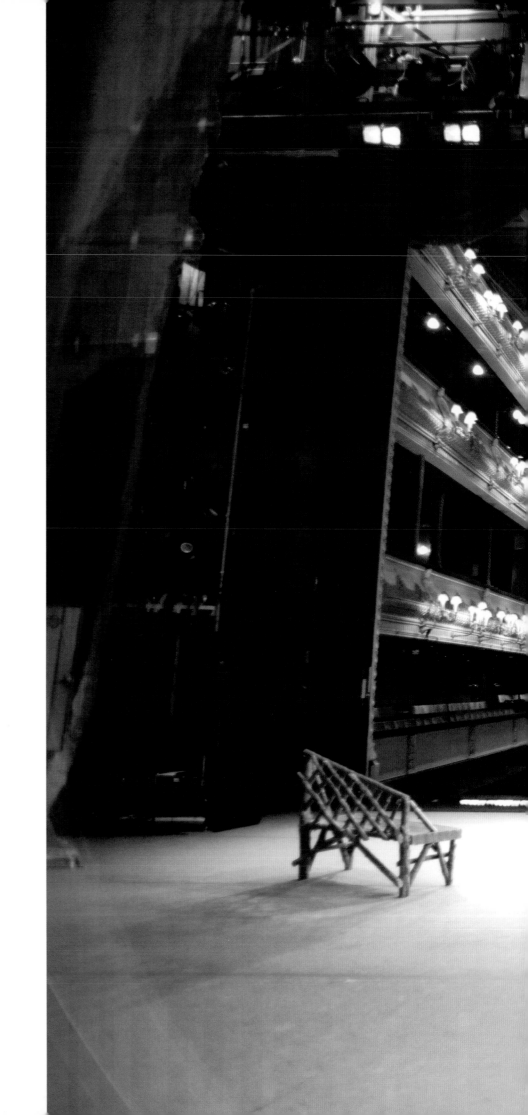

Melissa Hamilton

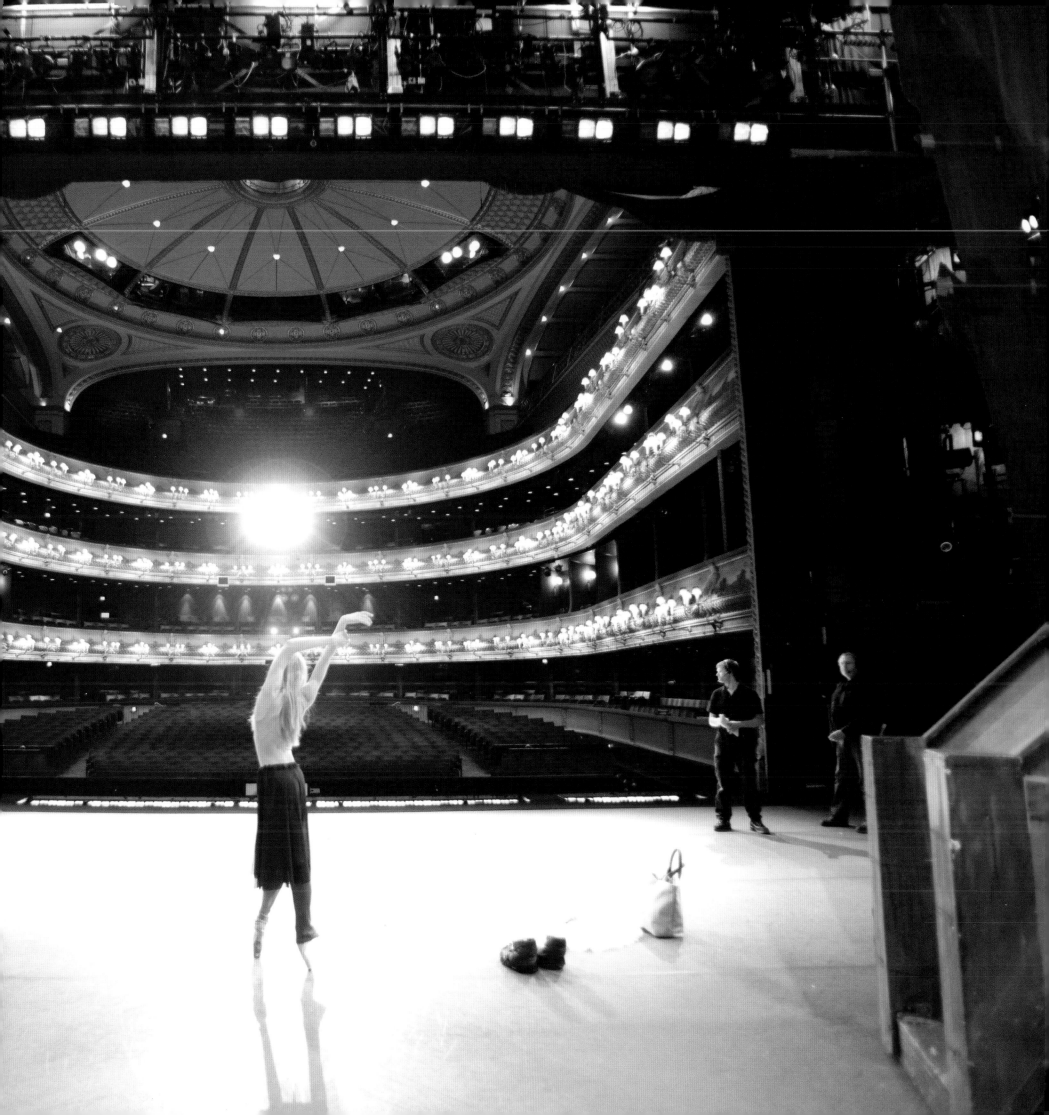

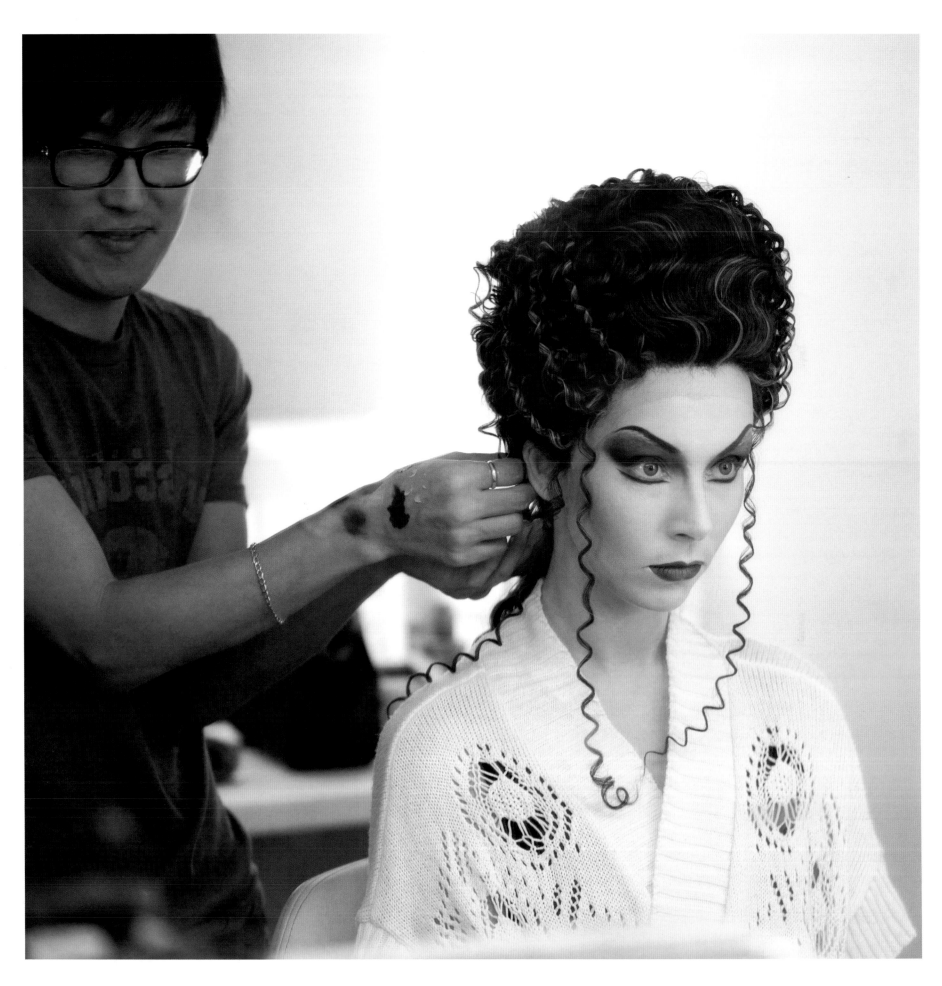

Kristen McNally
Opposite **Zenaida Yanowsky**

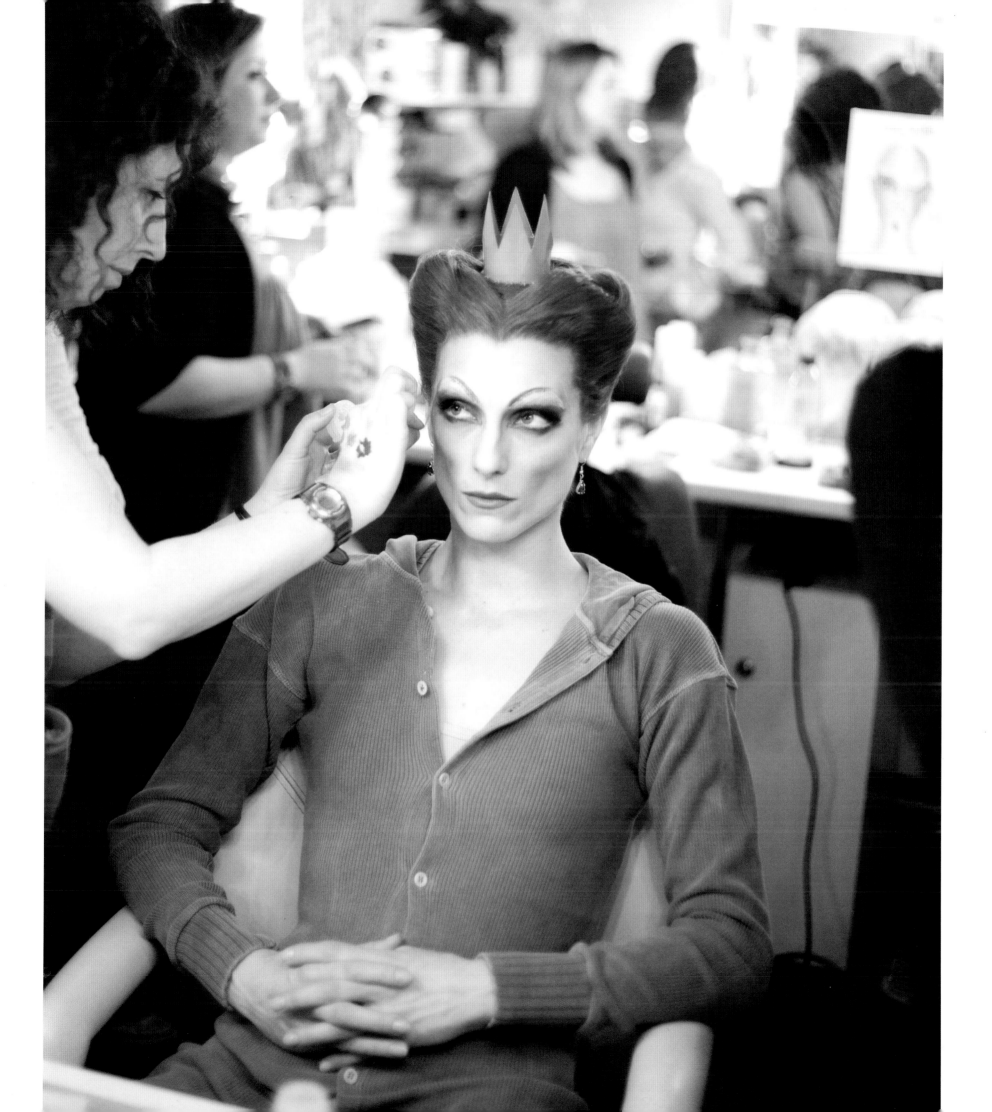

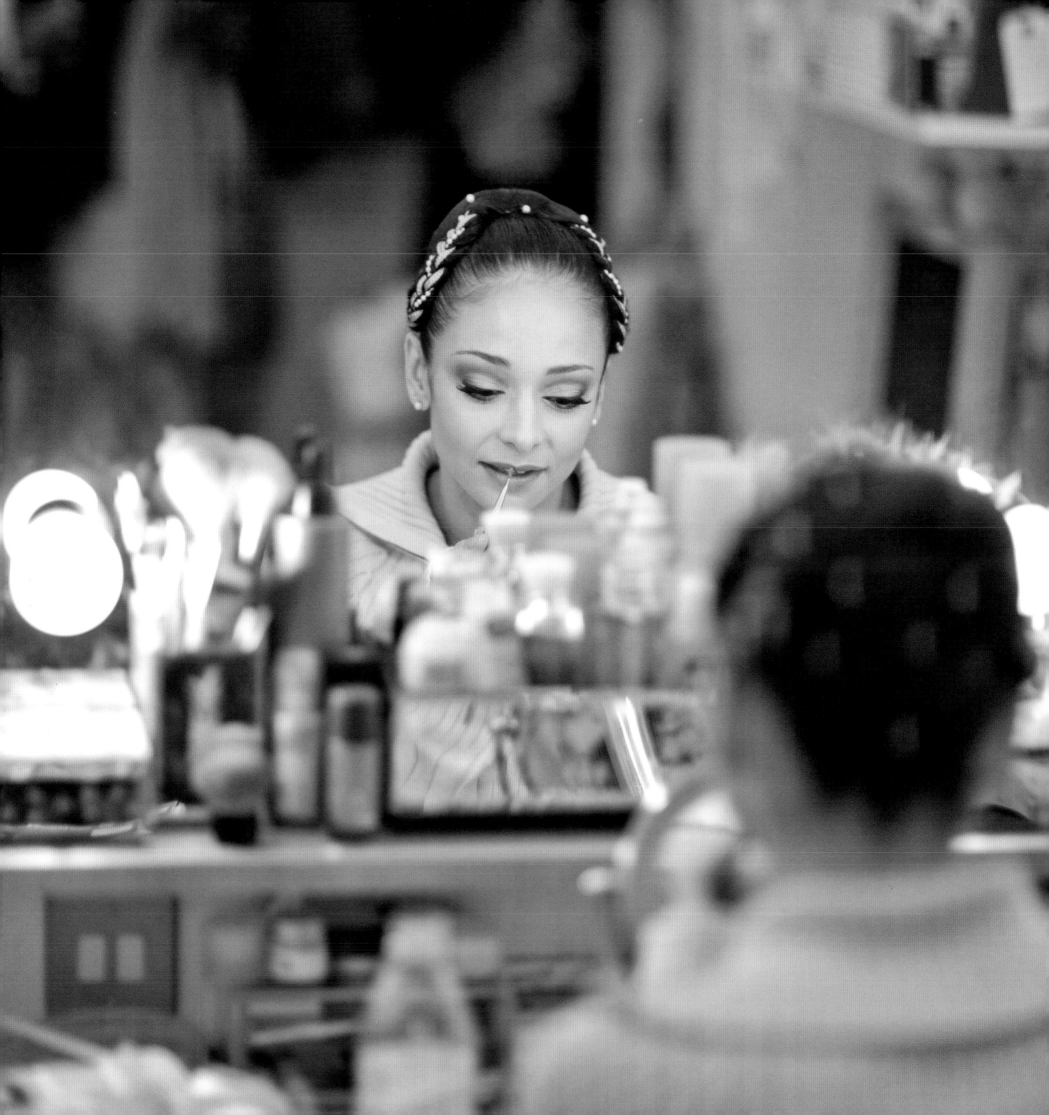

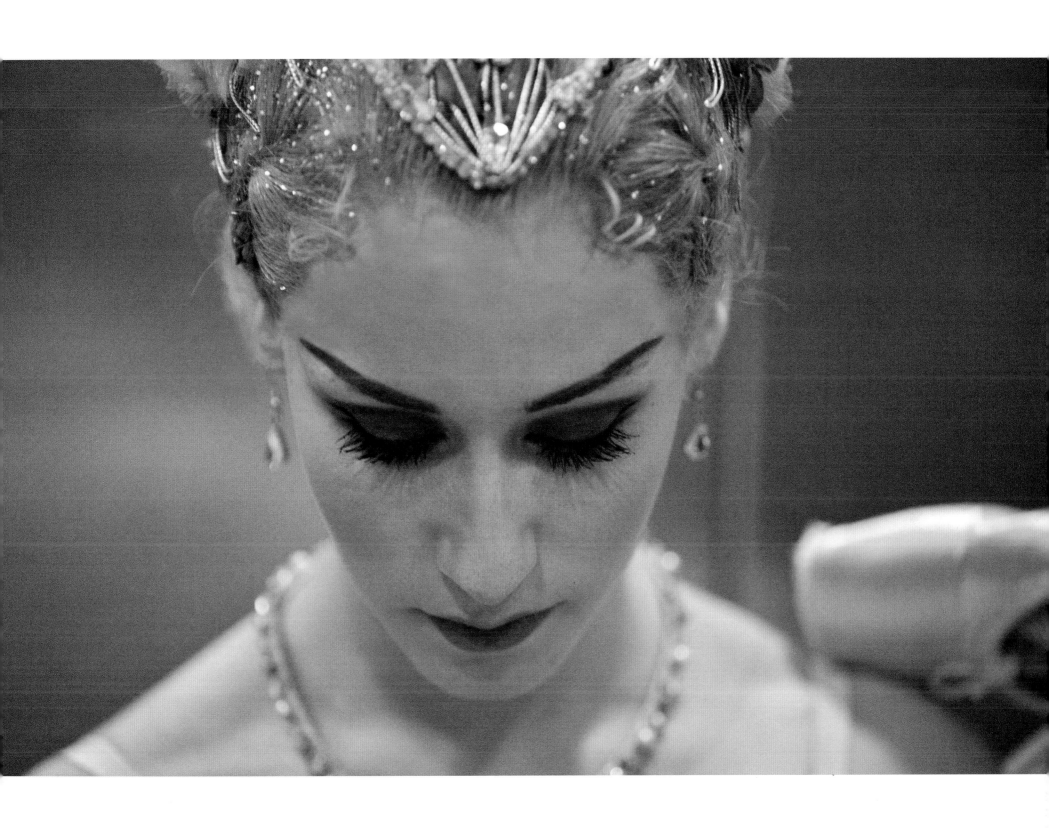

Emma Maguire
Opposite Roberta Marquez

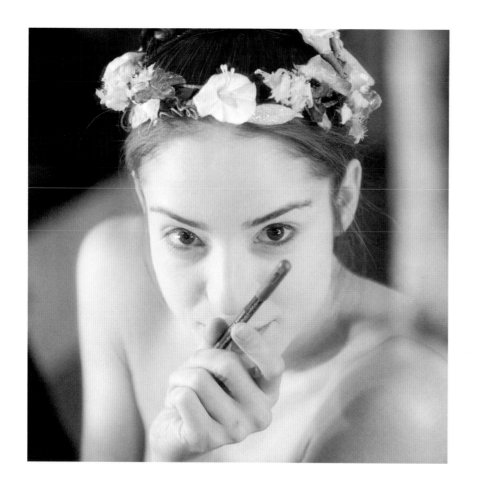
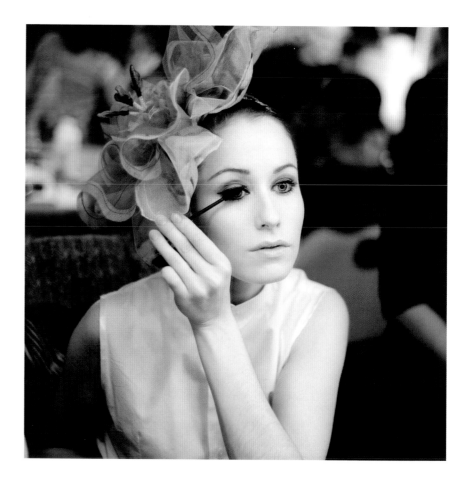
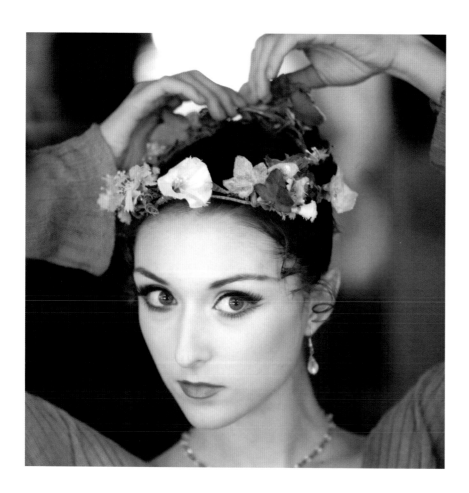

Clockwise from top left **Pietra Mello-Pittman**, **Emma Maguire**, **Tara-Brigitte Bhavnani** and **Elsa Godard**
Opposite **Claire Calvert**

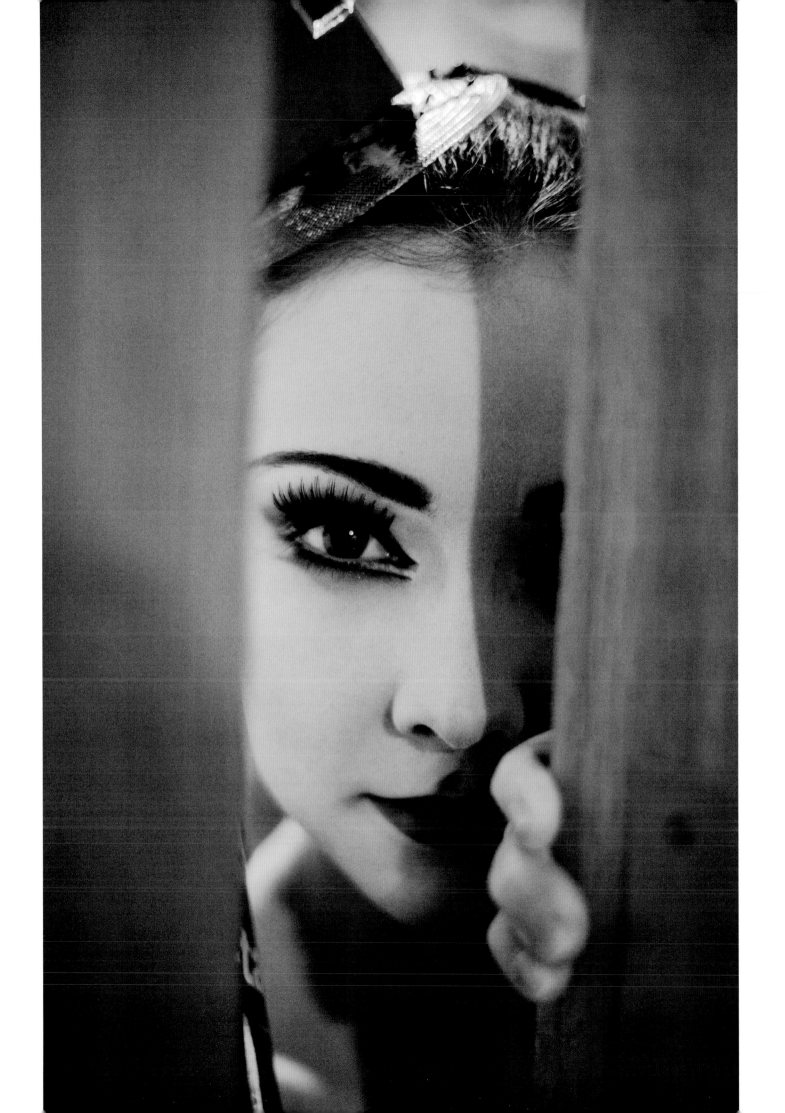

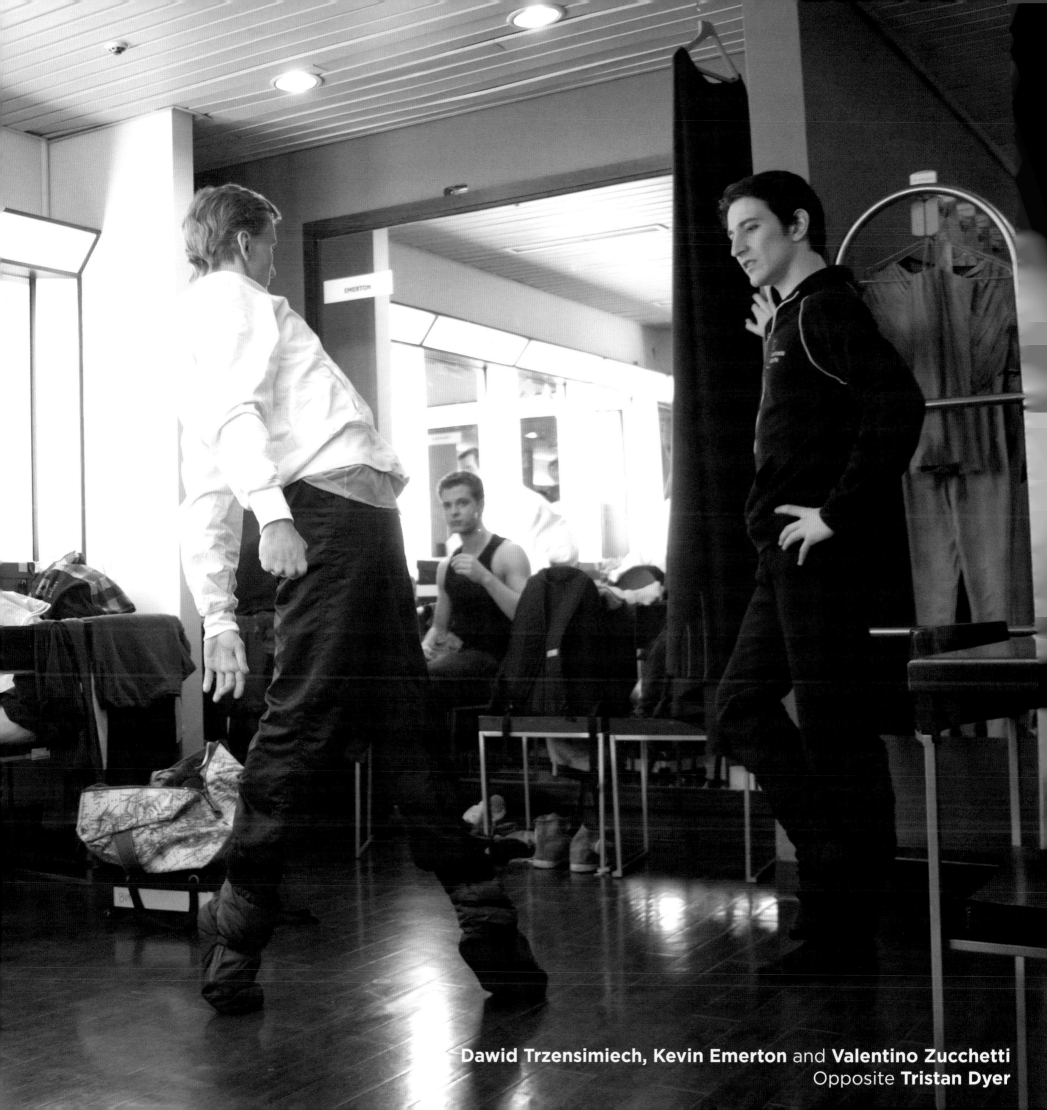

Dawid Trzensimiech, Kevin Emerton and **Valentino Zucchetti**
Opposite **Tristan Dyer**

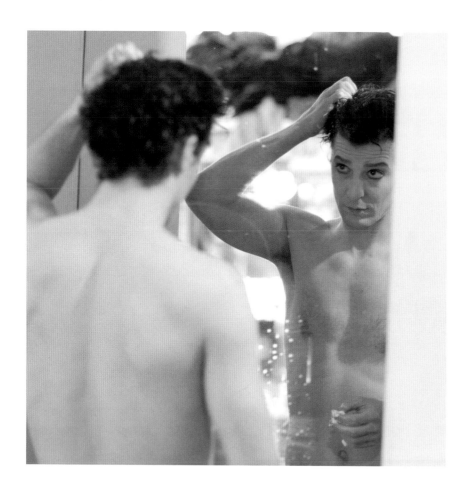

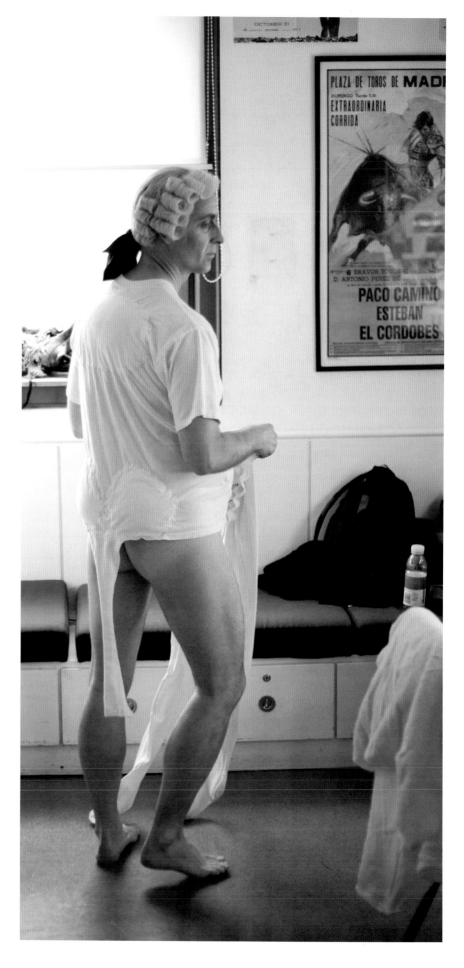

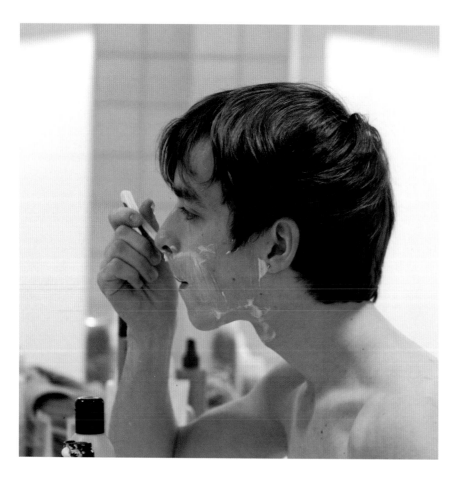

Clockwise from top left **Johannes Stepanek, Jonathan Howells** and **Sander Blommaert**
Opposite **Ricardo Cervera**

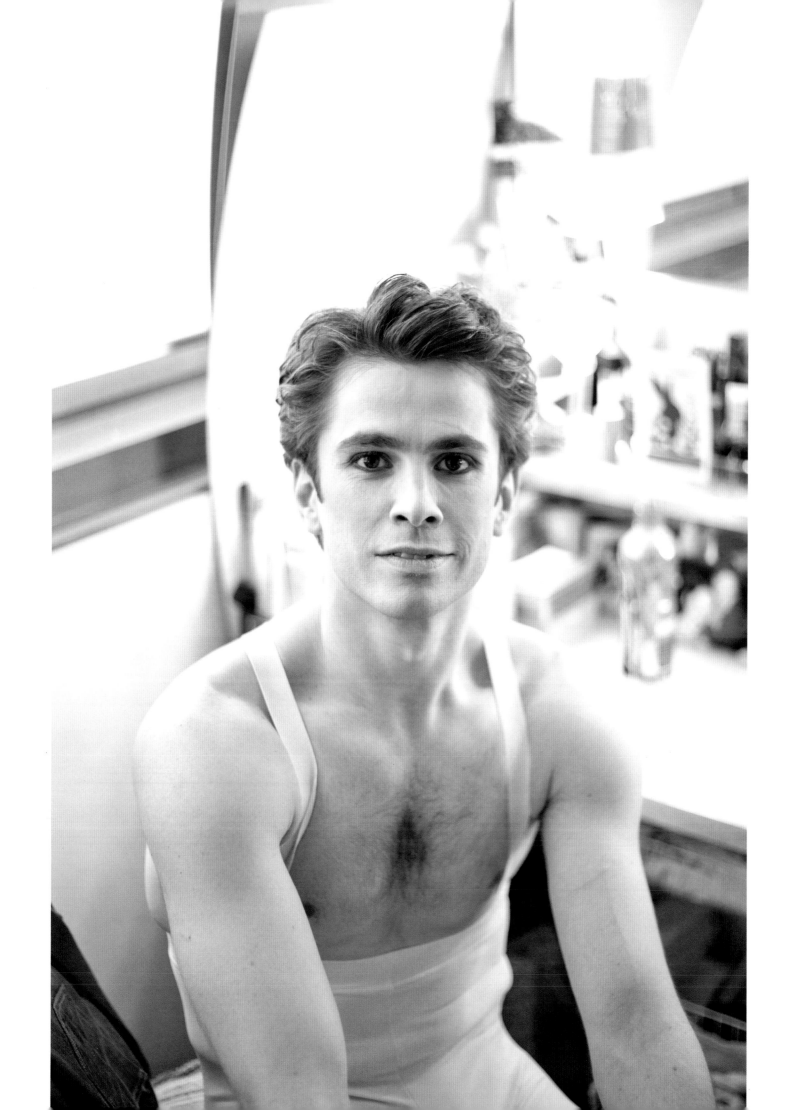

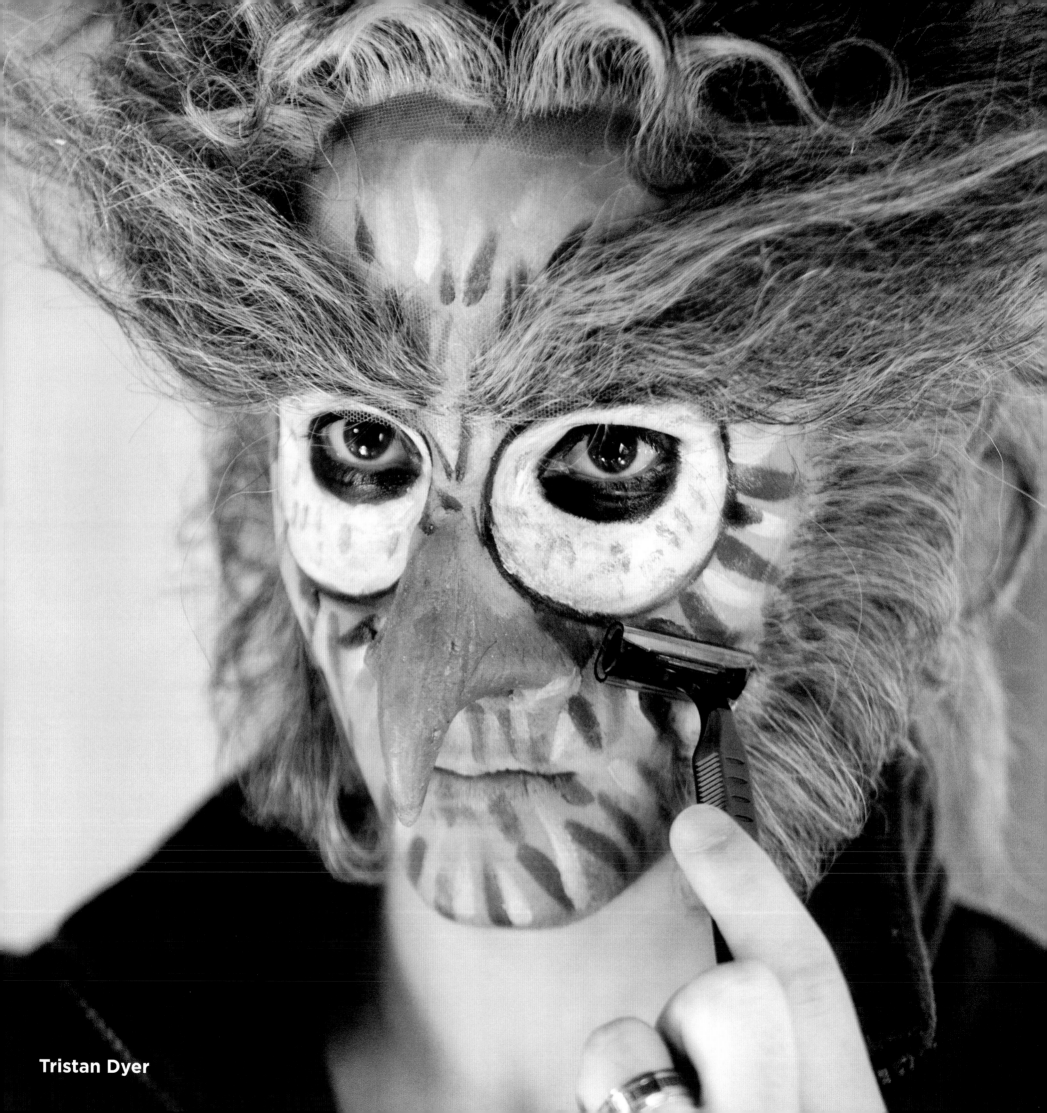

Tristan Dyer

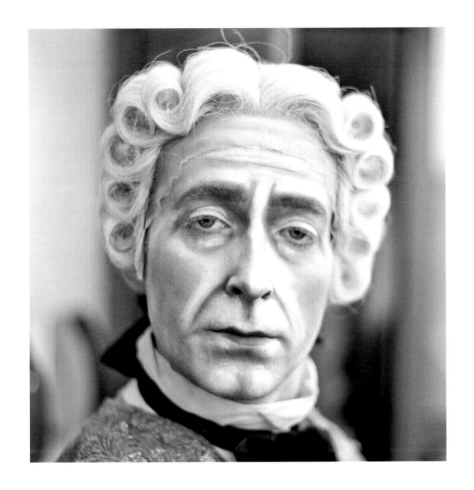
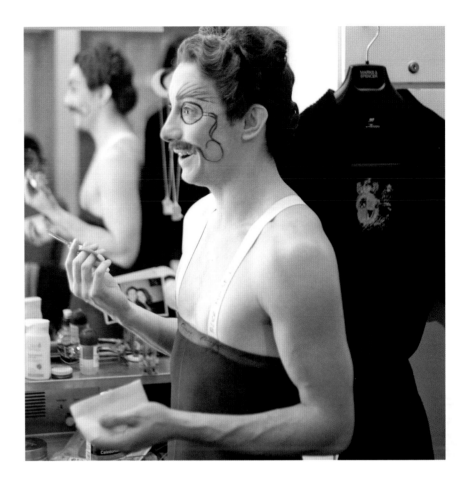
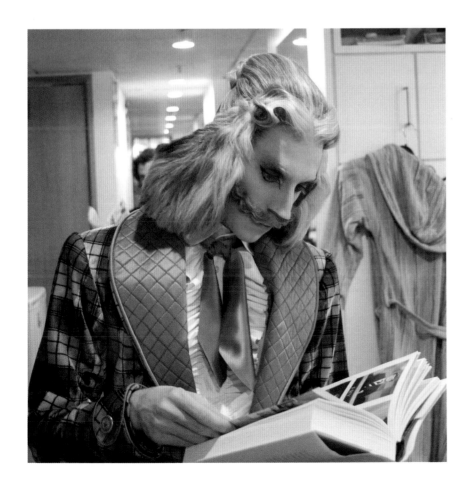
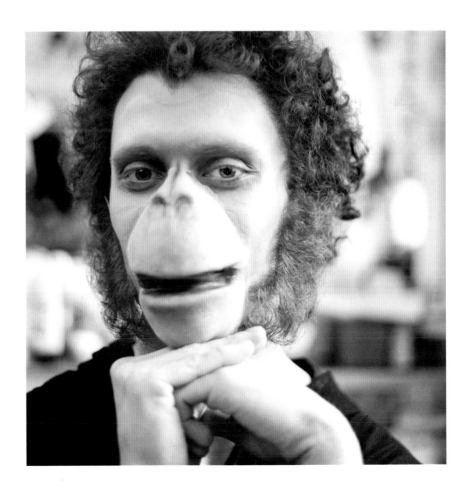

Clockwise from top left **Jonathan Howells, Michael Stojko, Dawid Trzensimiech** and **Jonathan Watkins**

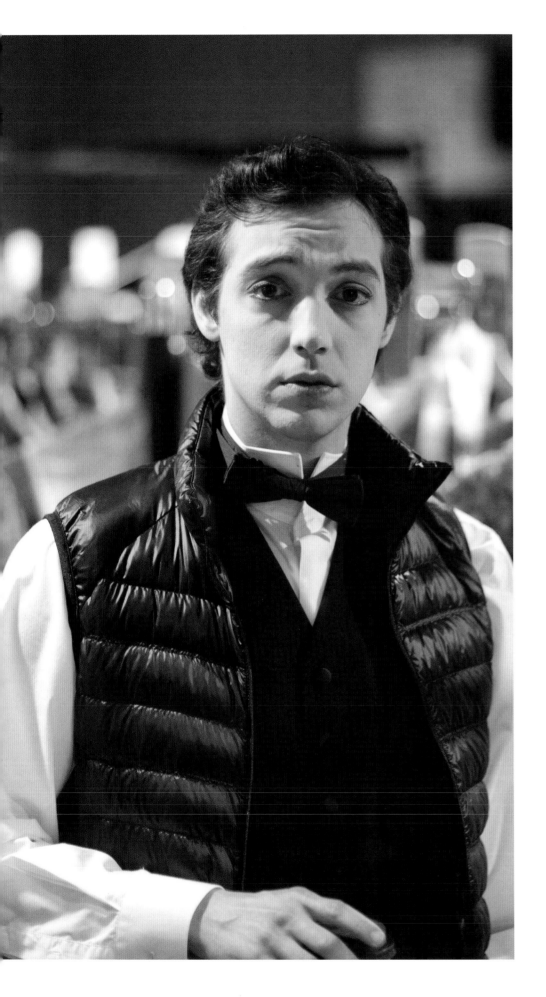
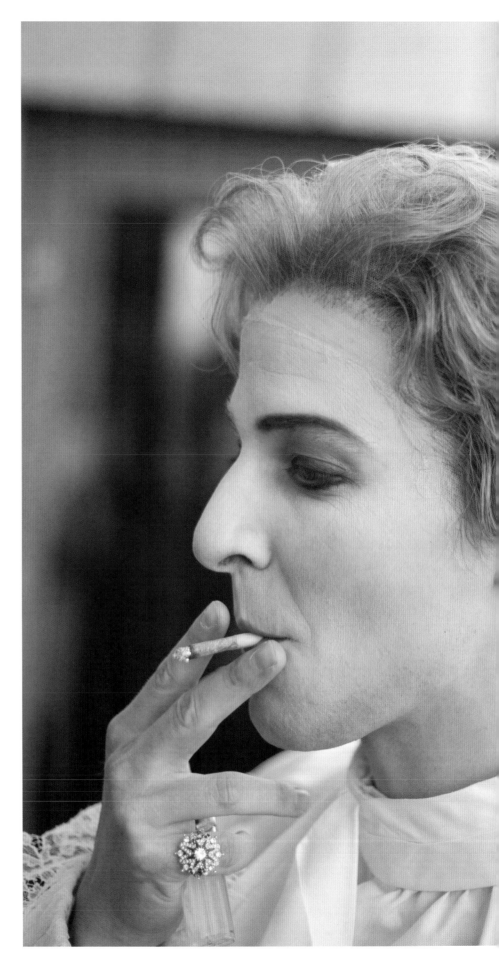

Ludovic Ondiviela, Johannes Stepanek

Bennet Gartside

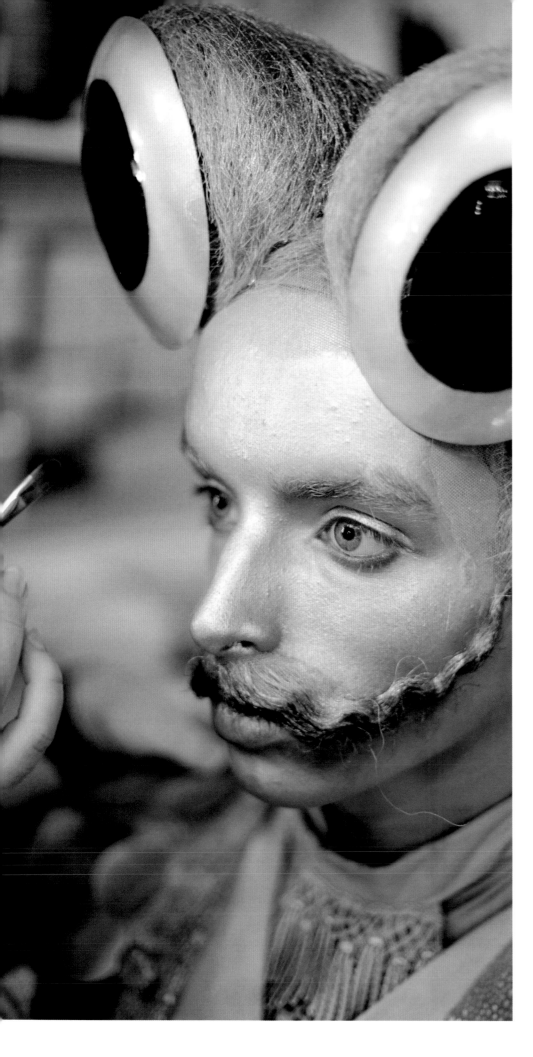
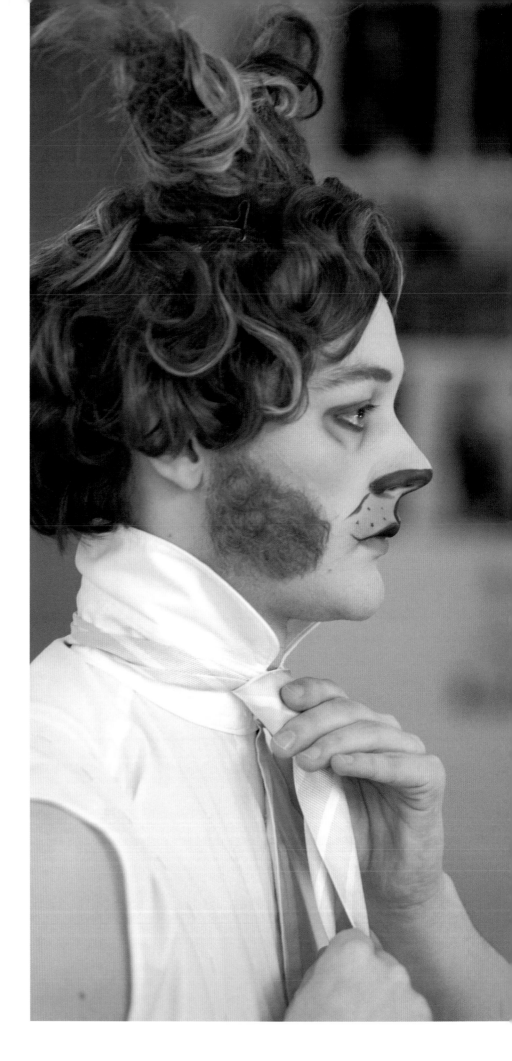

Sander Blommaert, Liam Scarlett

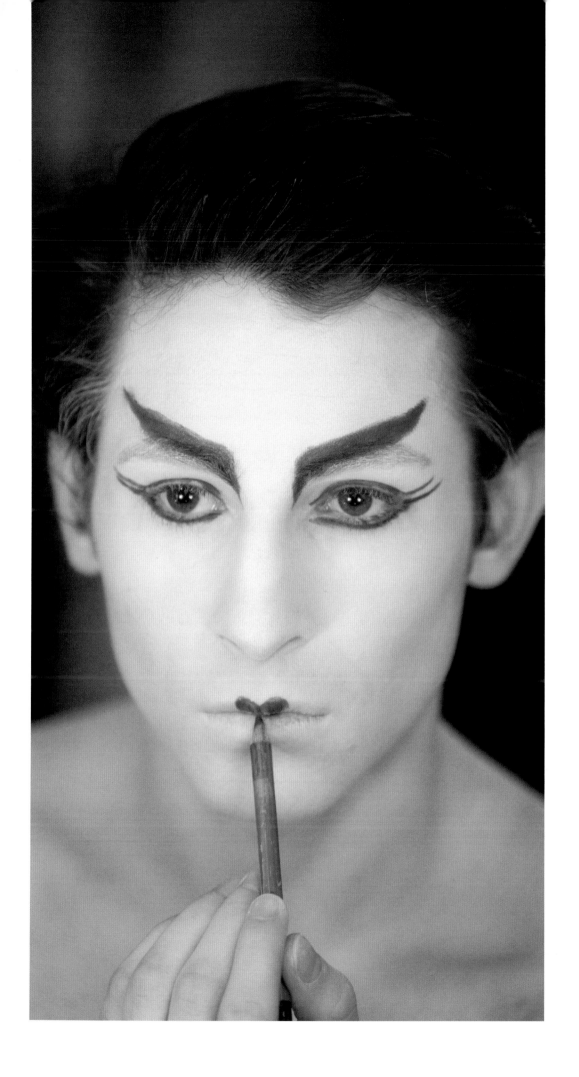

Tristan Dyer, James Wilkie

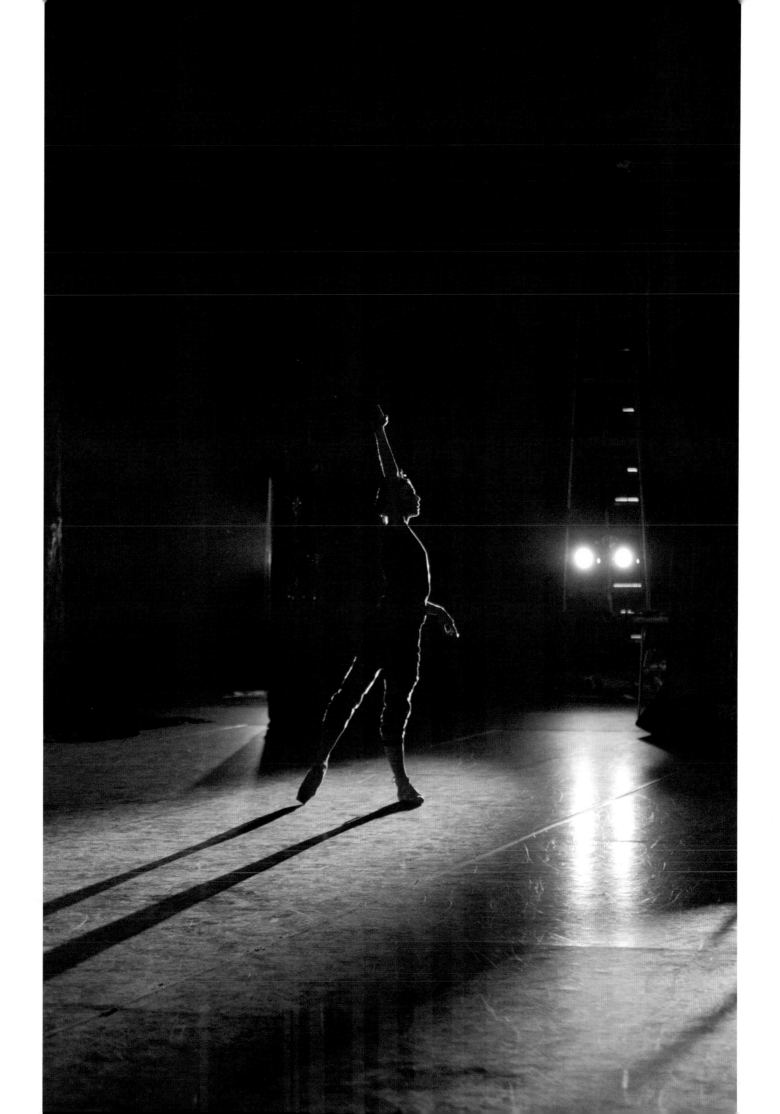

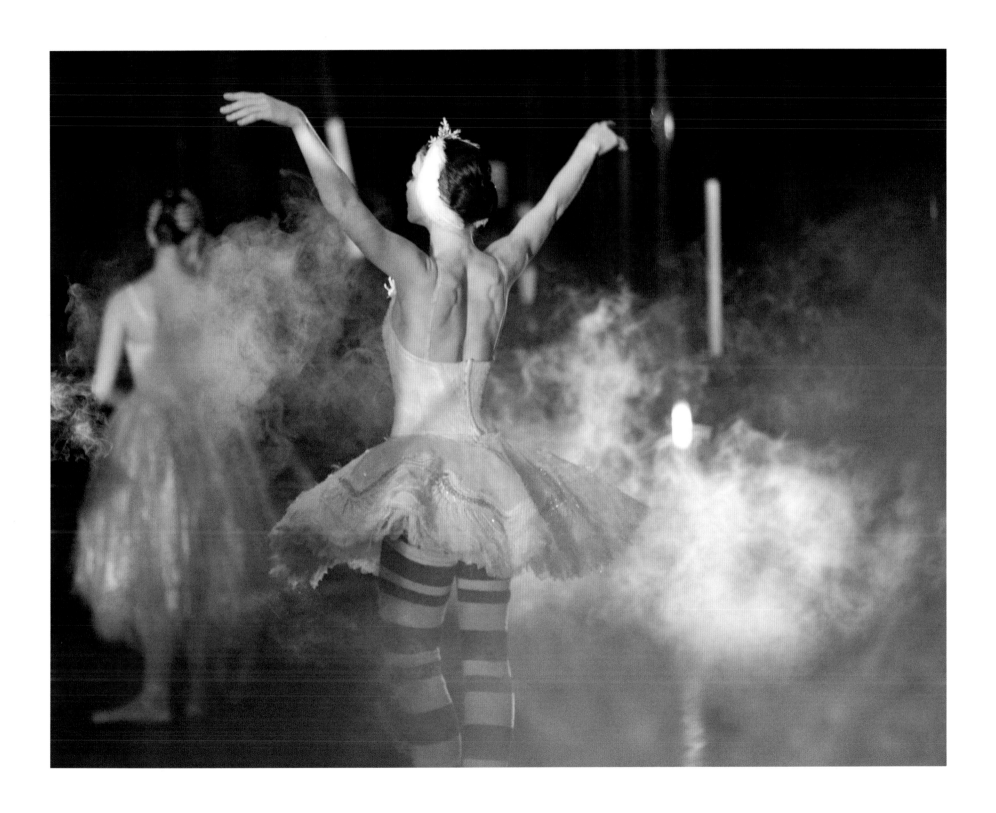

Natalia Osipova

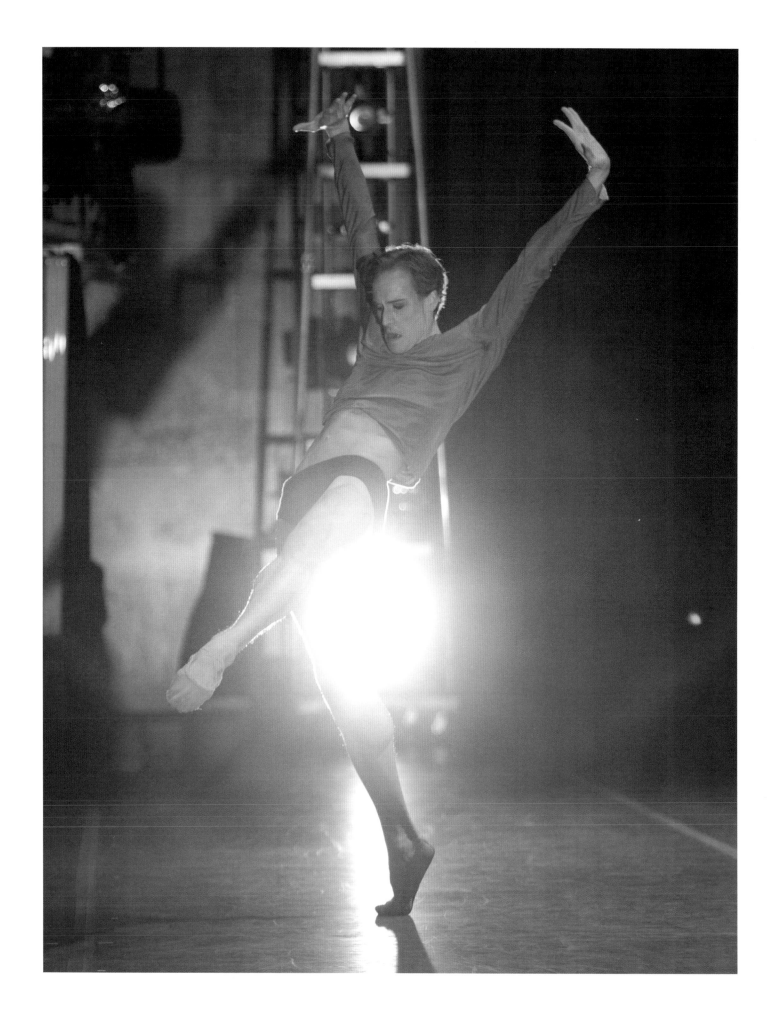

Edward Watson

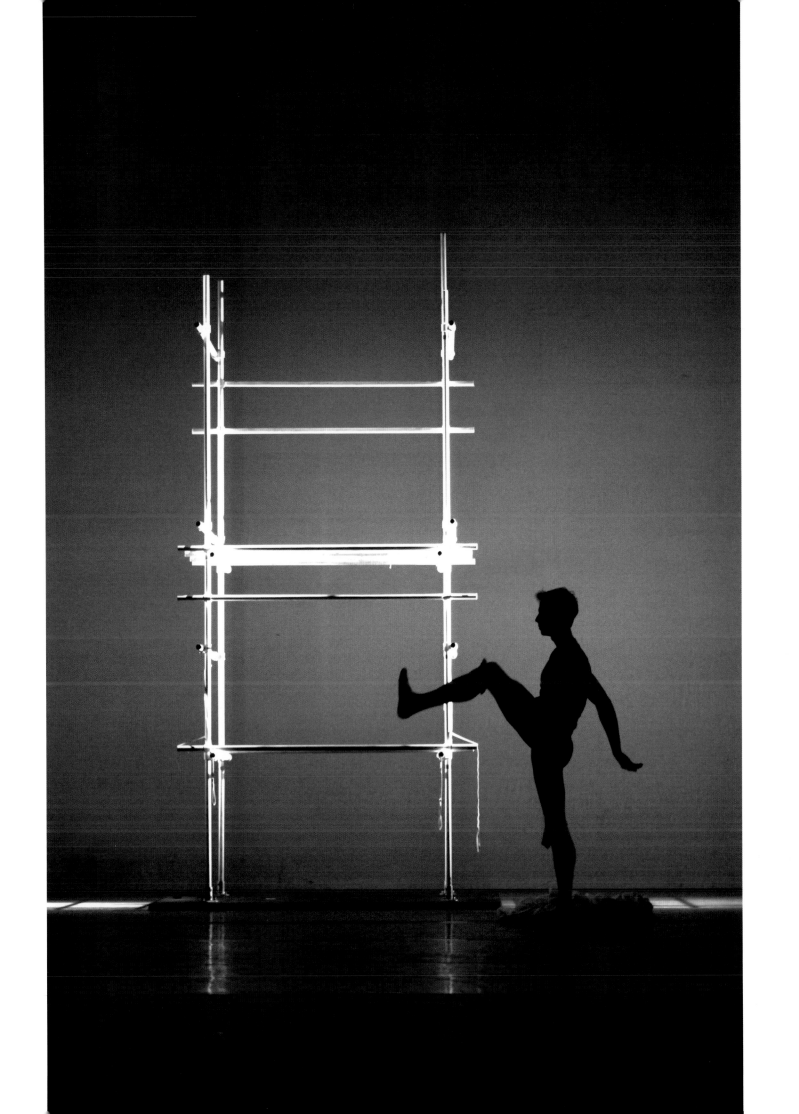

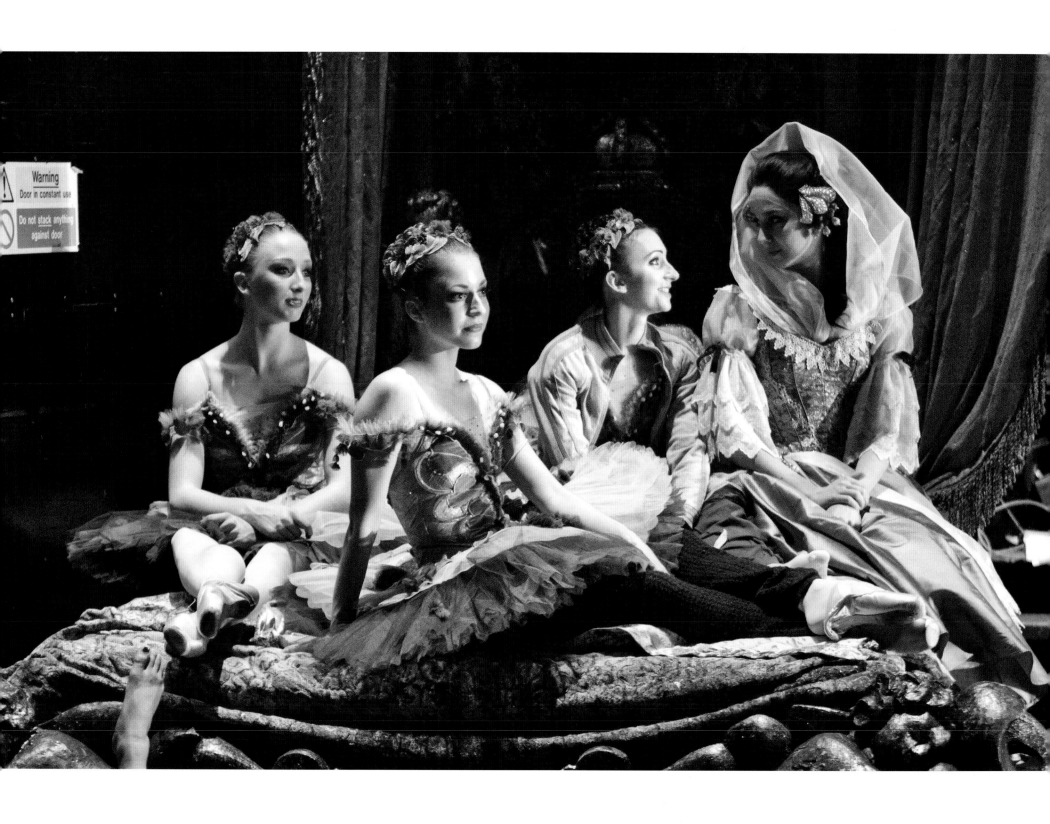

Left to right **Claudia Dean, Meaghan Grace Hinkis, Gemma Pitchley-Gale** and **Nathalie Harrison**

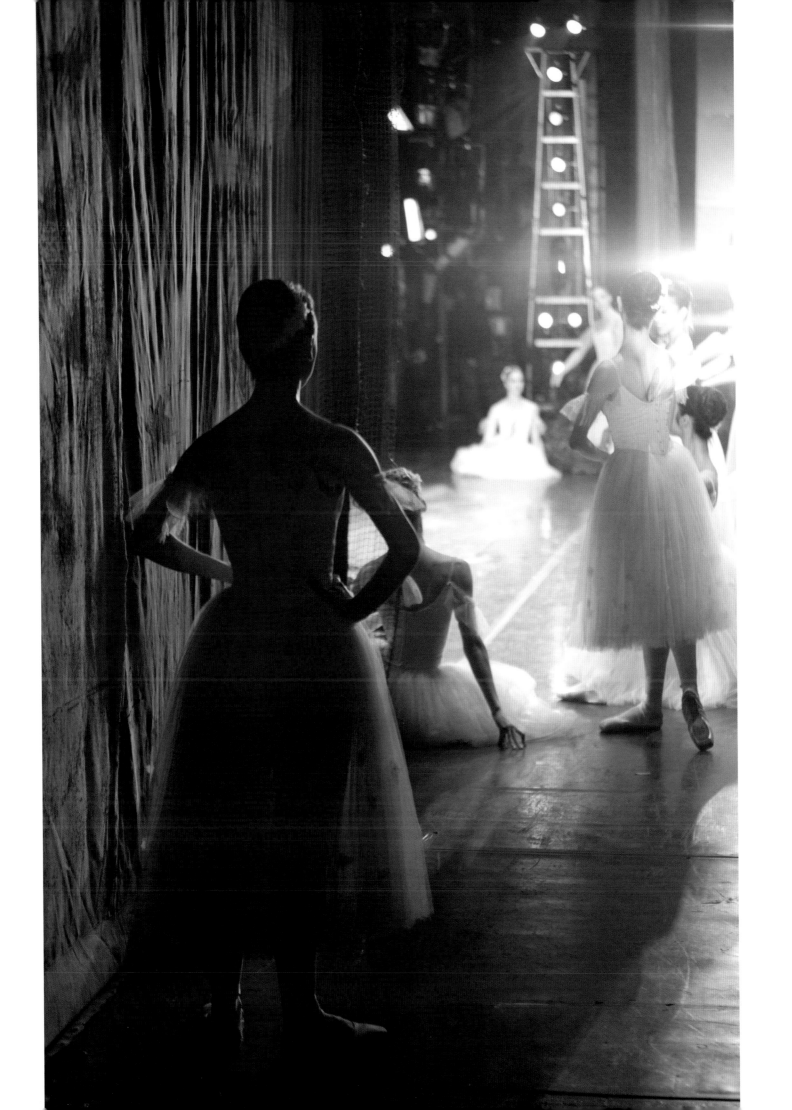

Steven McRae

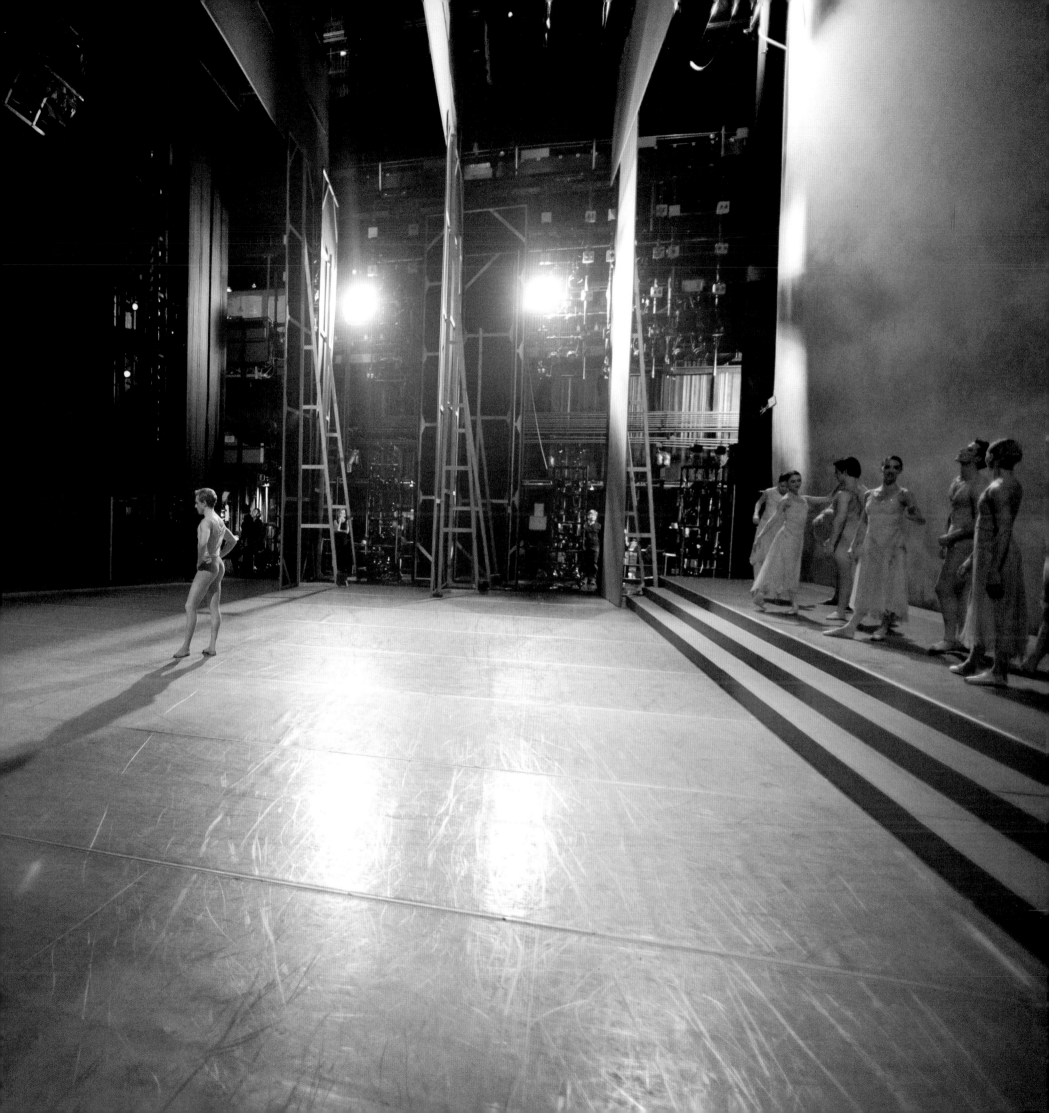

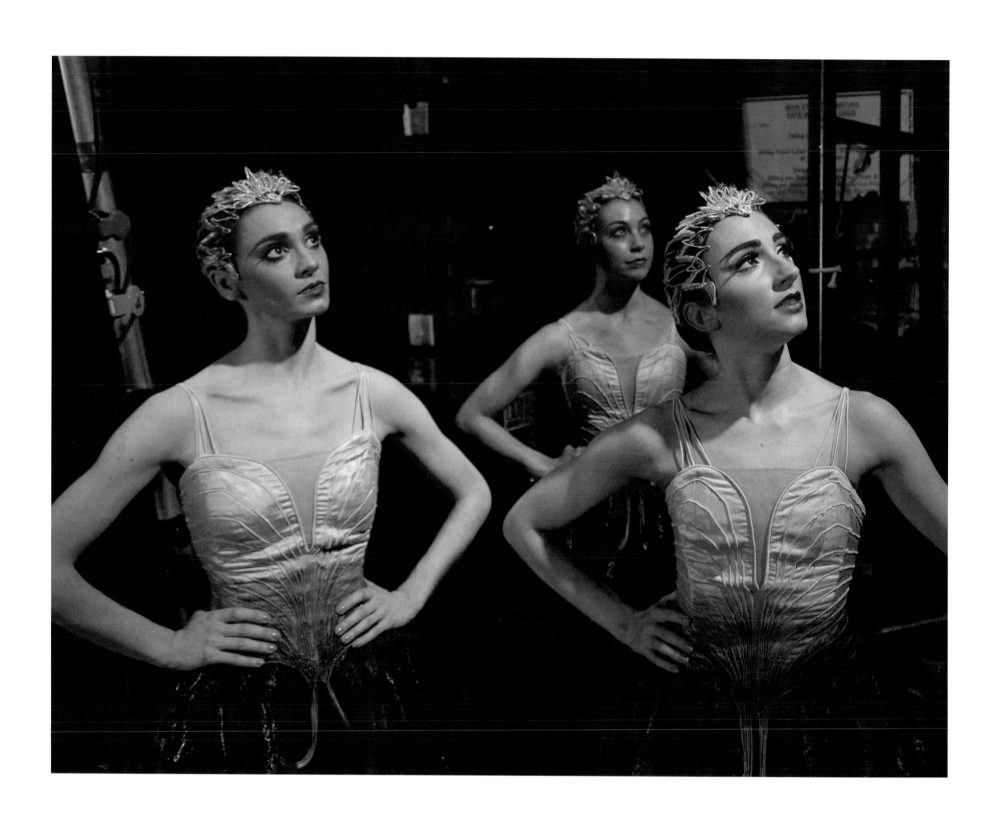

Left to right **Elizabeth Harrod, Leanne Cope** and **Gemma Pitchley-Gale**
Opposite **Alexander Agadzhanov, Carlos Acosta** and **Natalia Osipova**

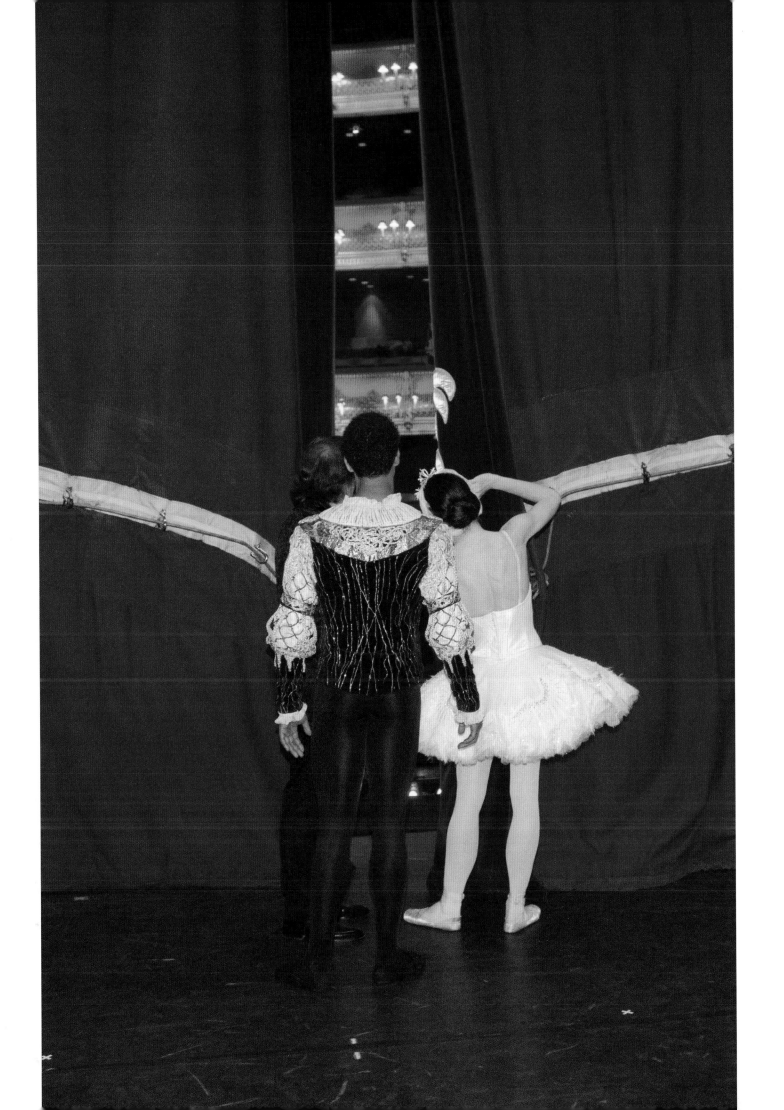

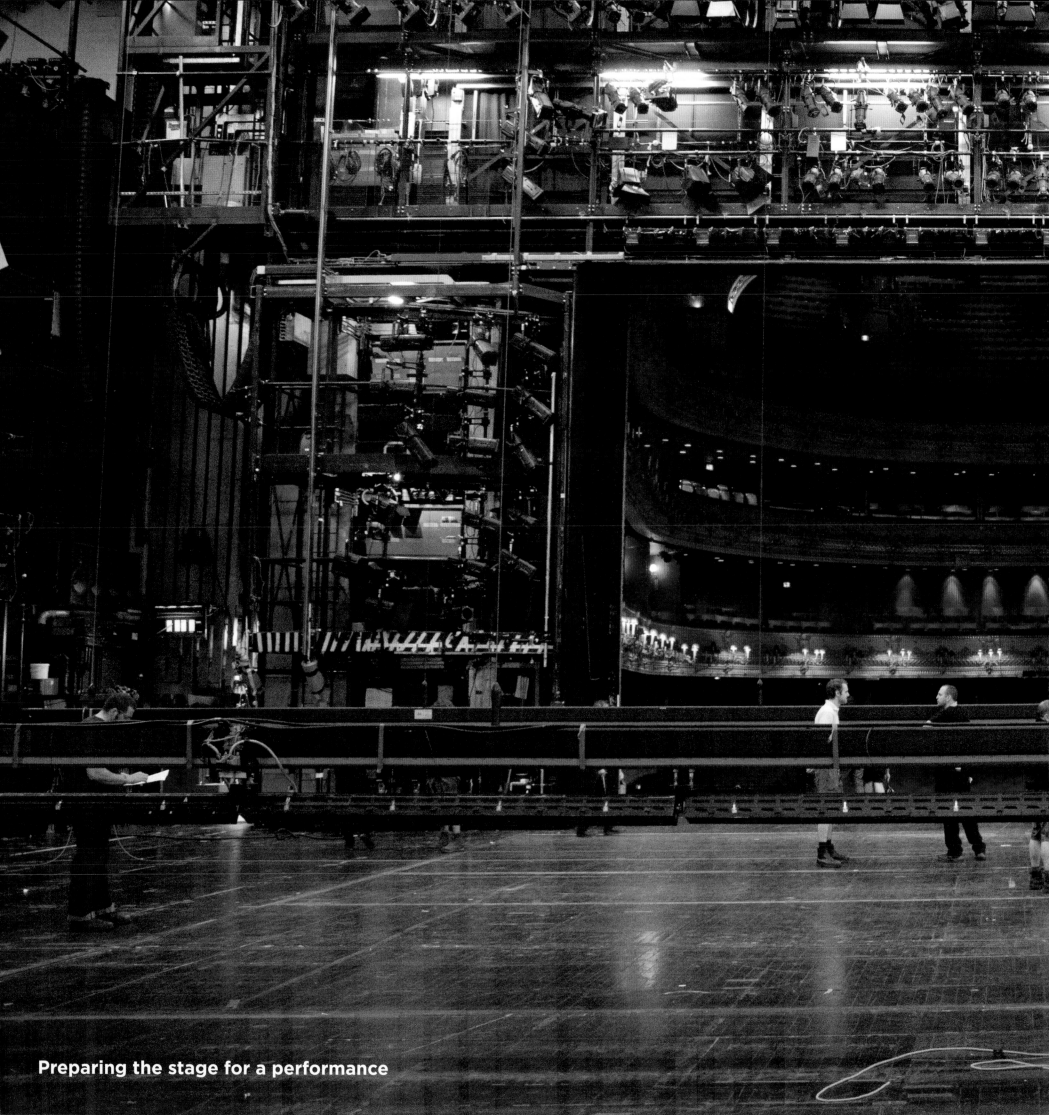

Preparing the stage for a performance

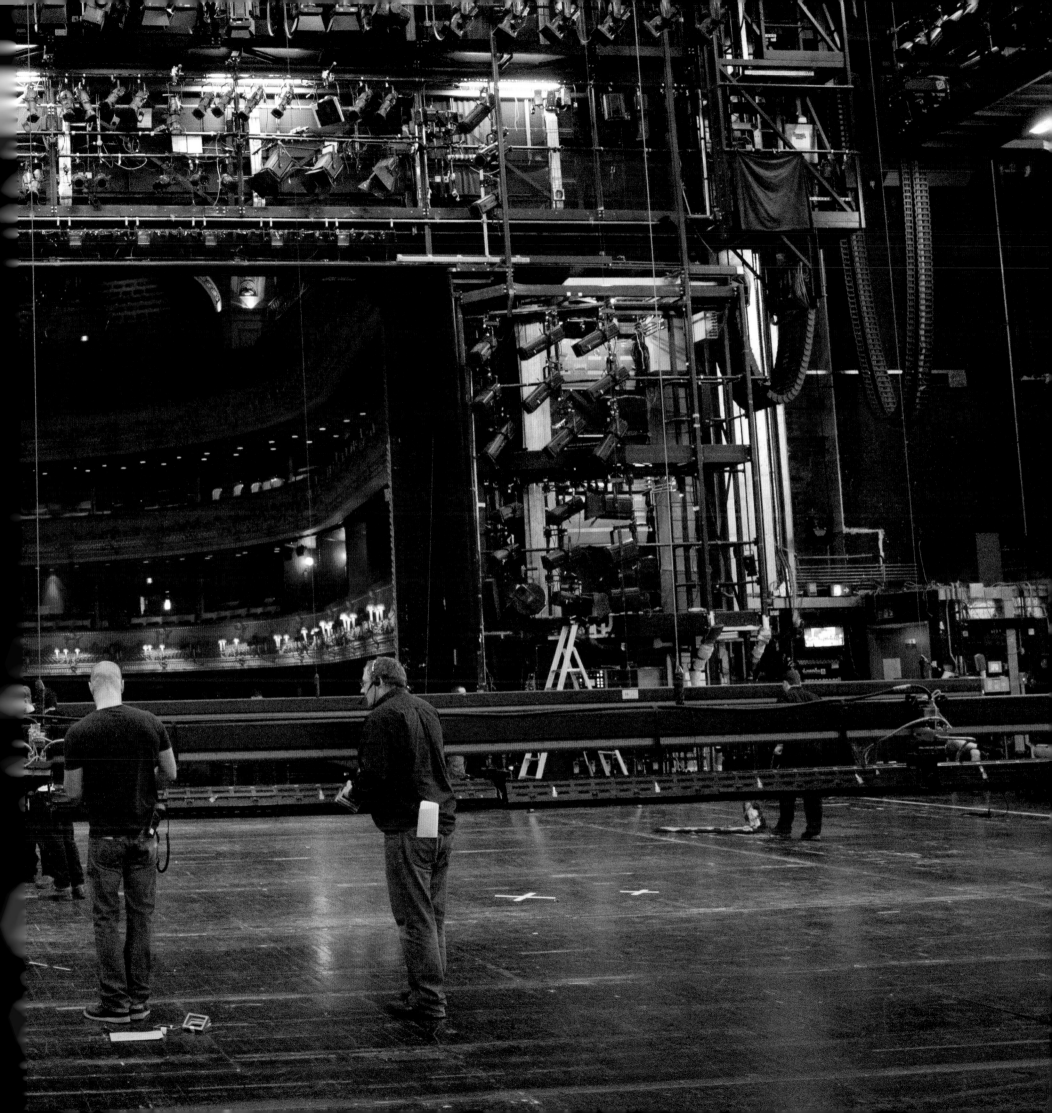

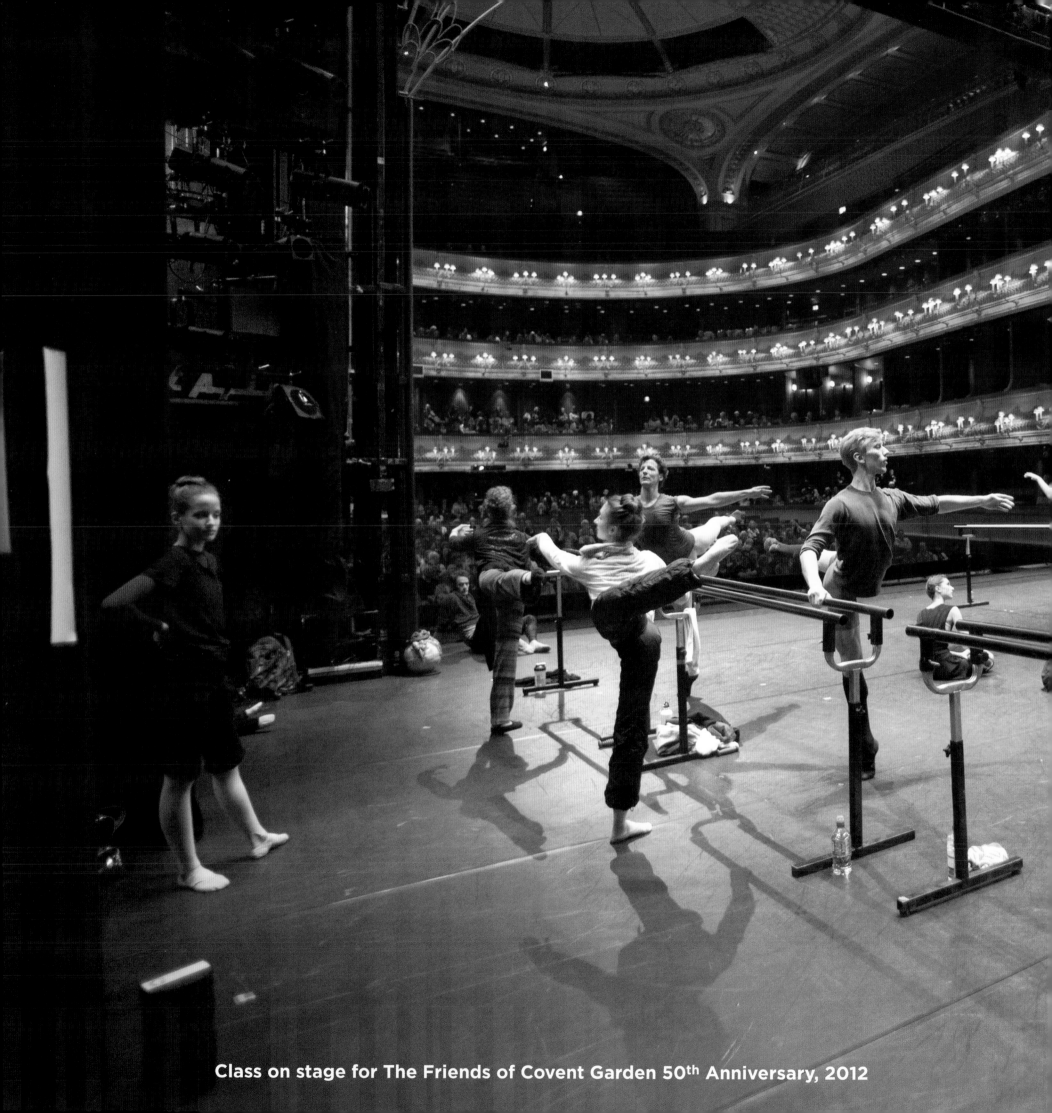

Class on stage for The Friends of Covent Garden 50th Anniversary, 2012

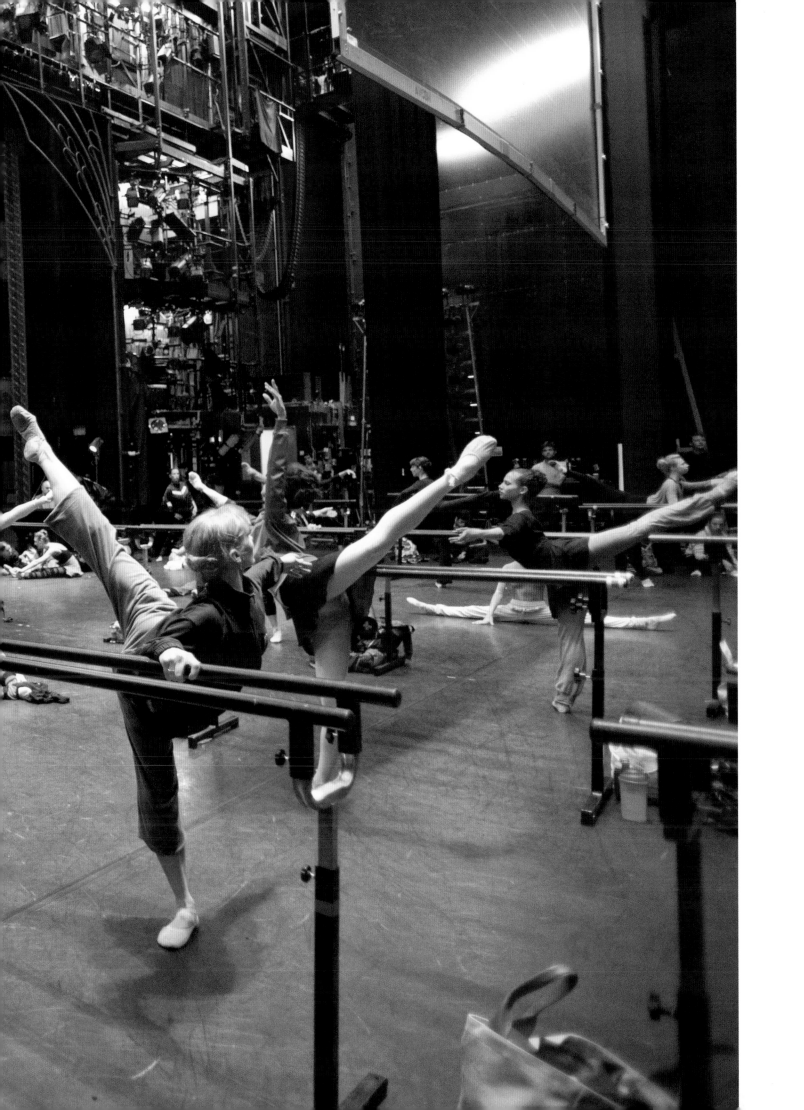

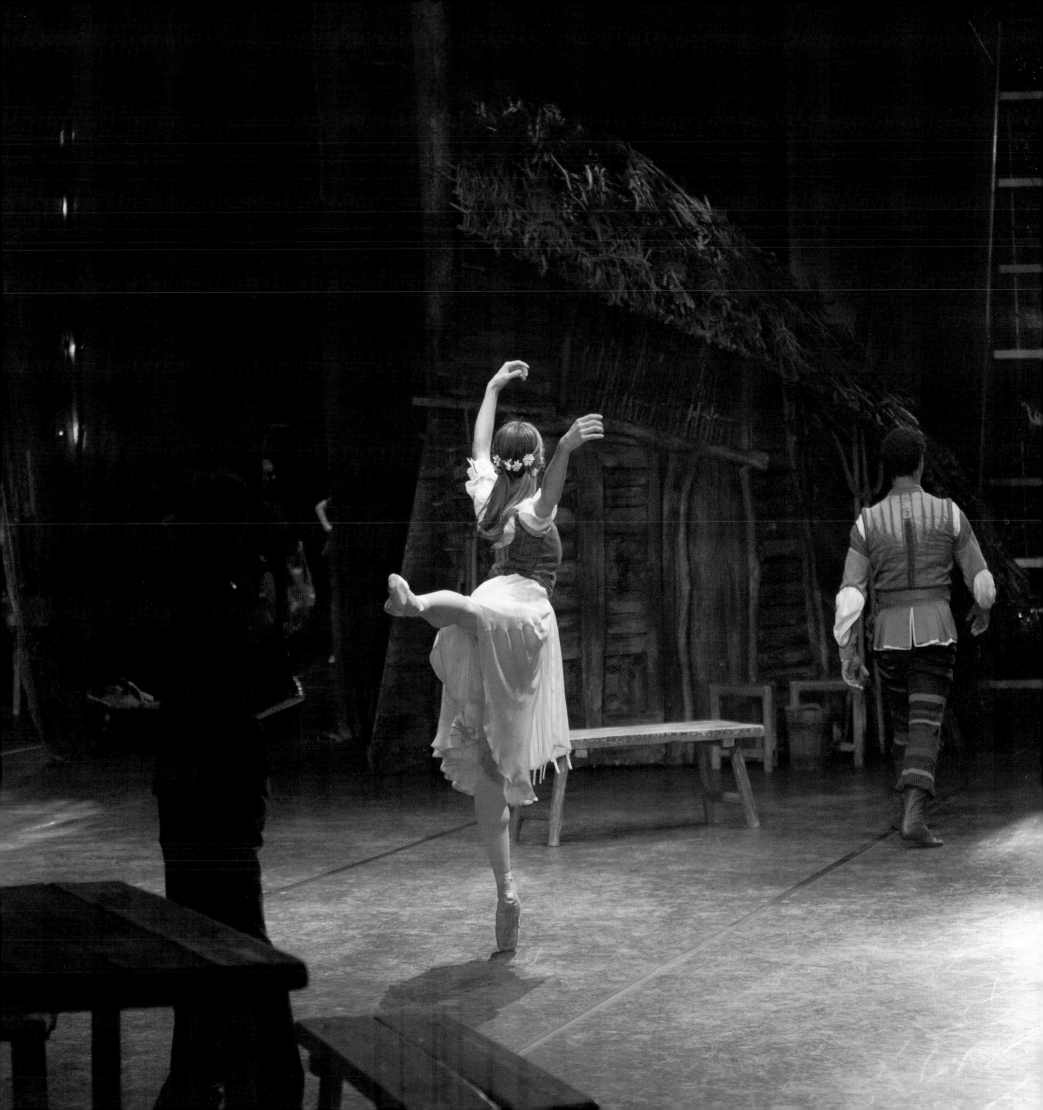

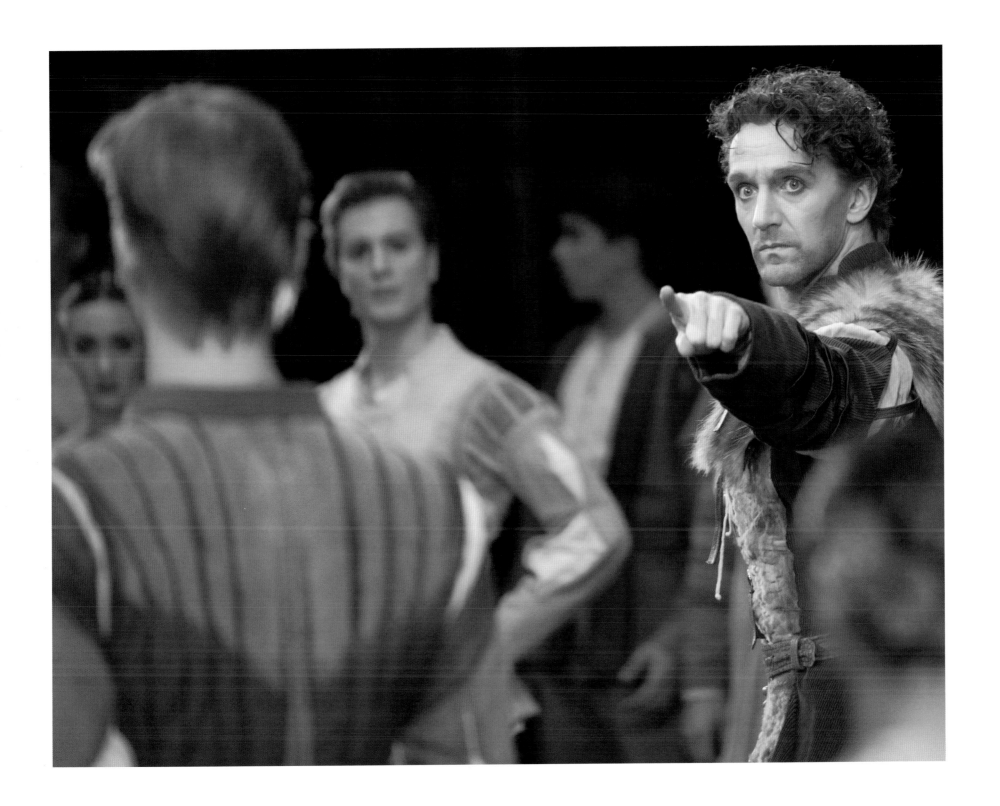

Gary Avis
Opposite **Marianela Nuñez** and **Carlos Acosta**
Giselle Choreography: Marius Petipa after Jean Coralli and Jules Perrot
Production: Peter Wright

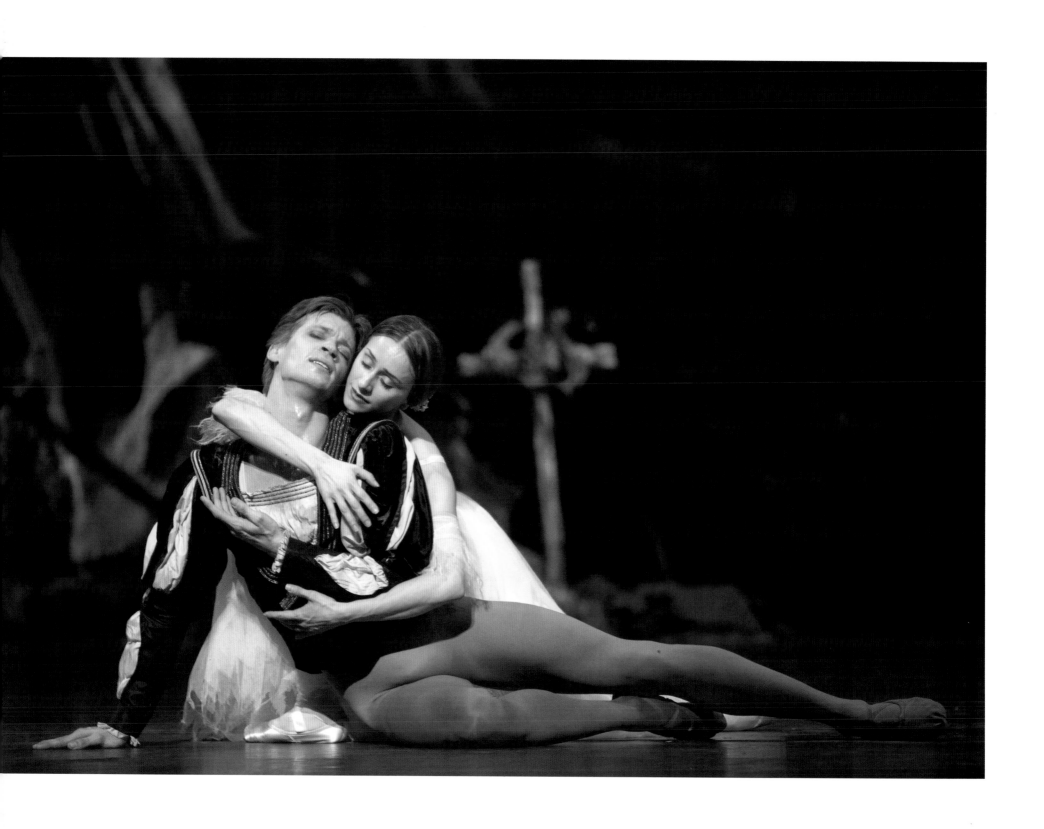

Marianela Nuñez and **Rupert Pennefather**
Opposite **Carlos Acosta**

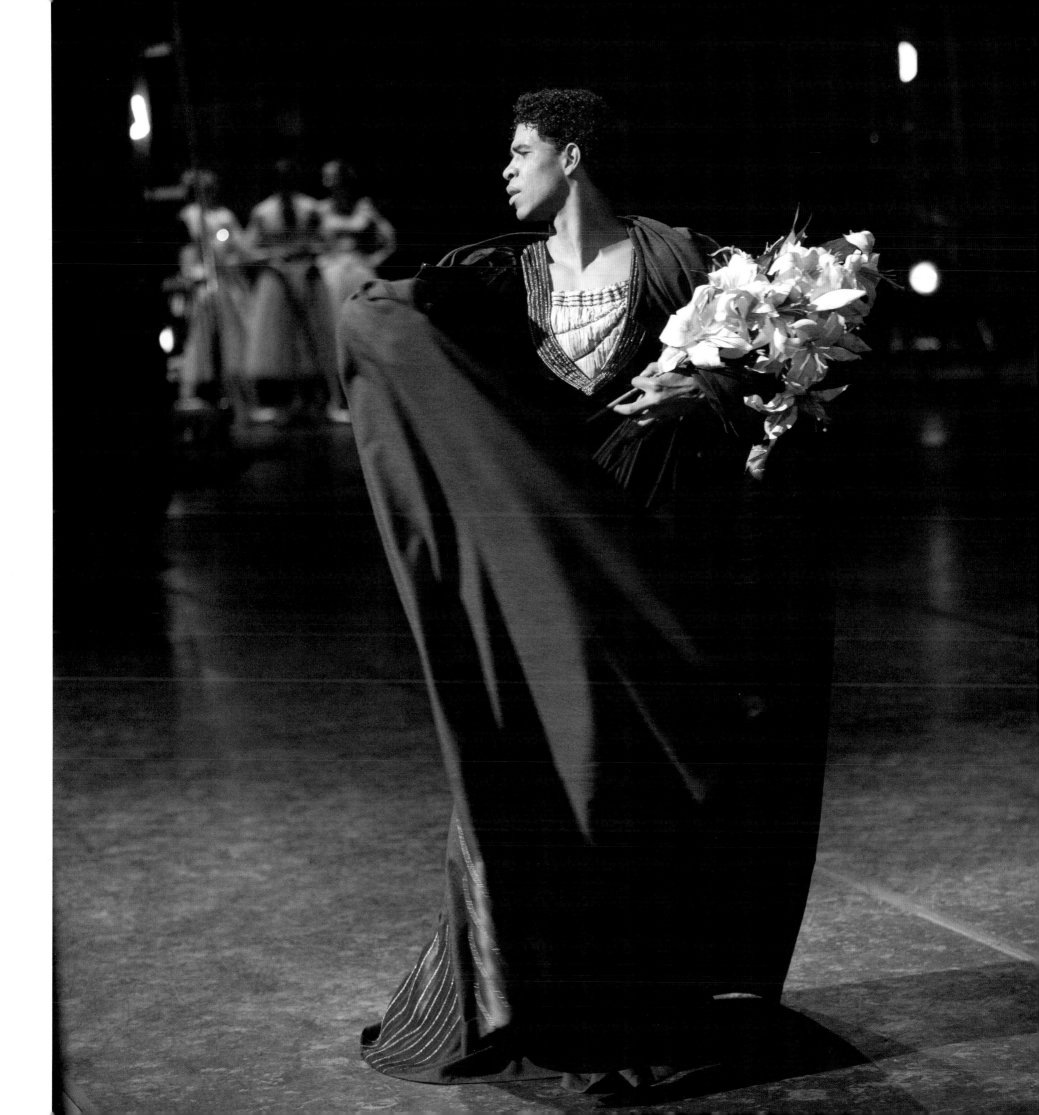

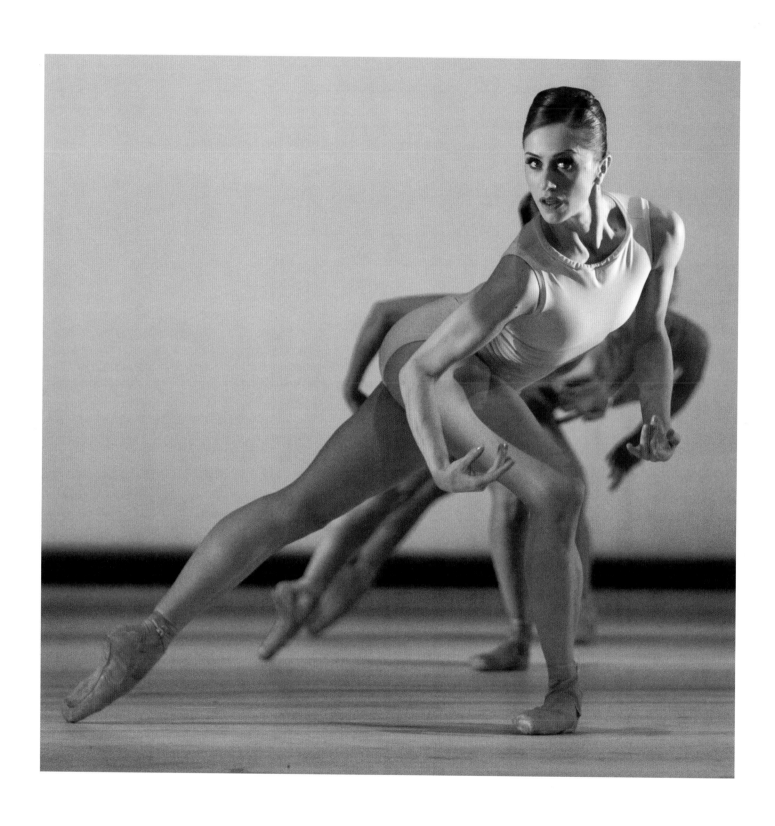

Marianela Nuñez
Opposite left to right **Mara Galeazzi, Gary Avis, Melissa Hamilton** and **Bennet Gartside**
Sensorium Choreography: Alastair Marriott

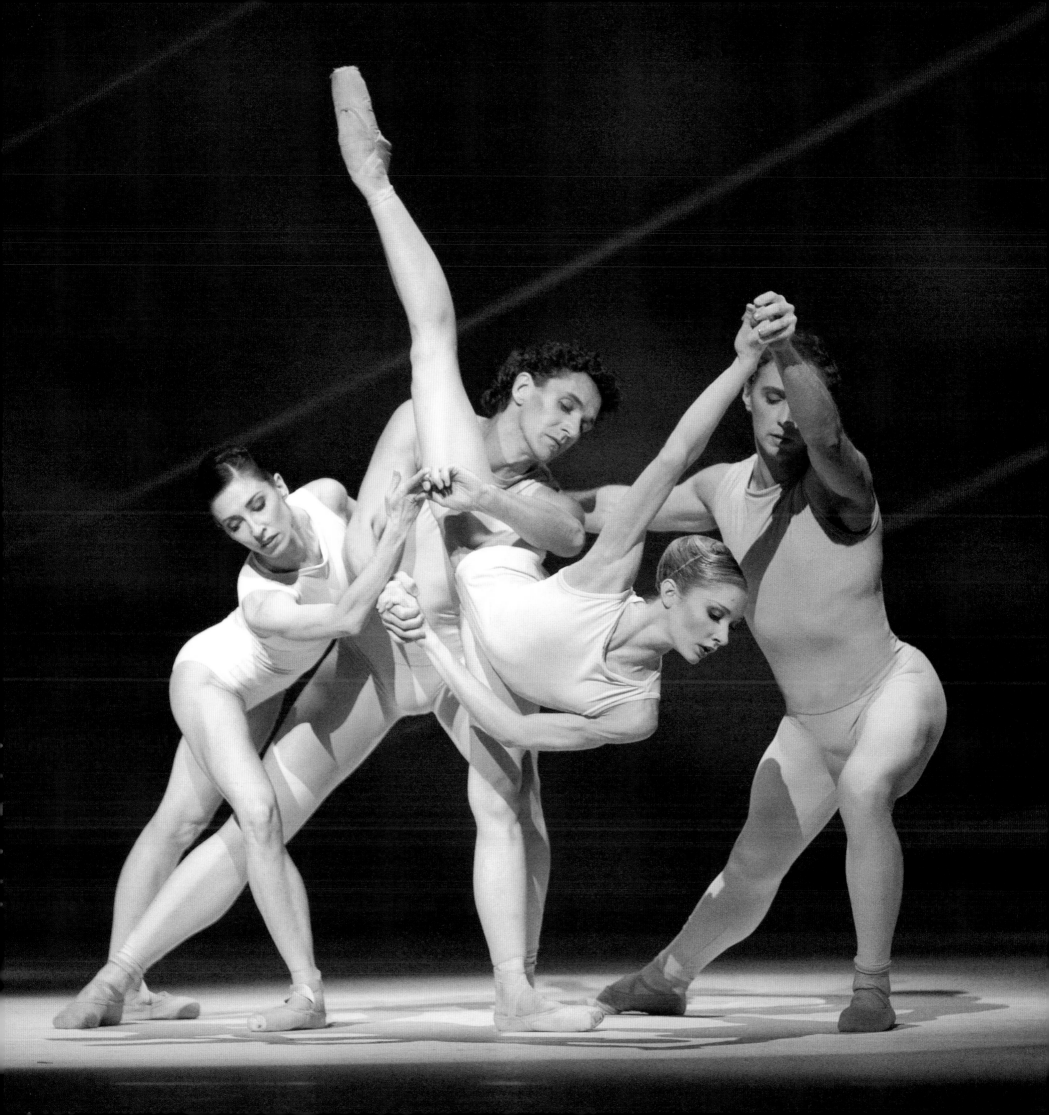

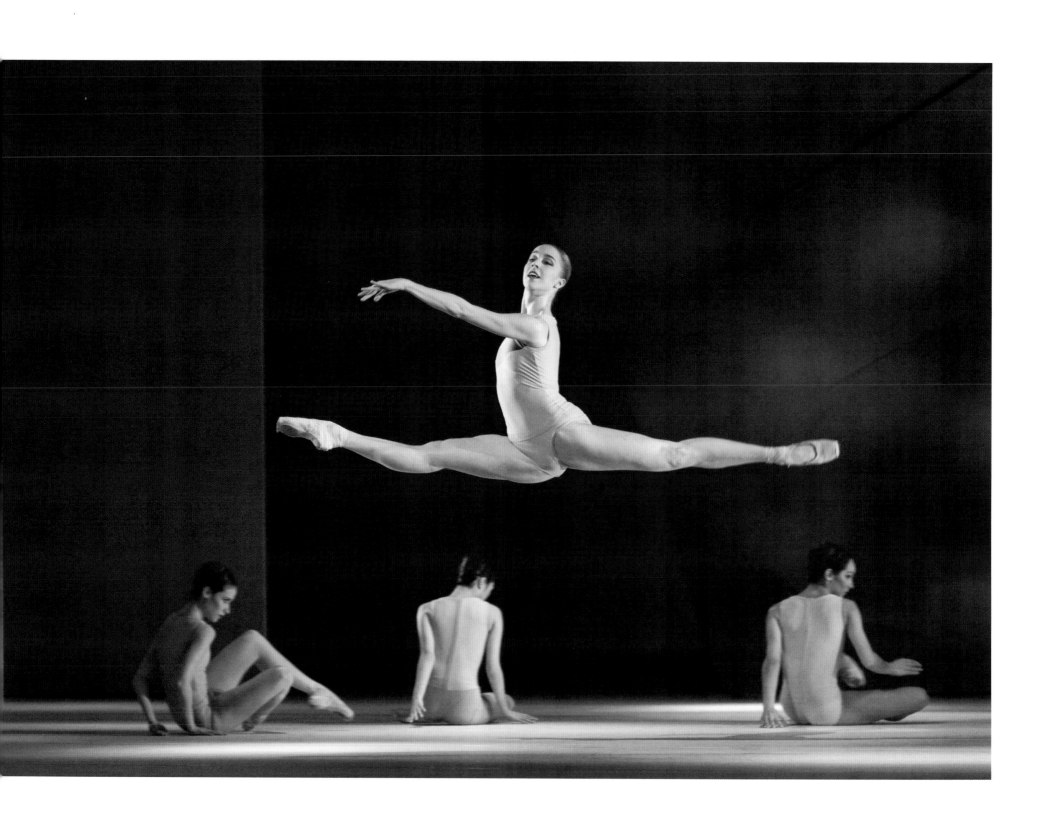

Nathalie Harrison
Opposite **Melissa Hamilton**

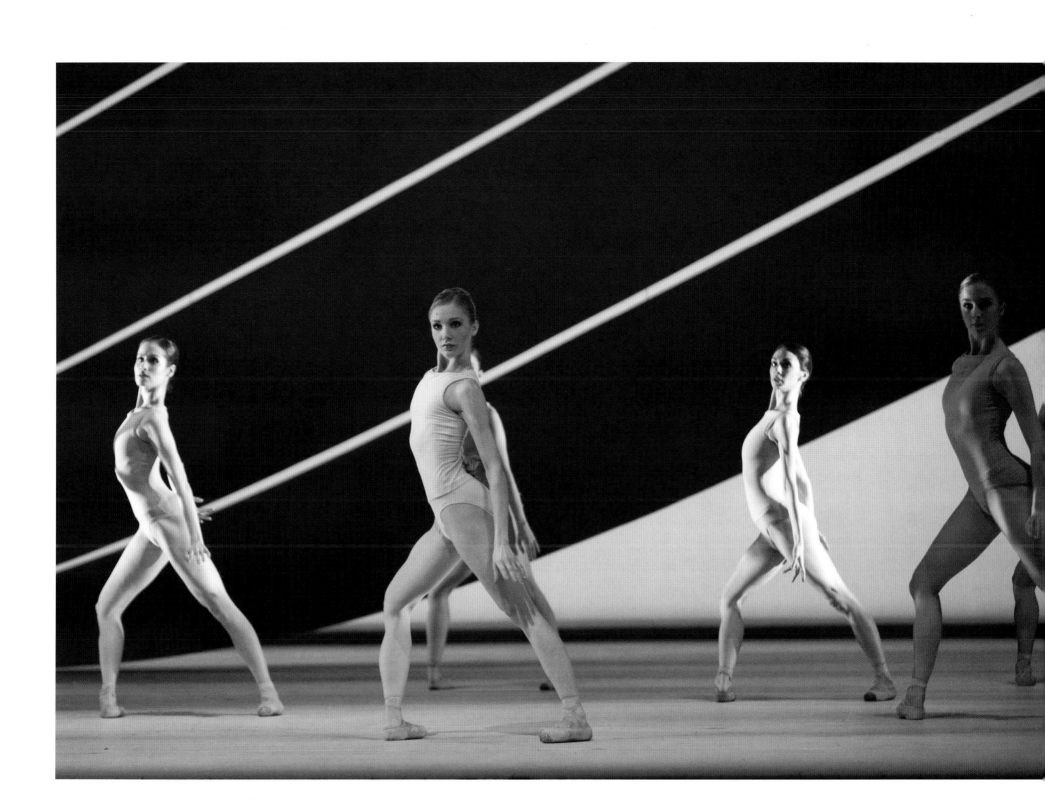

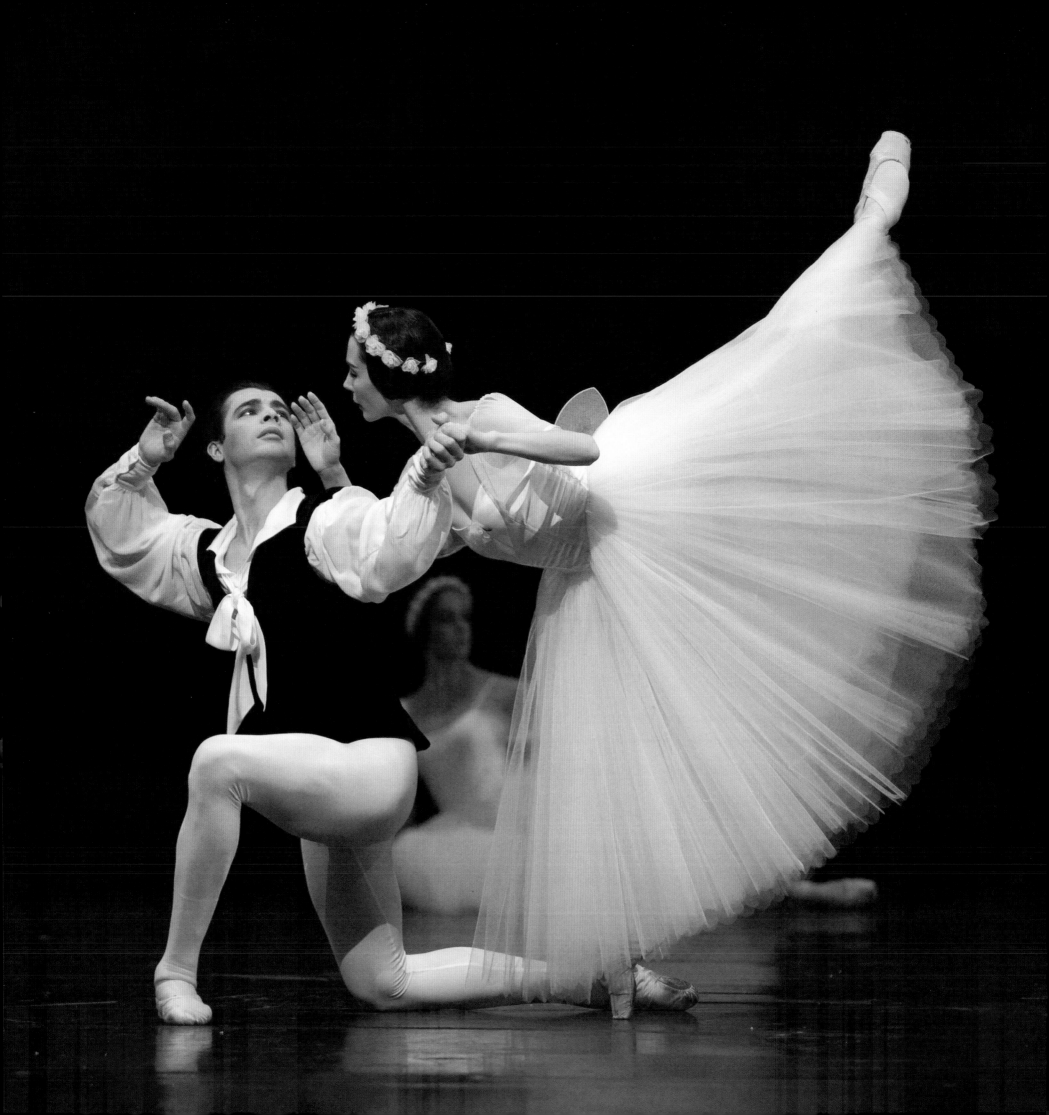

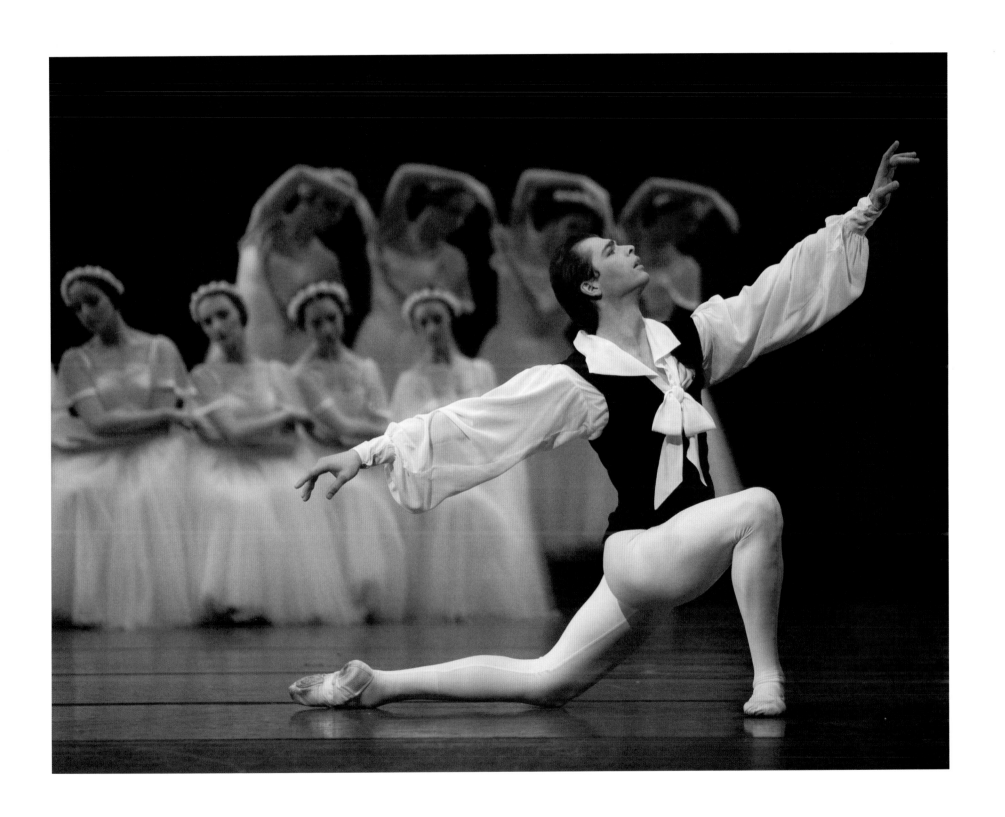

David Makhateli and **Tamara Rojo**
Les Sylphides Choreography: Mikhail Fokine
Production: Monica Mason

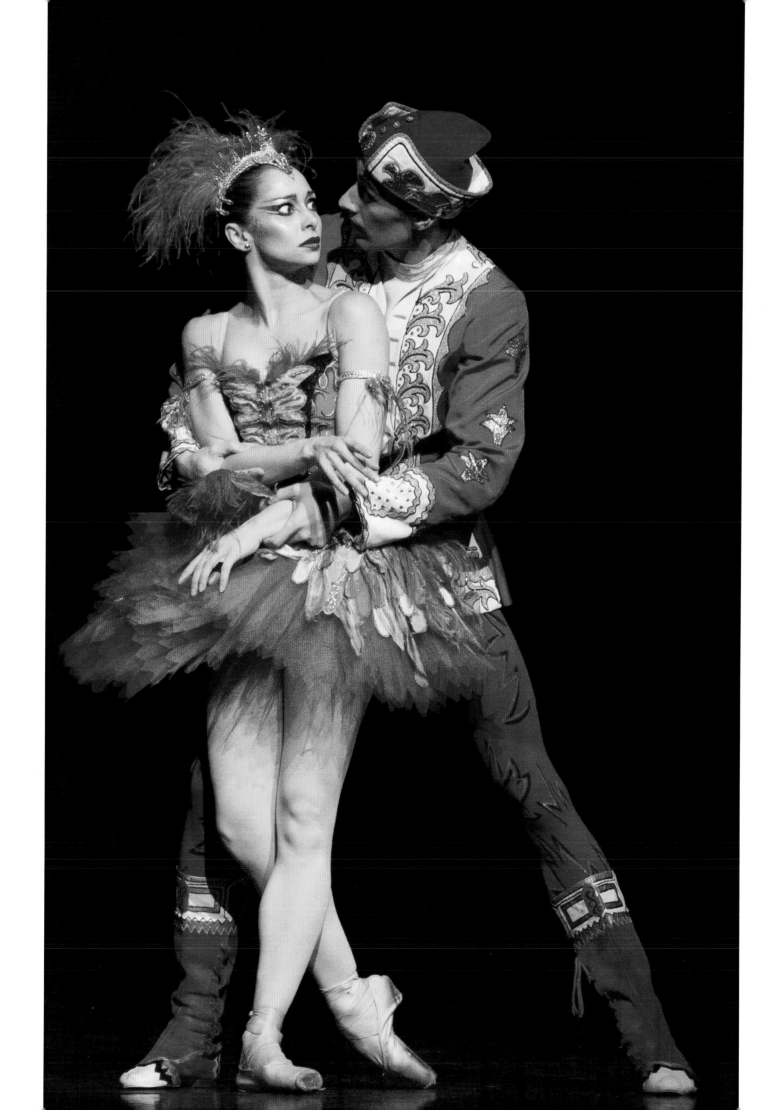

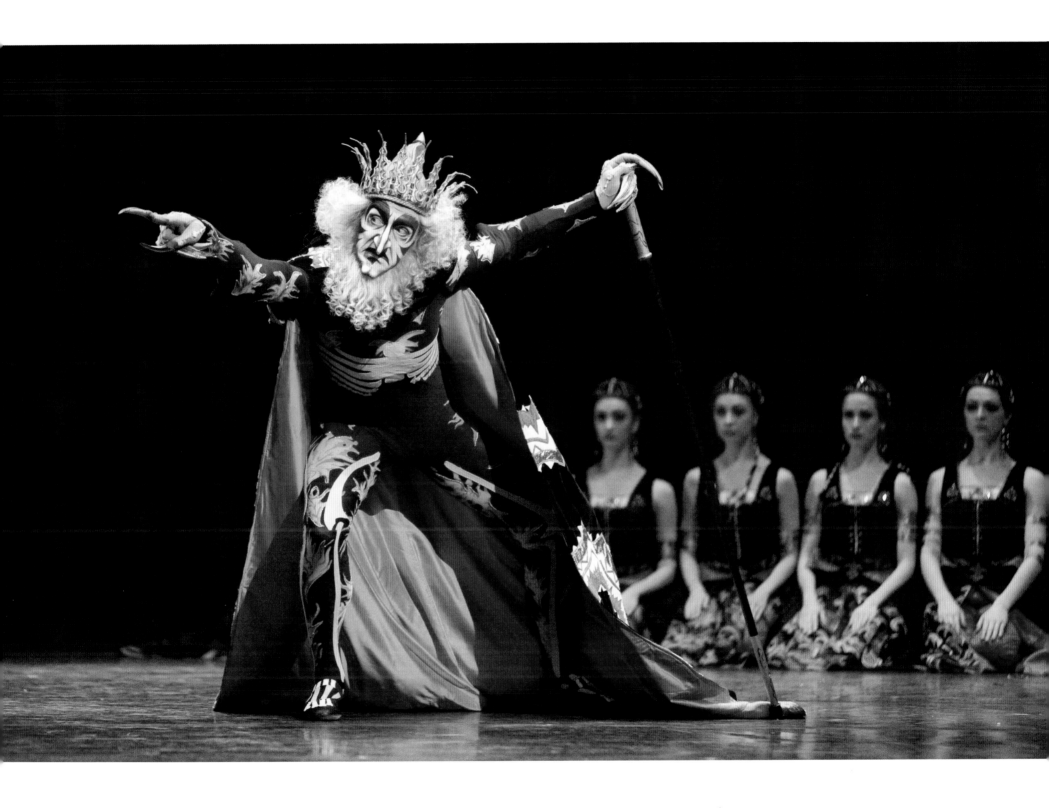

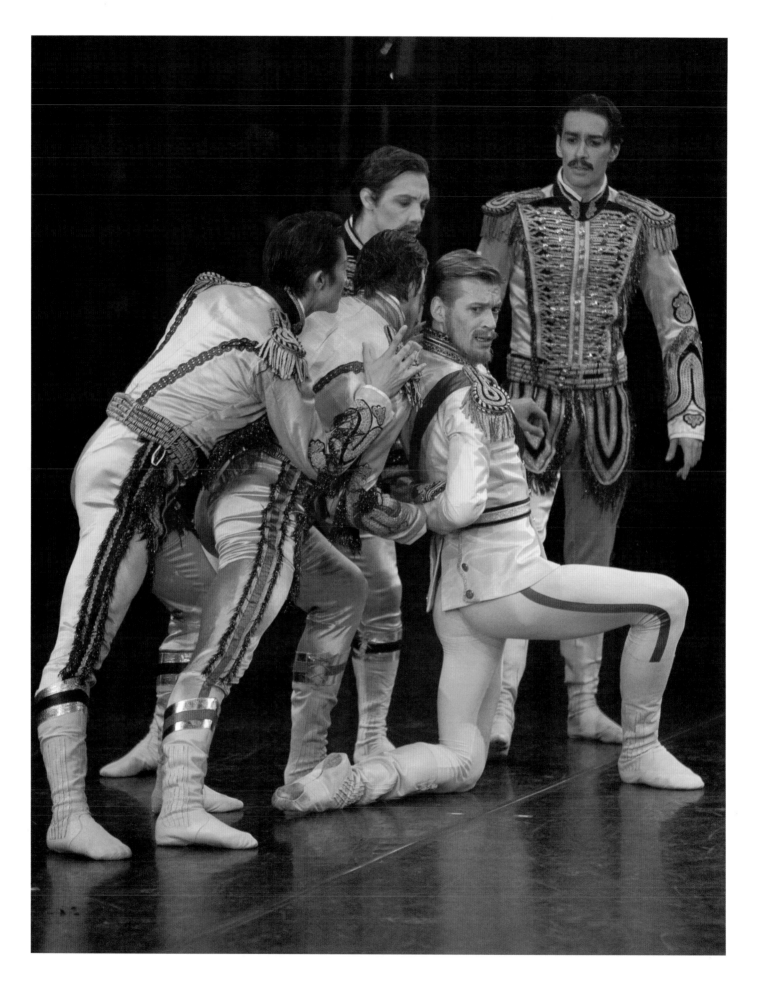

Rupert Pennefather
Opposite **Melissa Hamilton** and **Rupert Pennefather**
Mayerling Choreography: Kenneth MacMillan

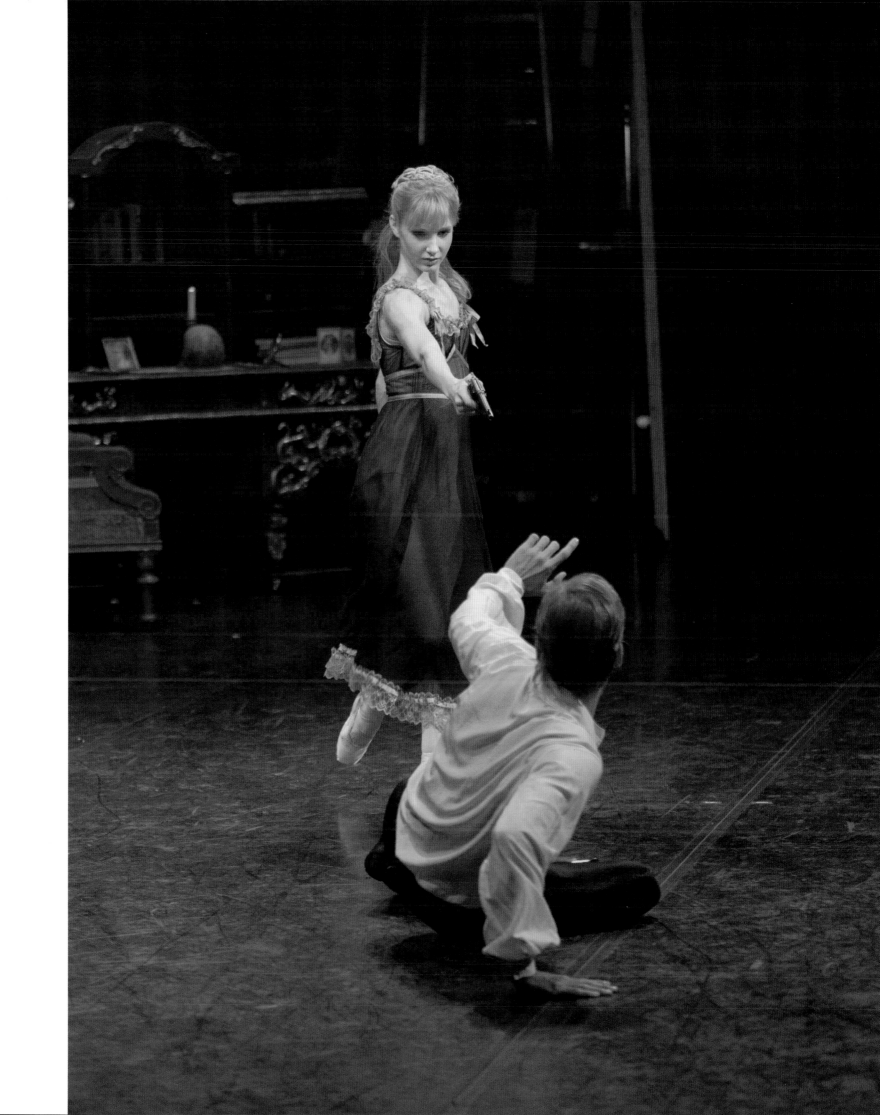

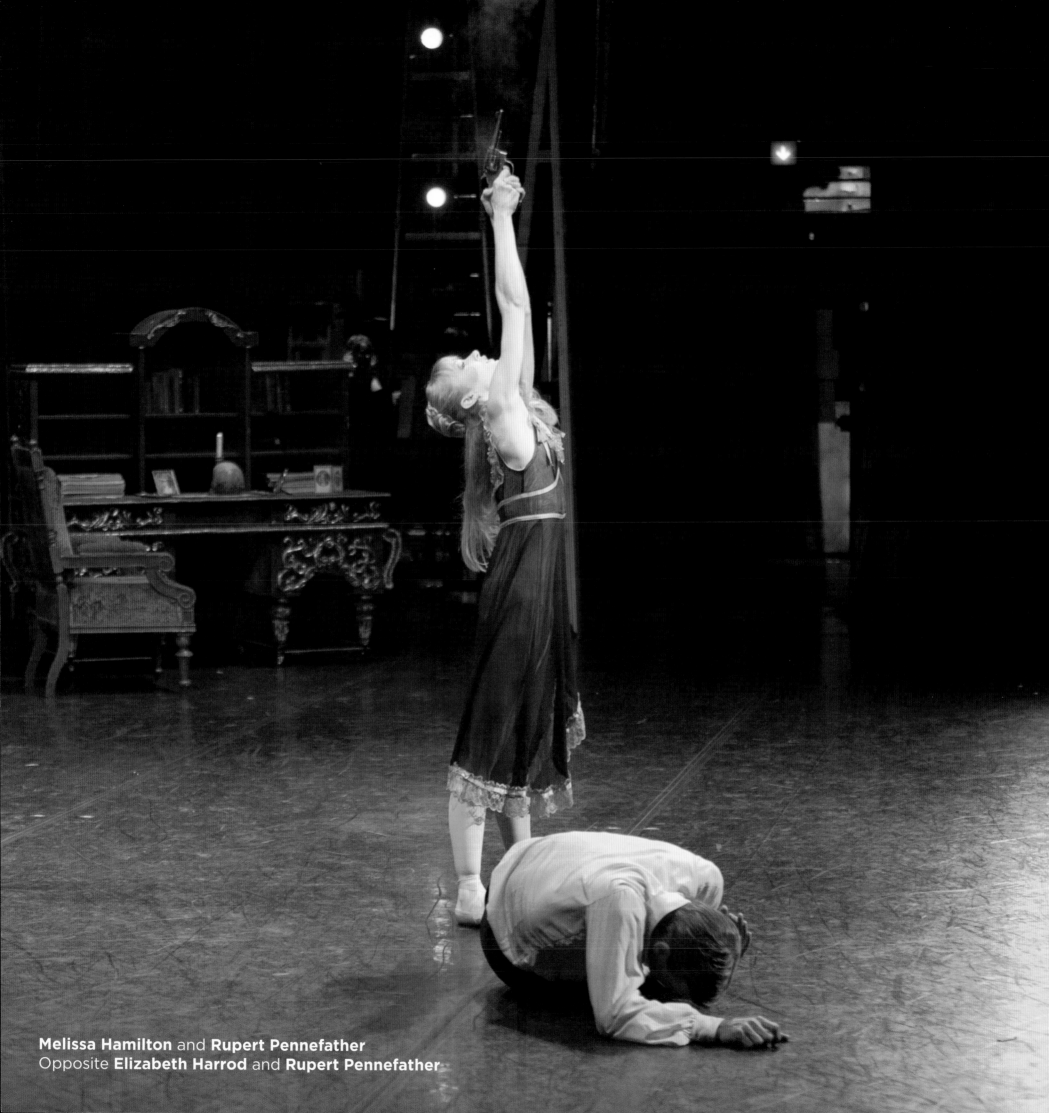

Melissa Hamilton and Rupert Pennefather
Opposite Elizabeth Harrod and Rupert Pennefather

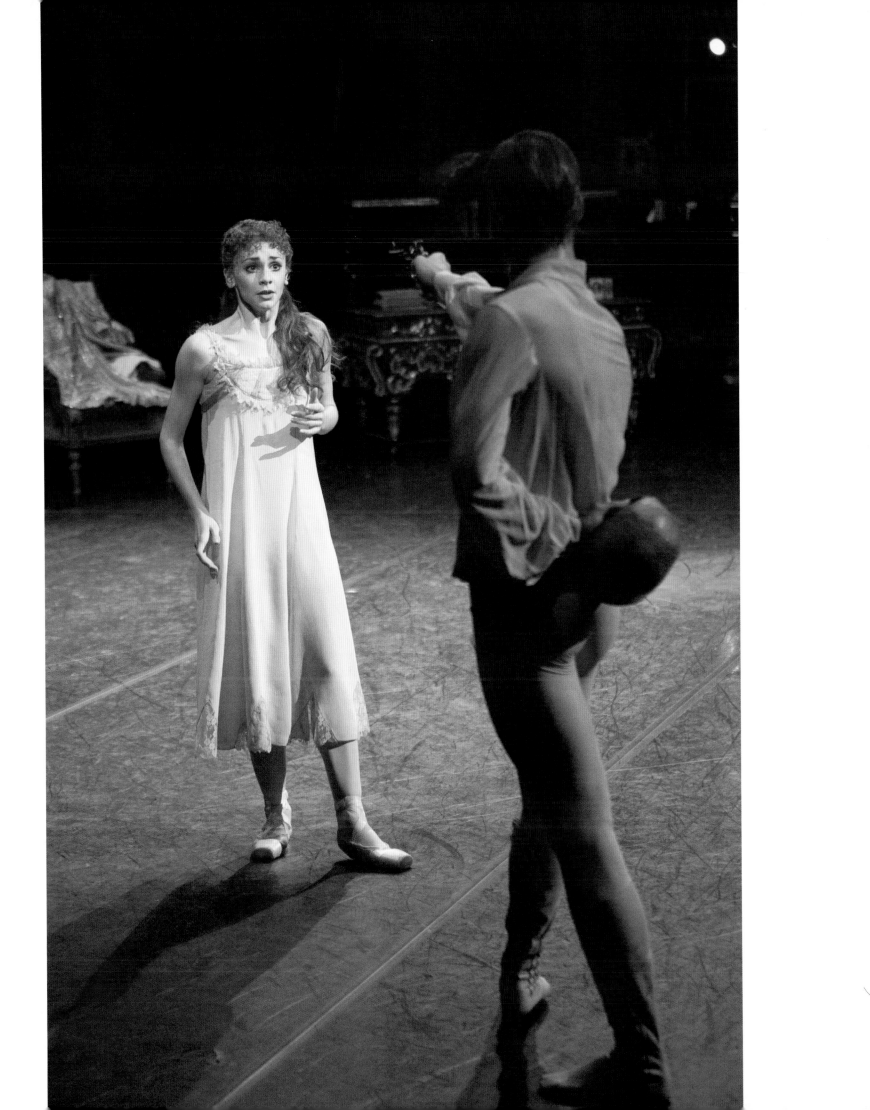

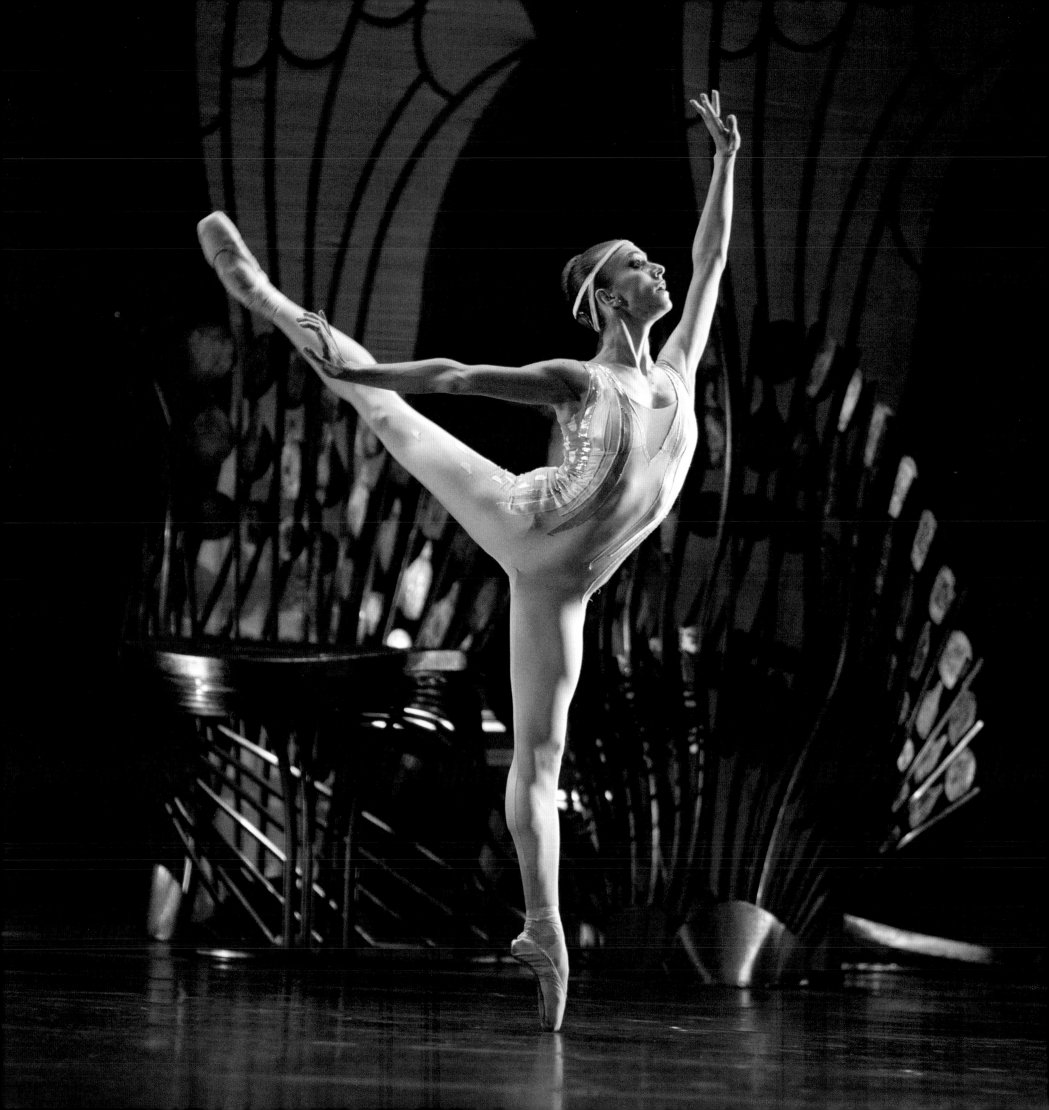

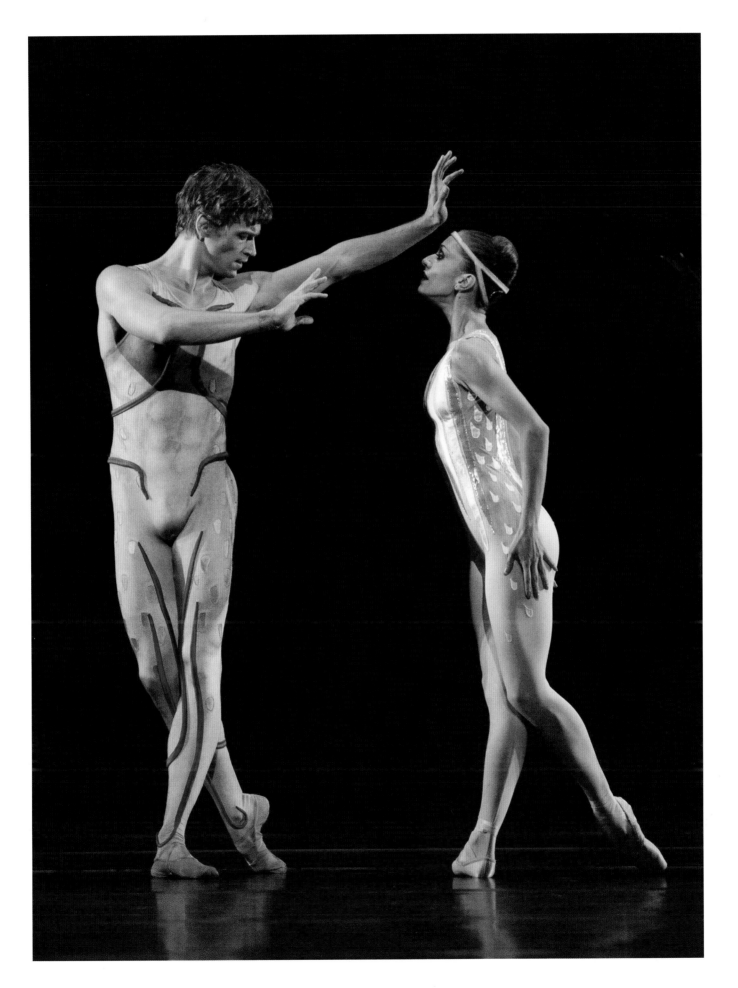

Marianela Nuñez and **Rupert Pennefather**
Sphinx Choreography: Glen Tetley

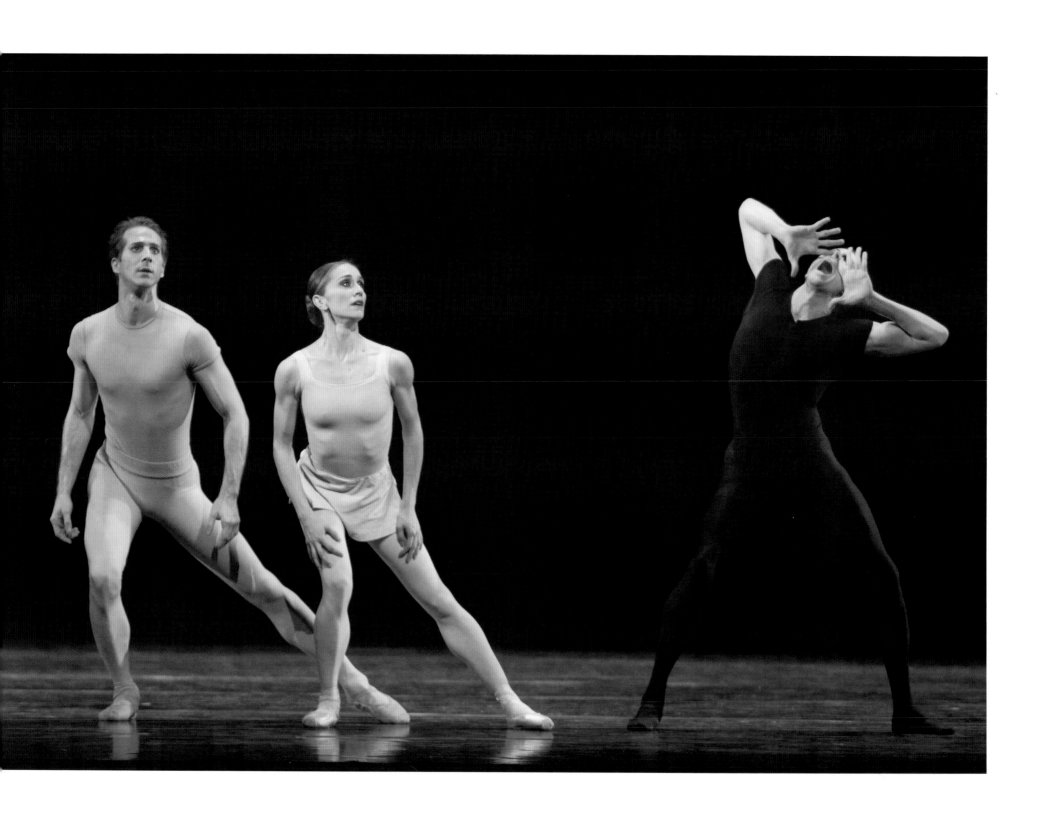

Left to right **Nehemiah Kish, Marianela Nuñez** and **Edward Watson**
Opposite **Edward Watson** and **Marianela Nuñez**
Song of the Earth Choreography: Kenneth MacMillan

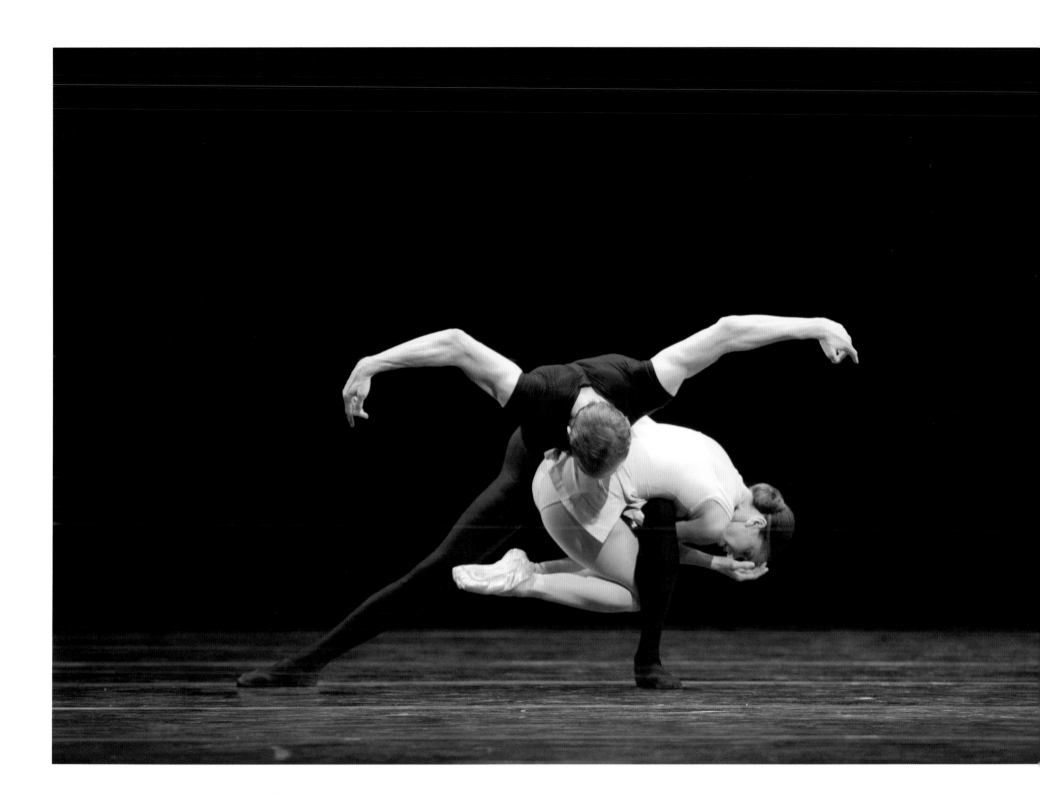

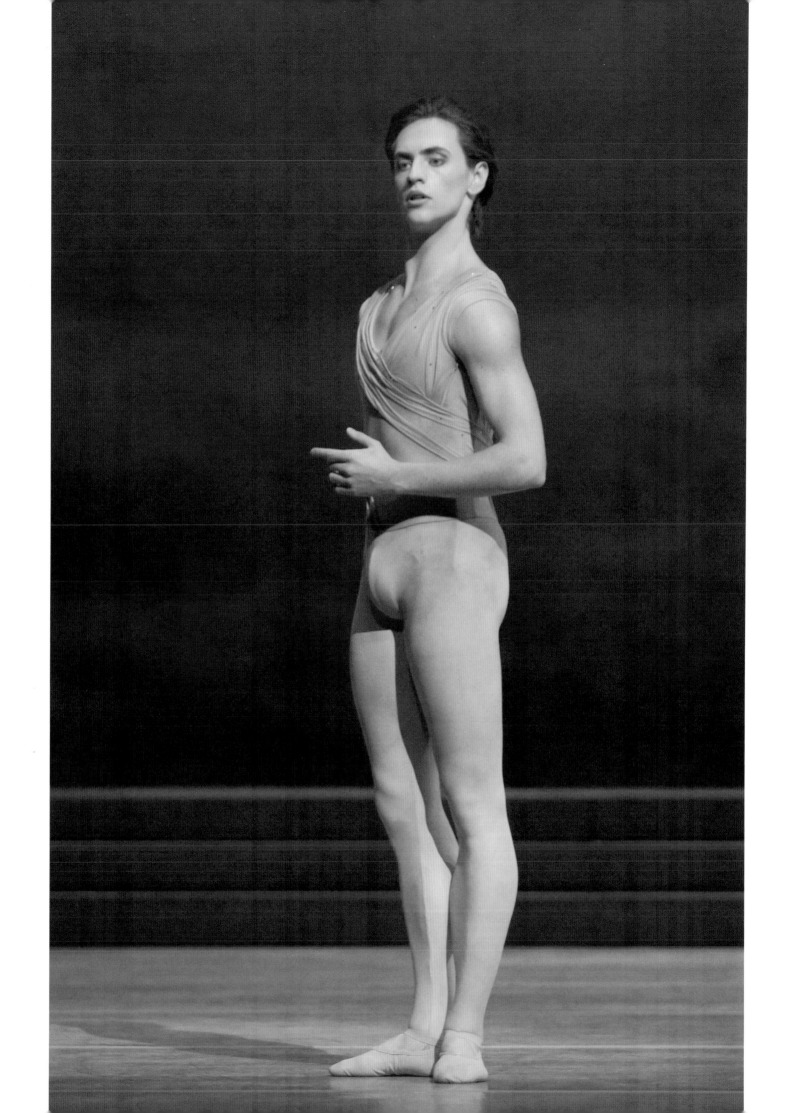

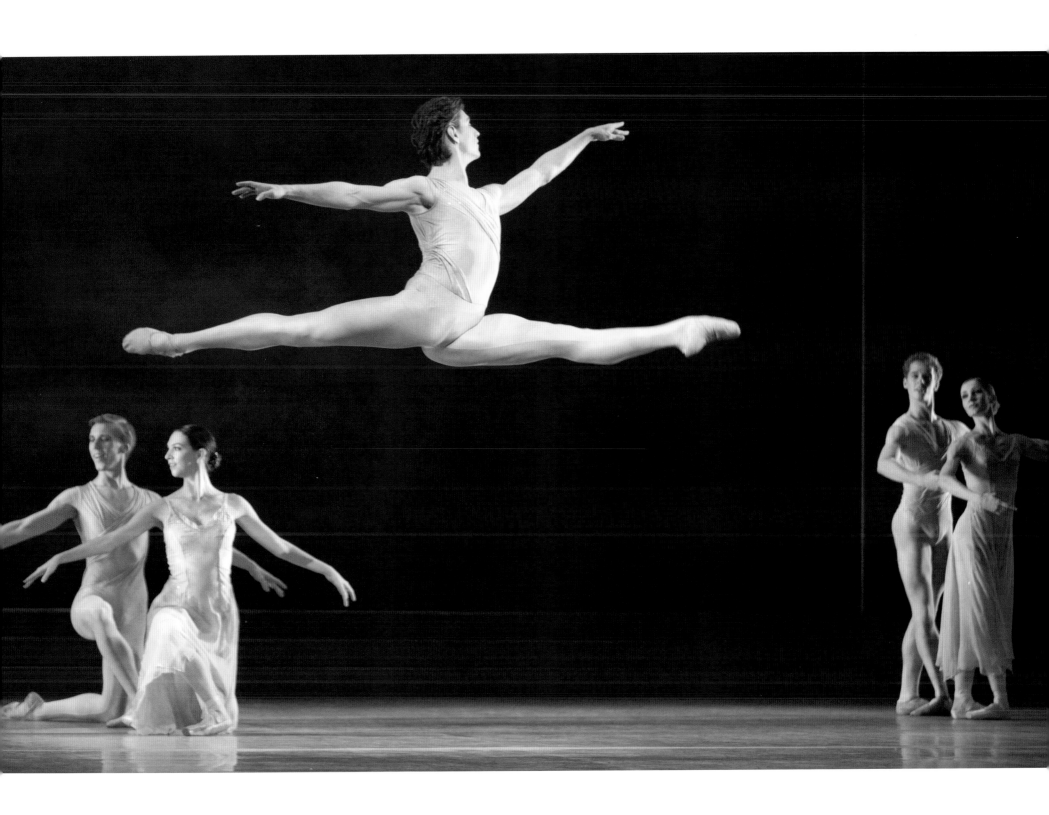

Sergei Polunin
Rhapsody Choreography: Frederick Ashton

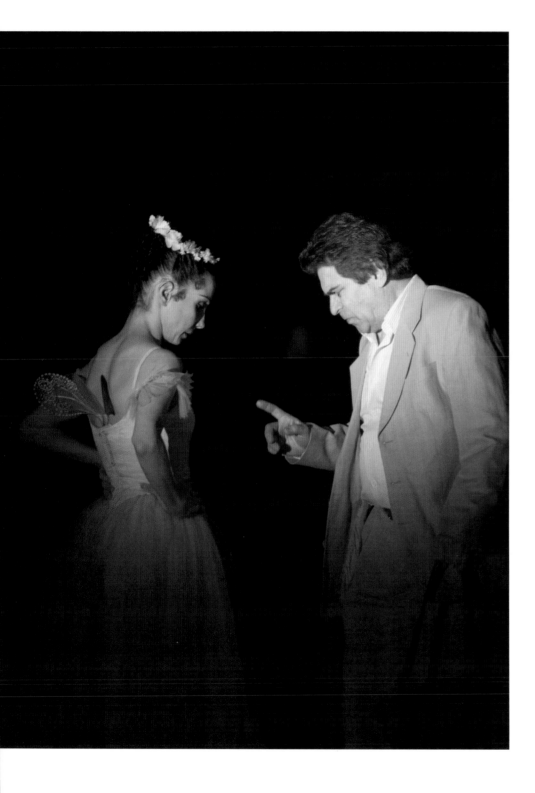
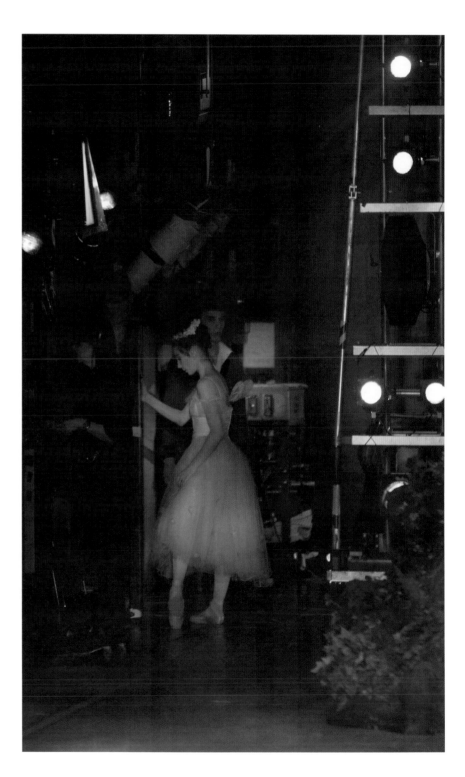

Tamara Rojo and **Alexander Agadzhanov, Tamara Rojo** and **Dawid Trzensimiech**
La Sylphide Choreography: August Bournonville
Production: Johan Kobborg

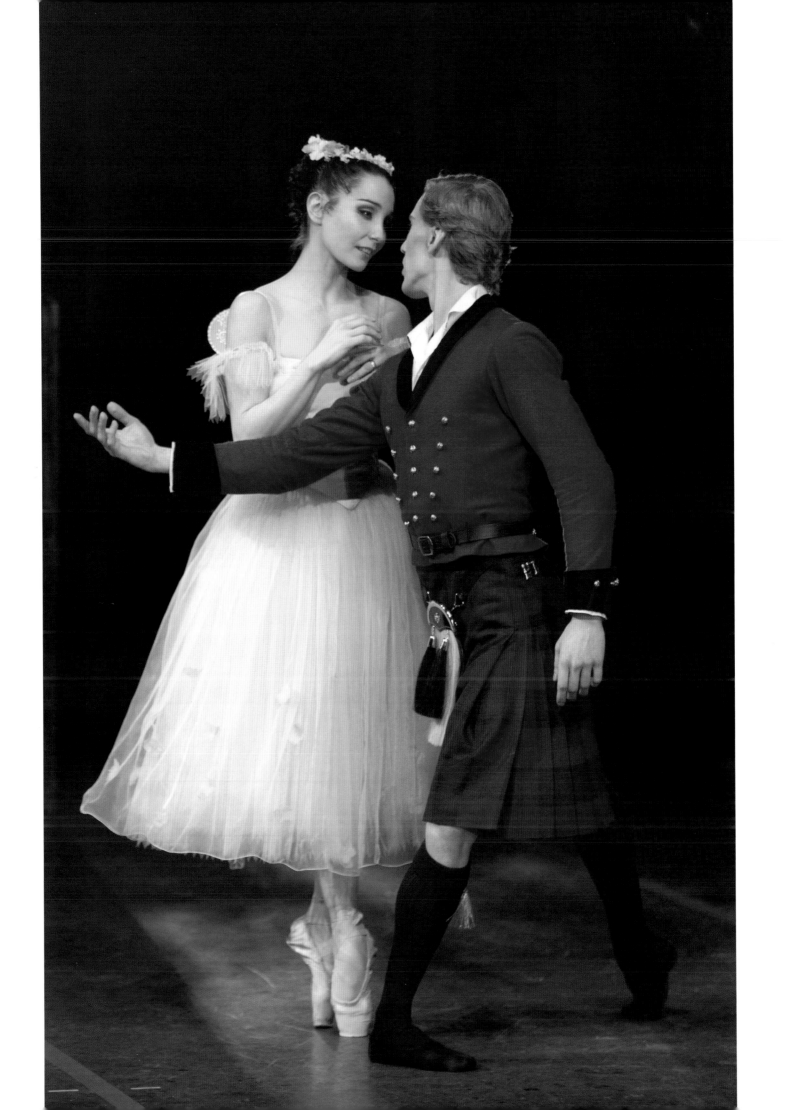

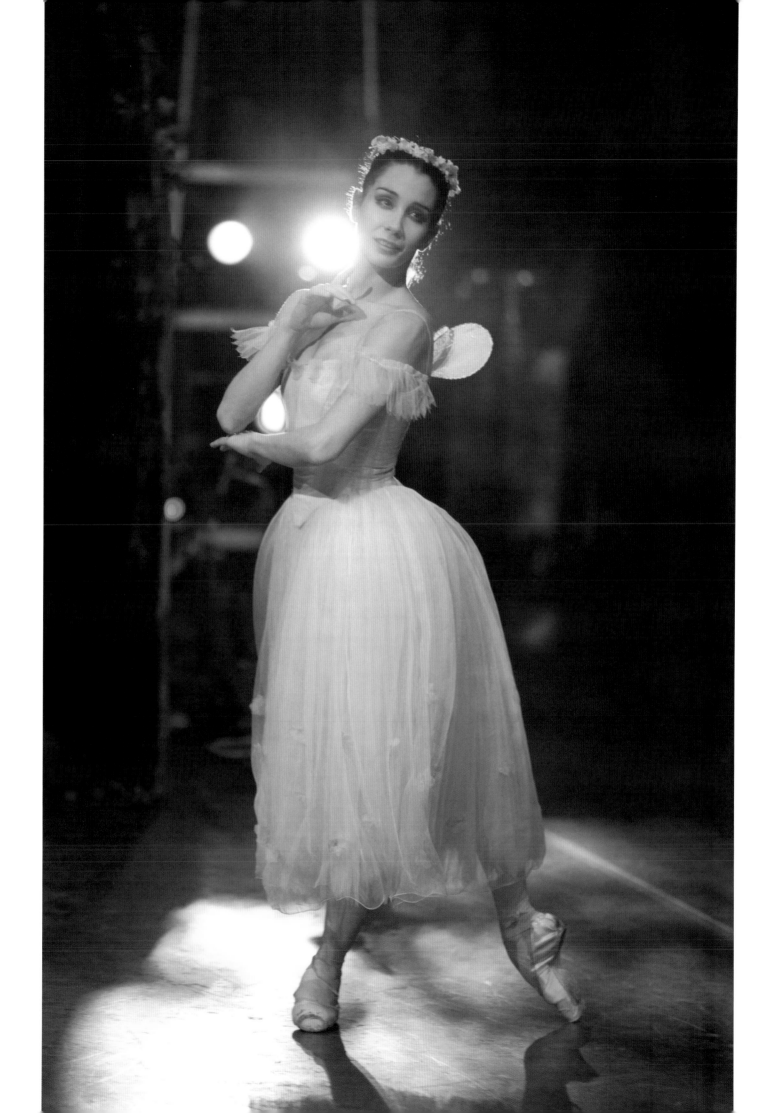

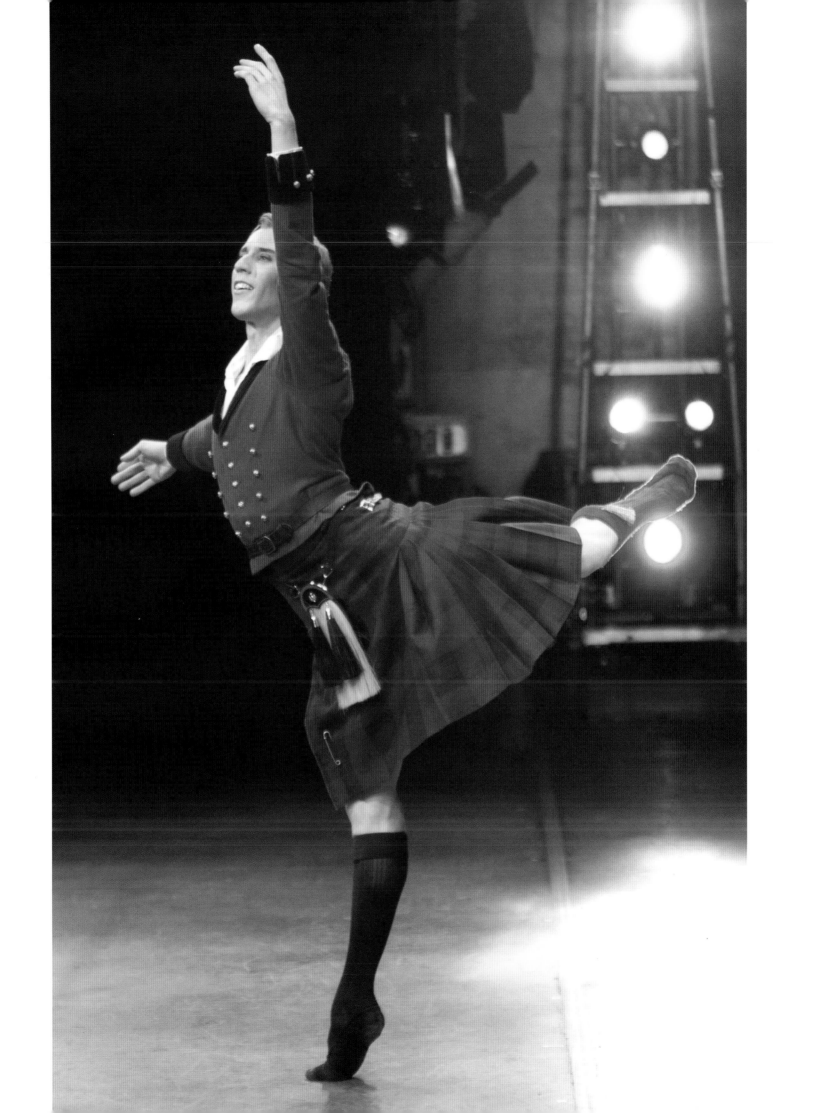

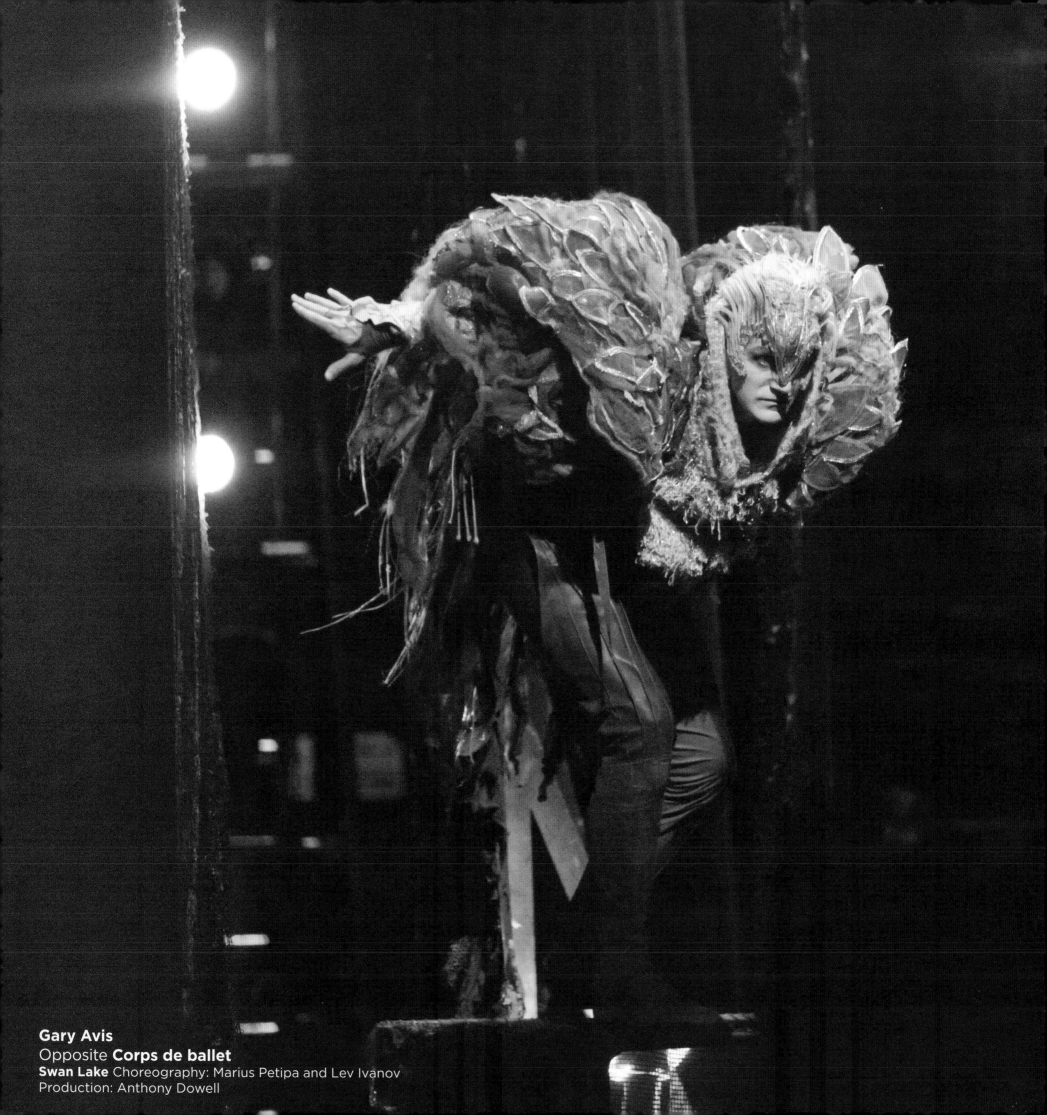

Gary Avis
Opposite **Corps de ballet**
Swan Lake Choreography: Marius Petipa and Lev Ivanov
Production: Anthony Dowell

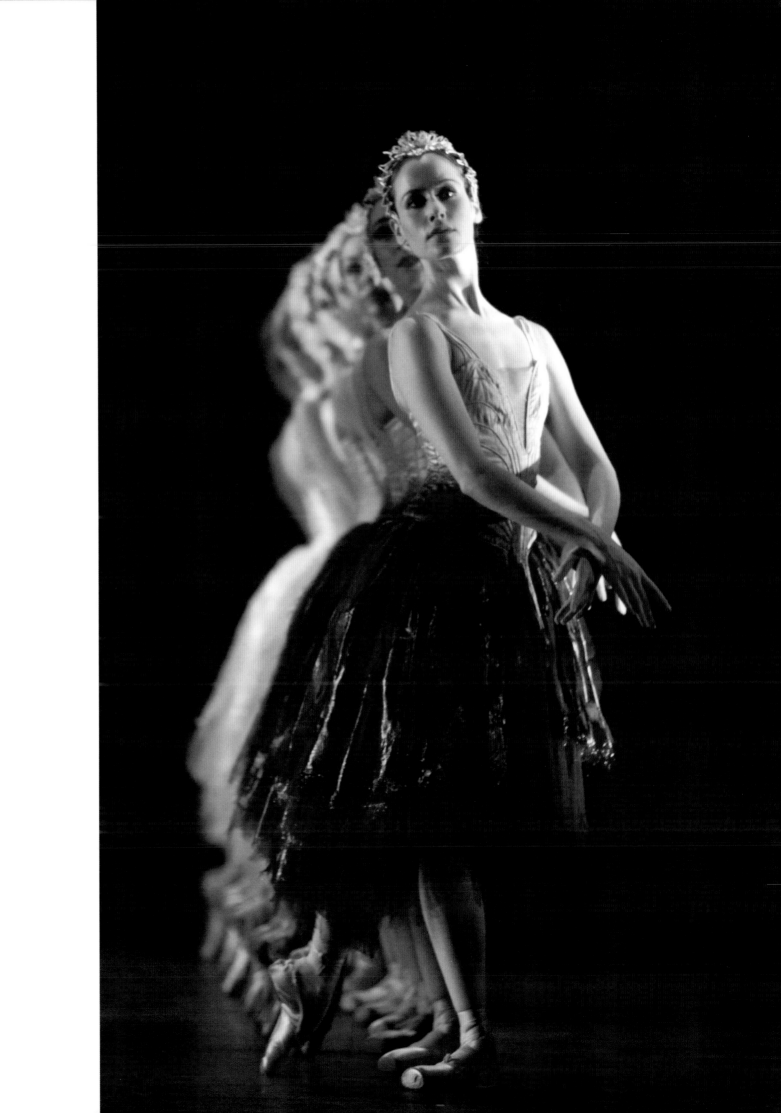

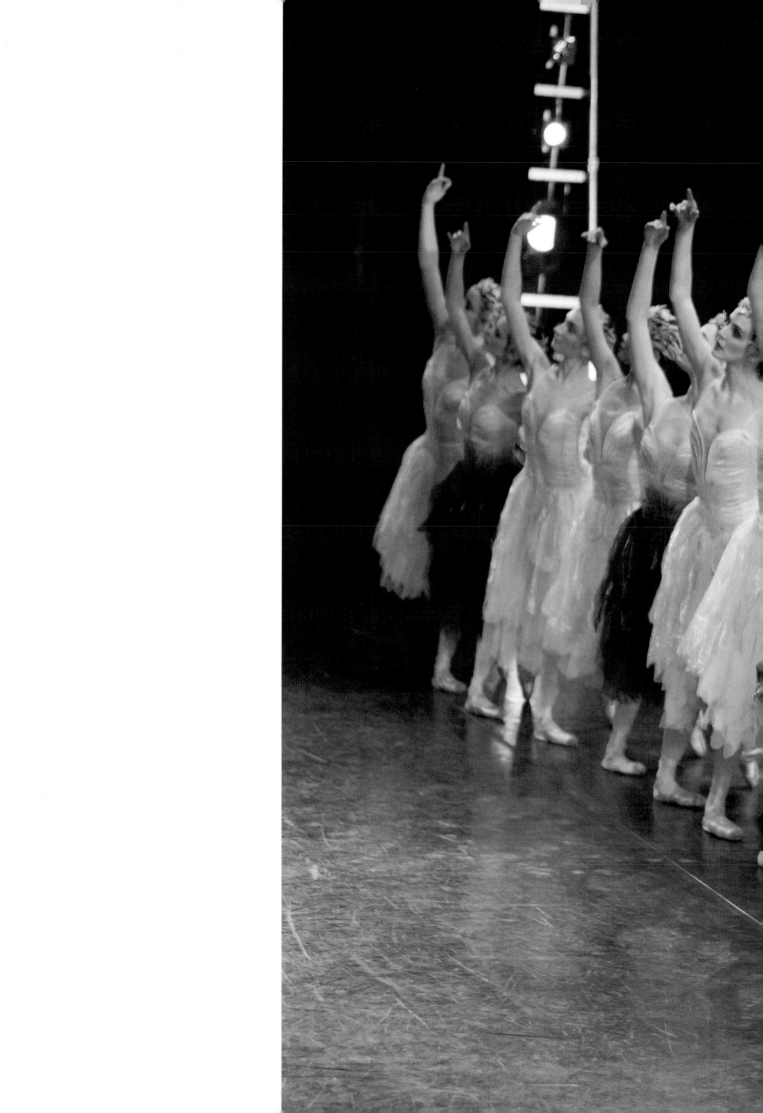

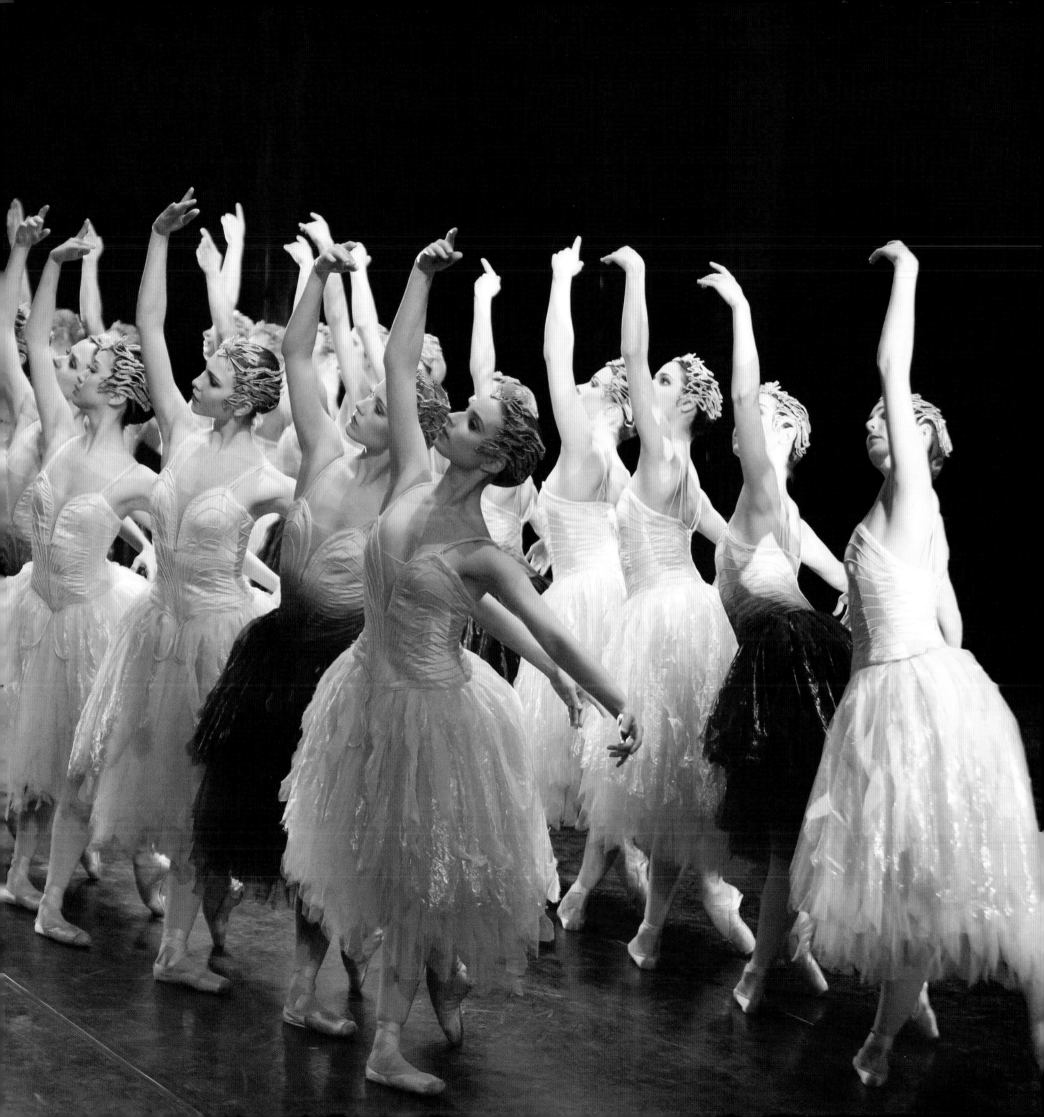

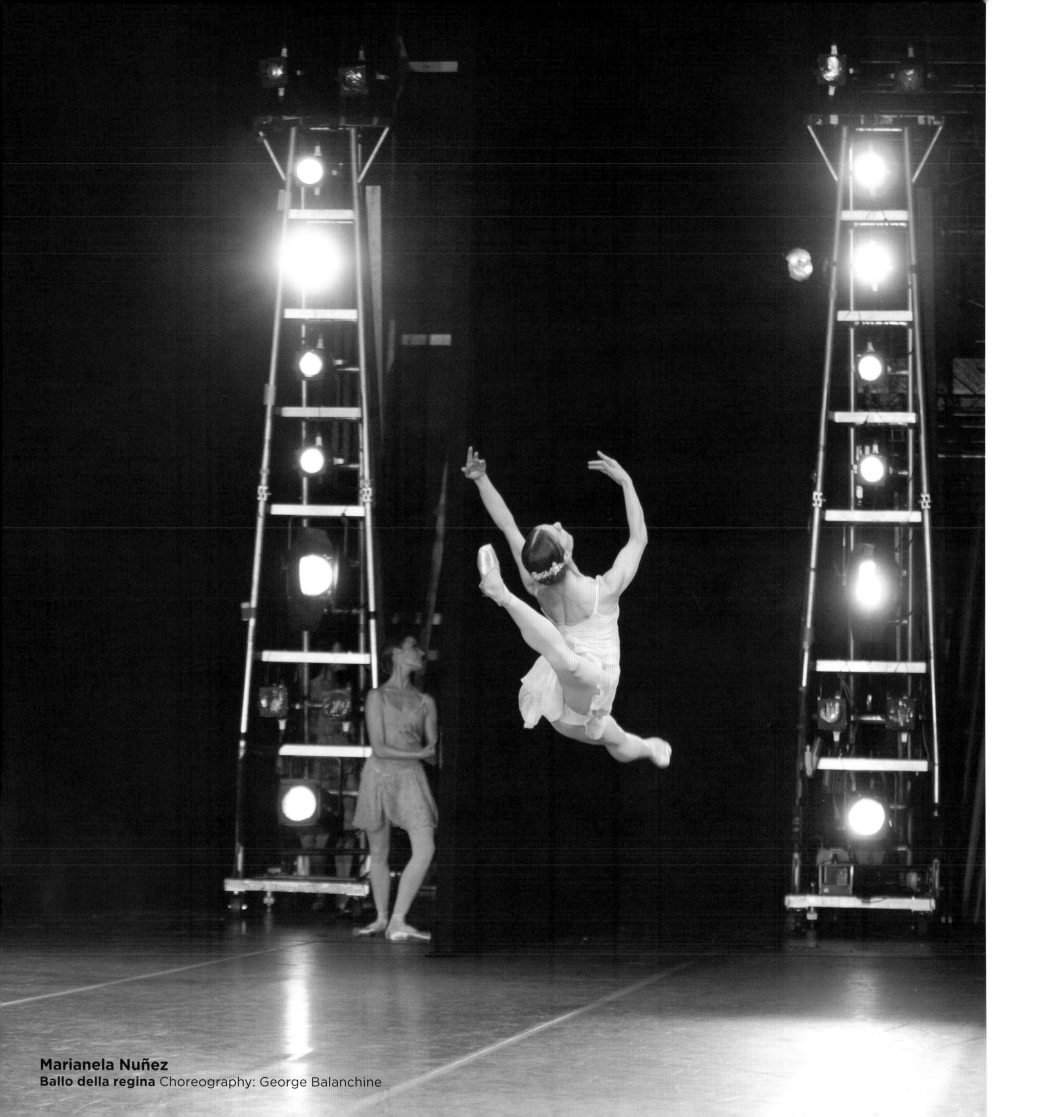

Marianela Nuñez
Ballo della regina Choreography: George Balanchine

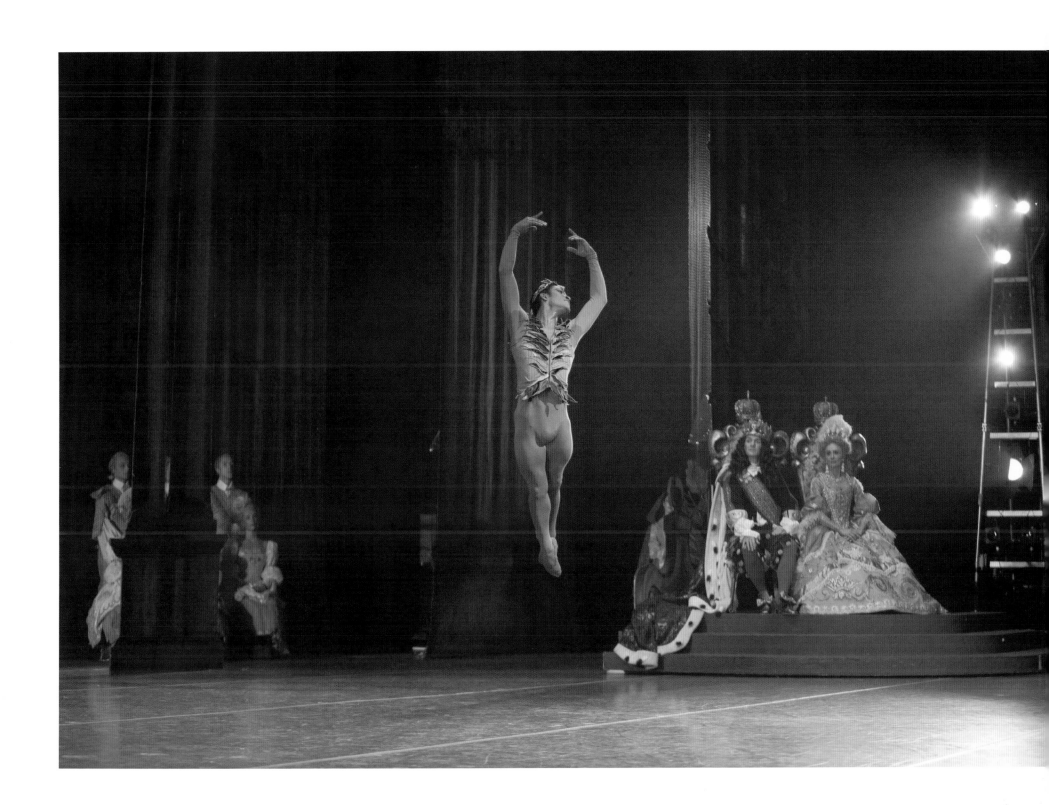

Fernando Montaño
The Sleeping Beauty Choreography: Marius Petipa
Production: Monica Mason and Christopher Newton after Ninette de Valois and Nicholas Sergeyev

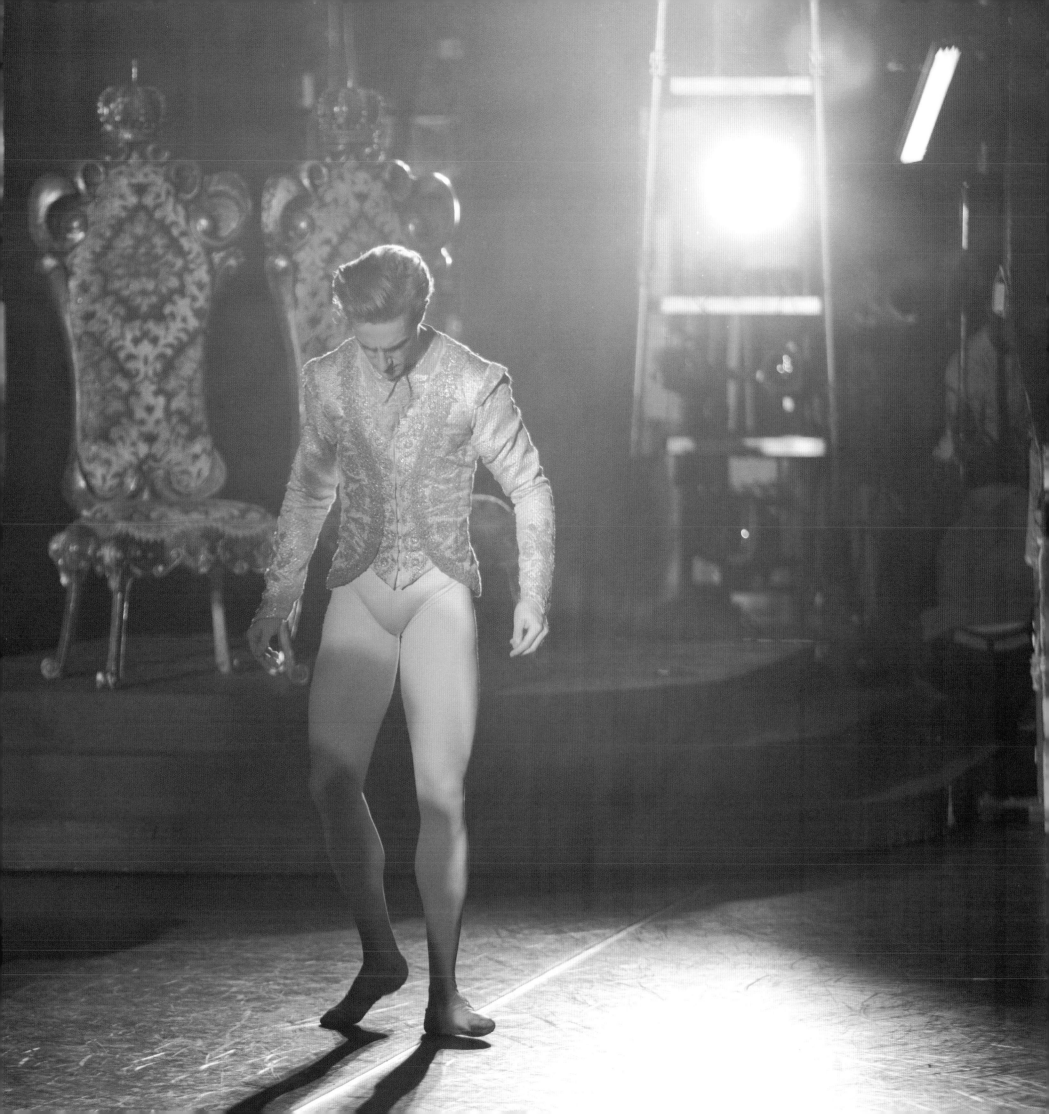

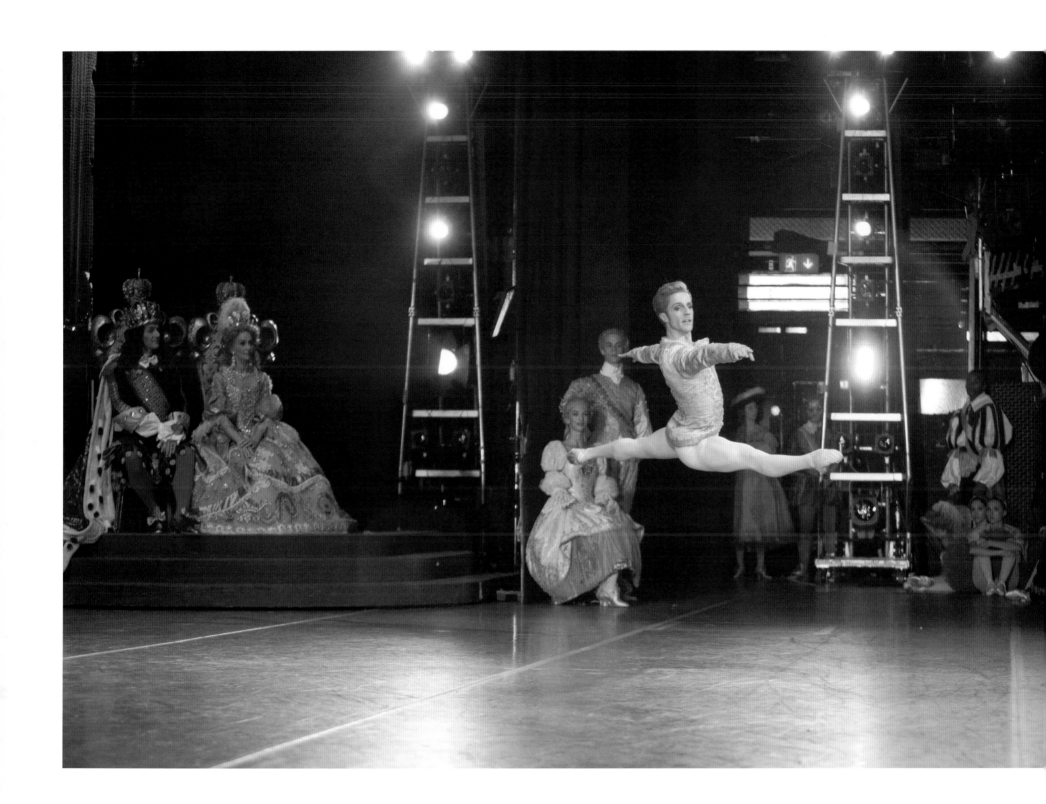

Steven McRae
The Sleeping Beauty Choreography: Marius Petipa
Production: Monica Mason and Christopher Newton after Ninette de Valois and Nicholas Sergeyev

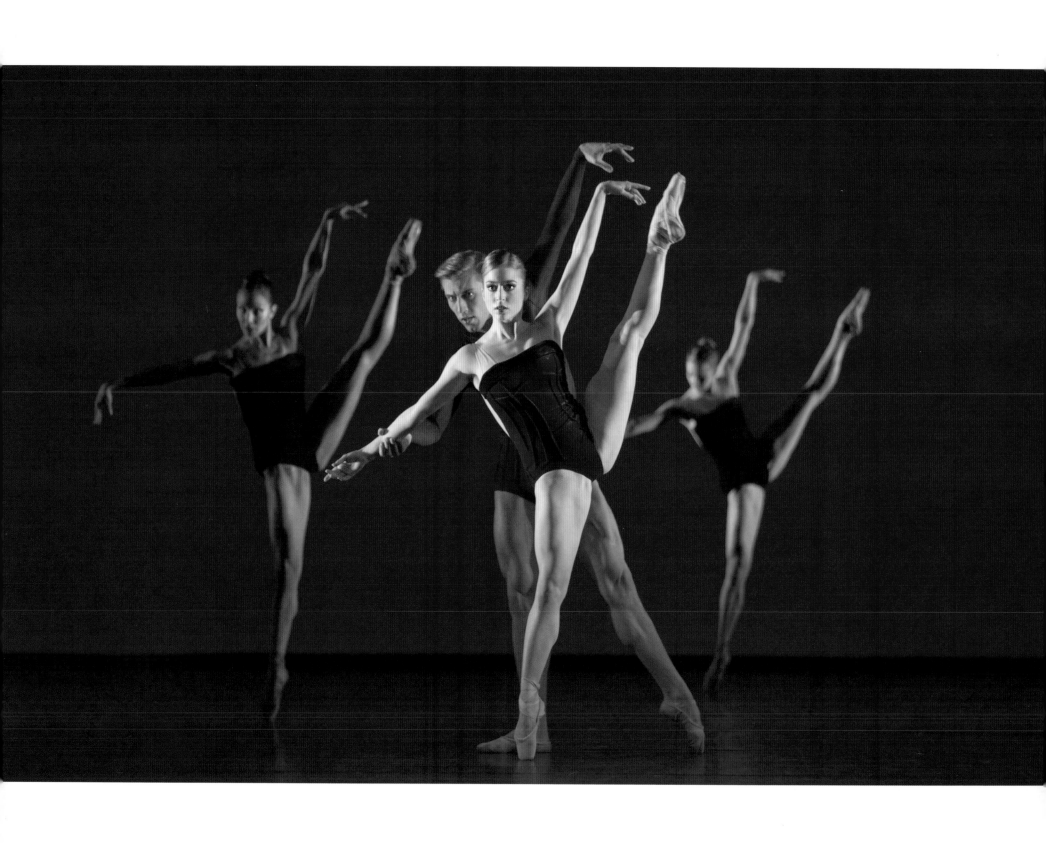

Dawid Trzensimiech and **Meaghan Grace Hinkis**
Opposite **Alexander Campbell, Laura Morera** and **Tristan Dyer**
Viscera Choreography: Liam Scarlett

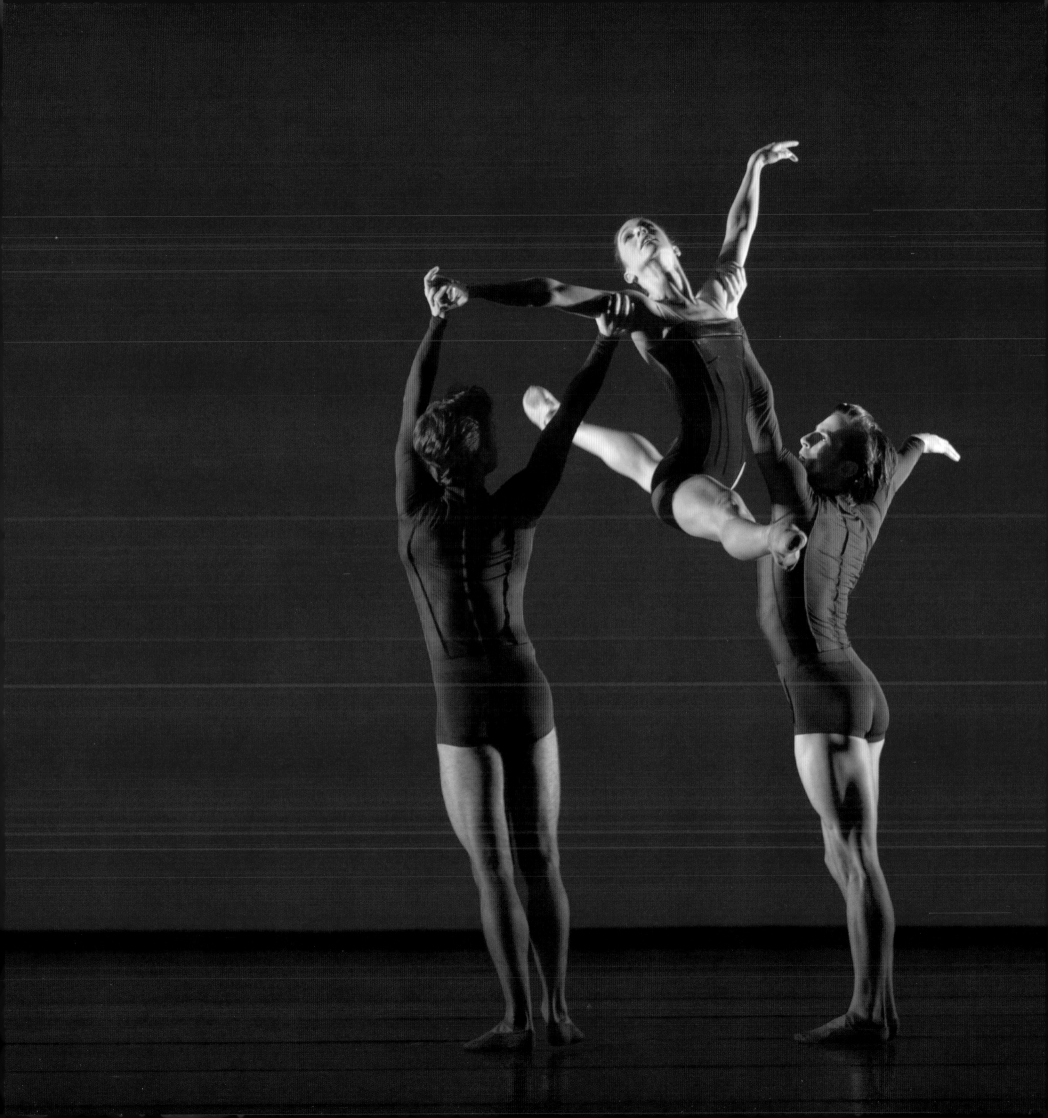

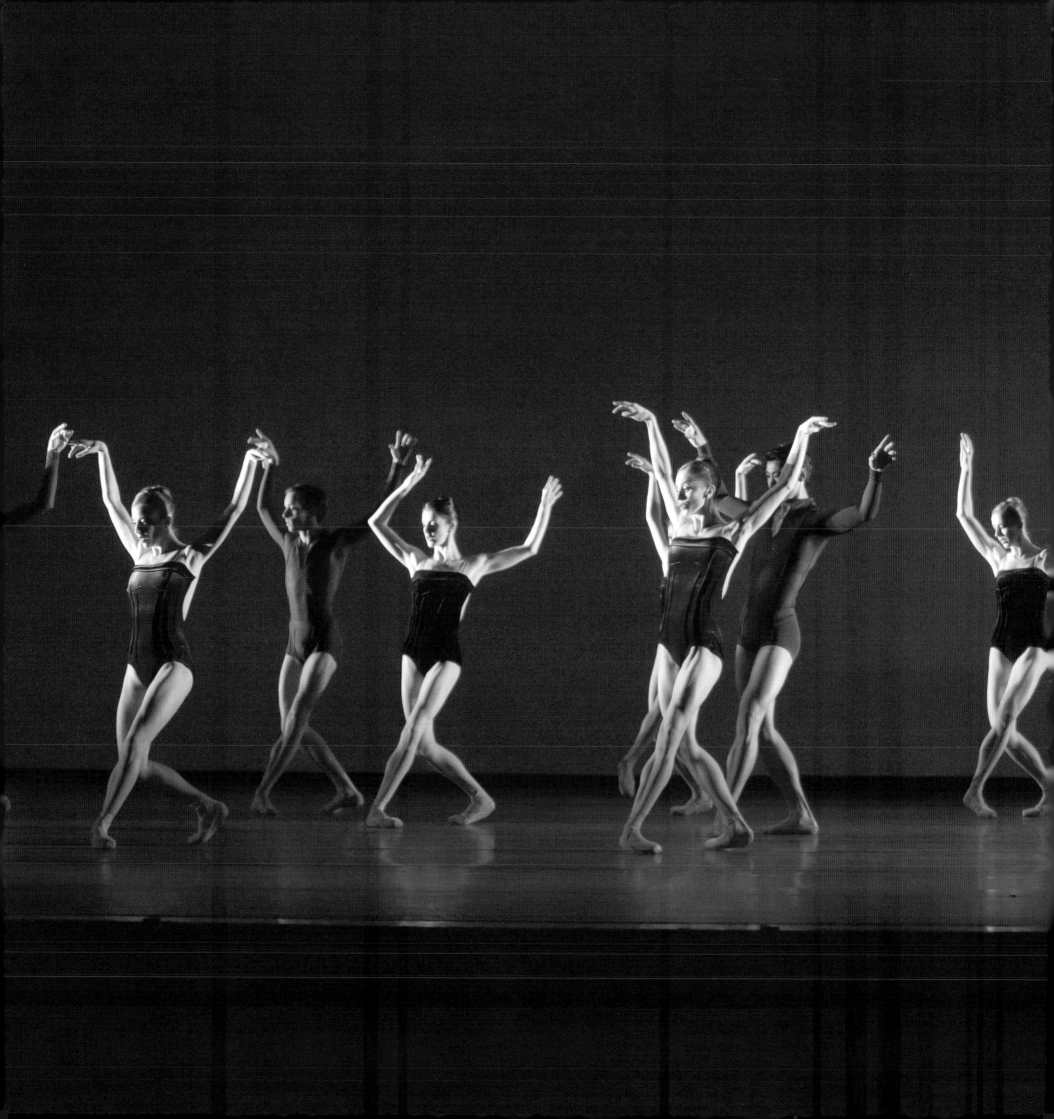

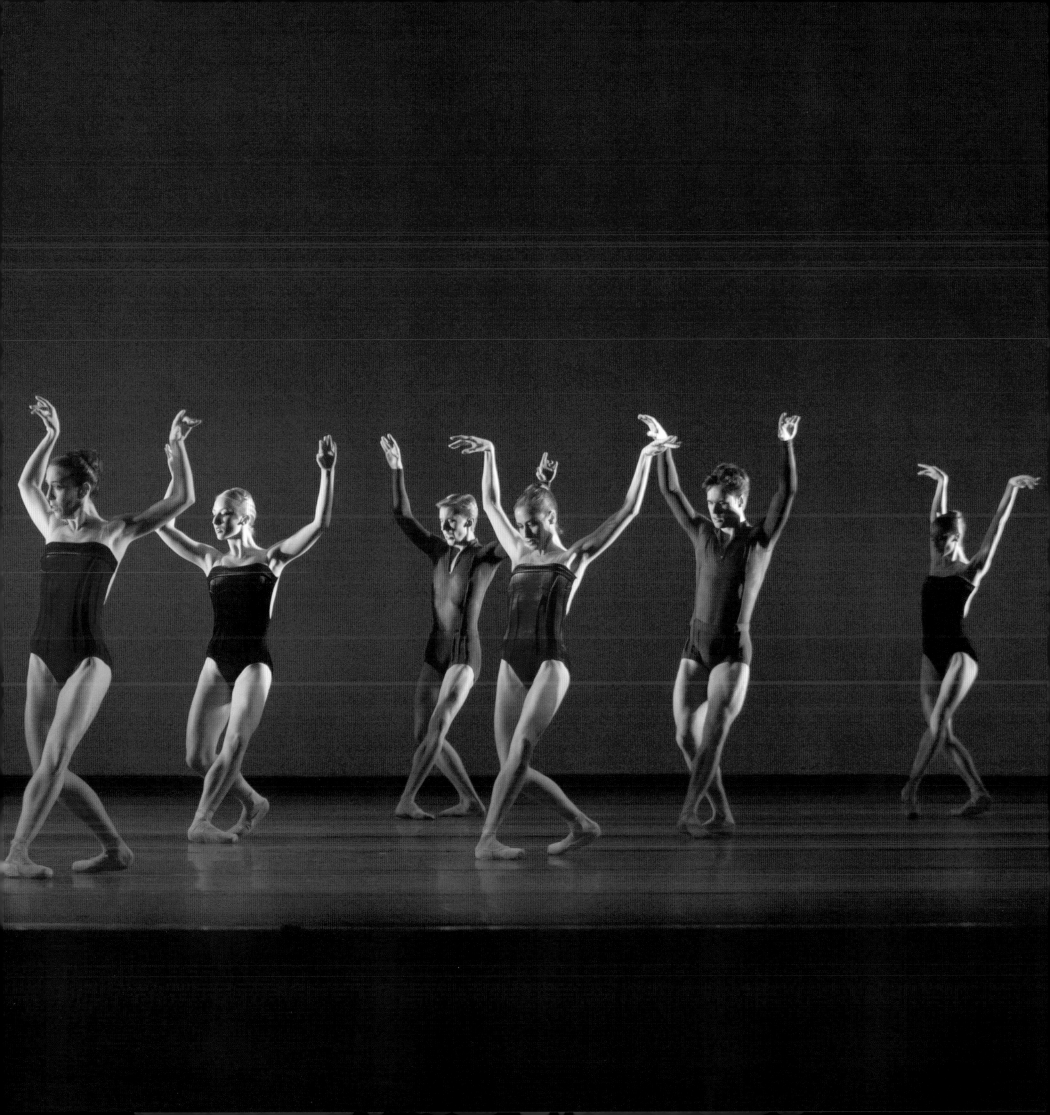

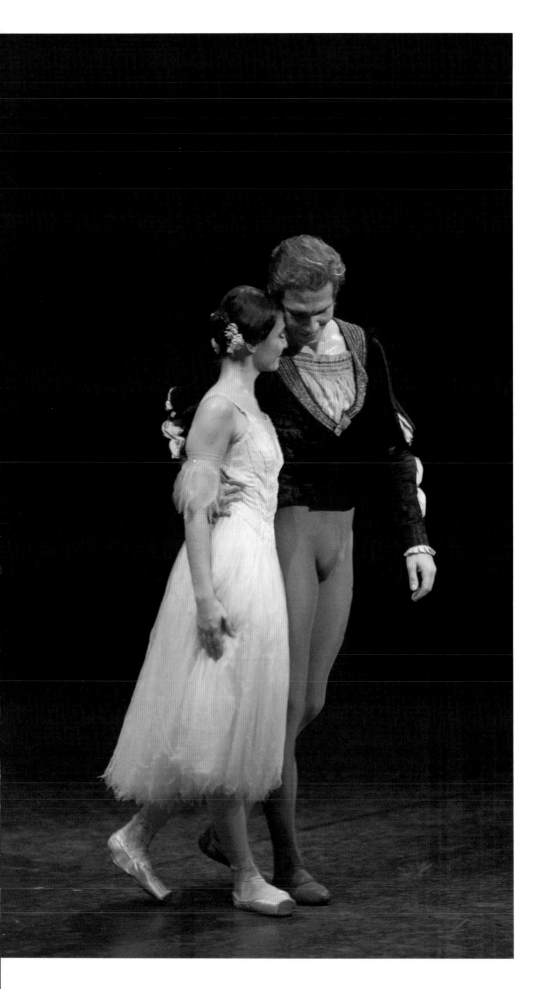
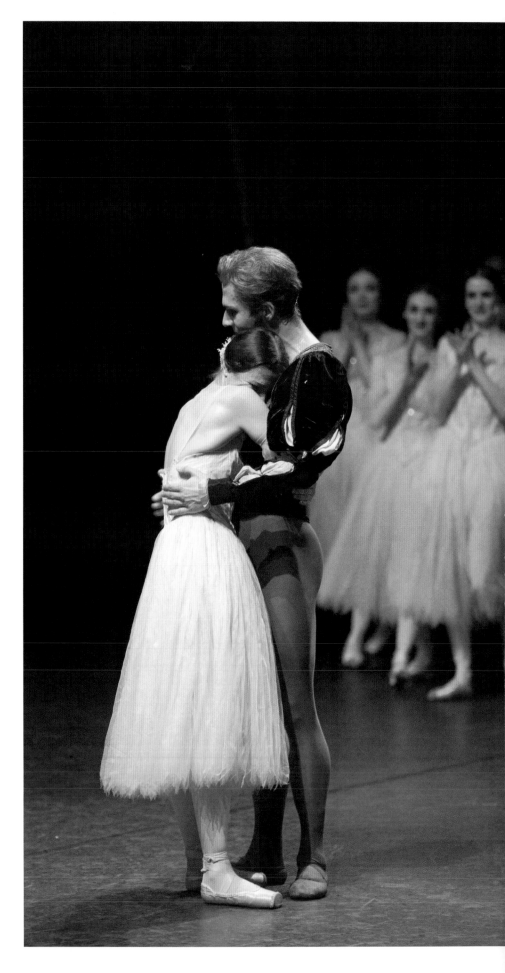

Alina Cojocaru and **Johan Kobborg**
Giselle Curtain call

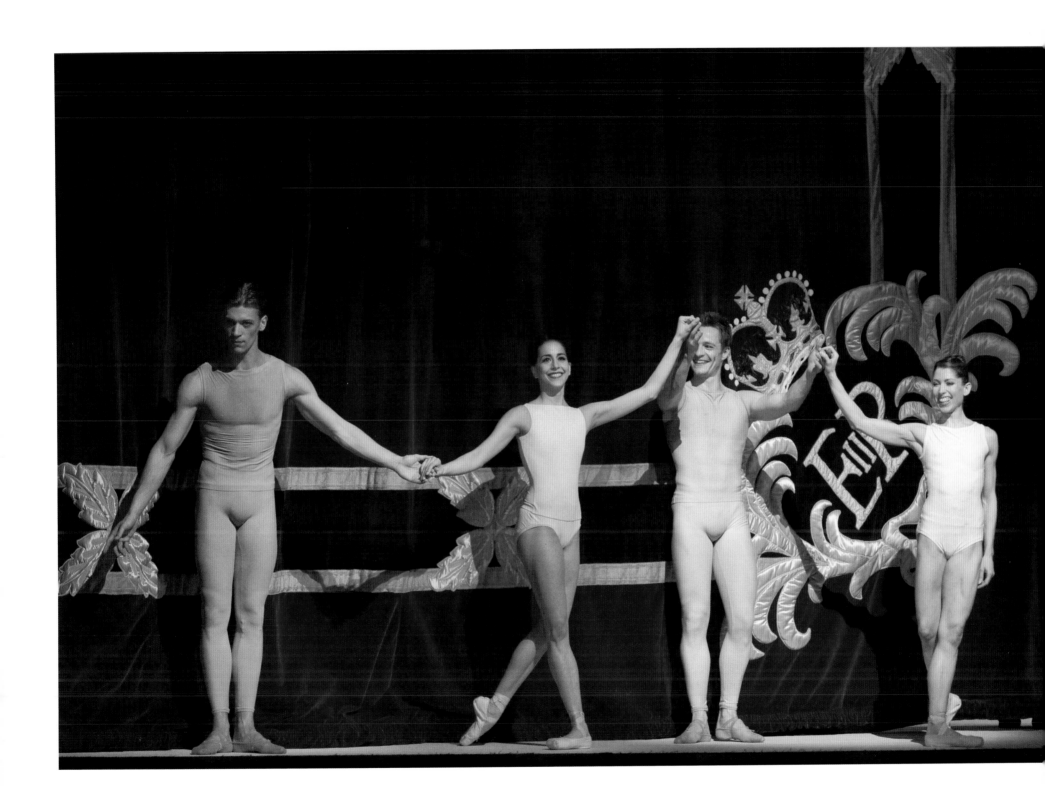

Left to right **Rupert Pennefather, Alexandra Ansanelli, Thomas Whitehead** and **Leanne Benjamin**
Sensorium Curtain call

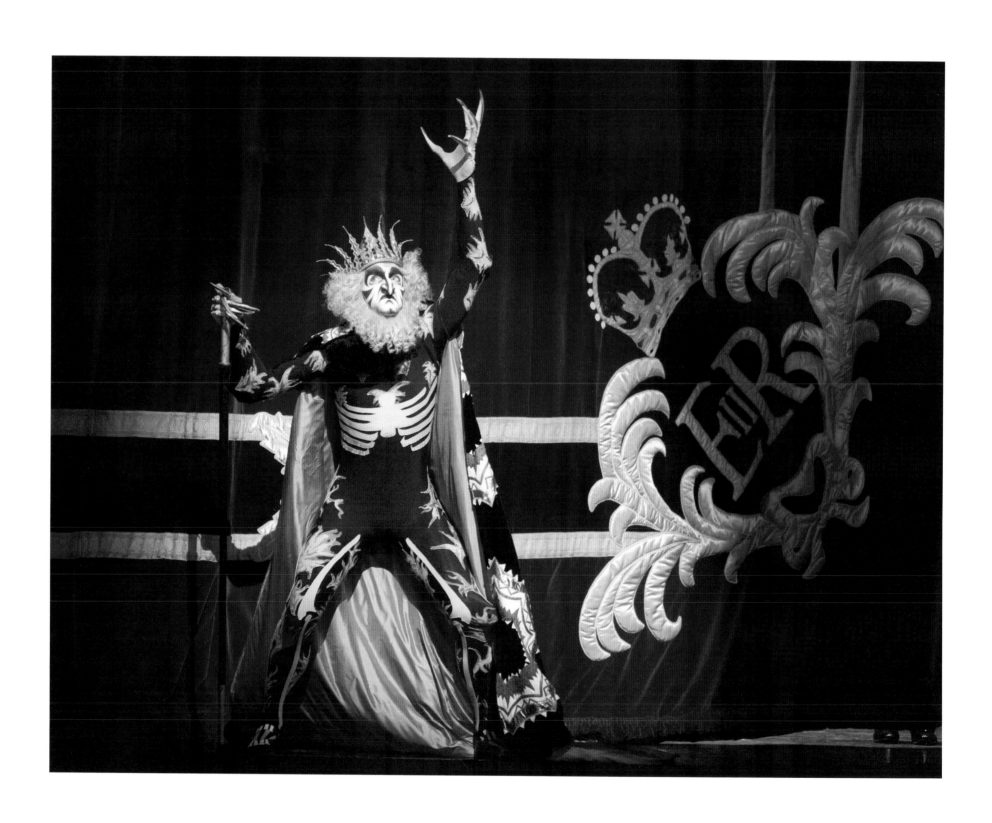

Gary Avis
The Firebird Curtain call

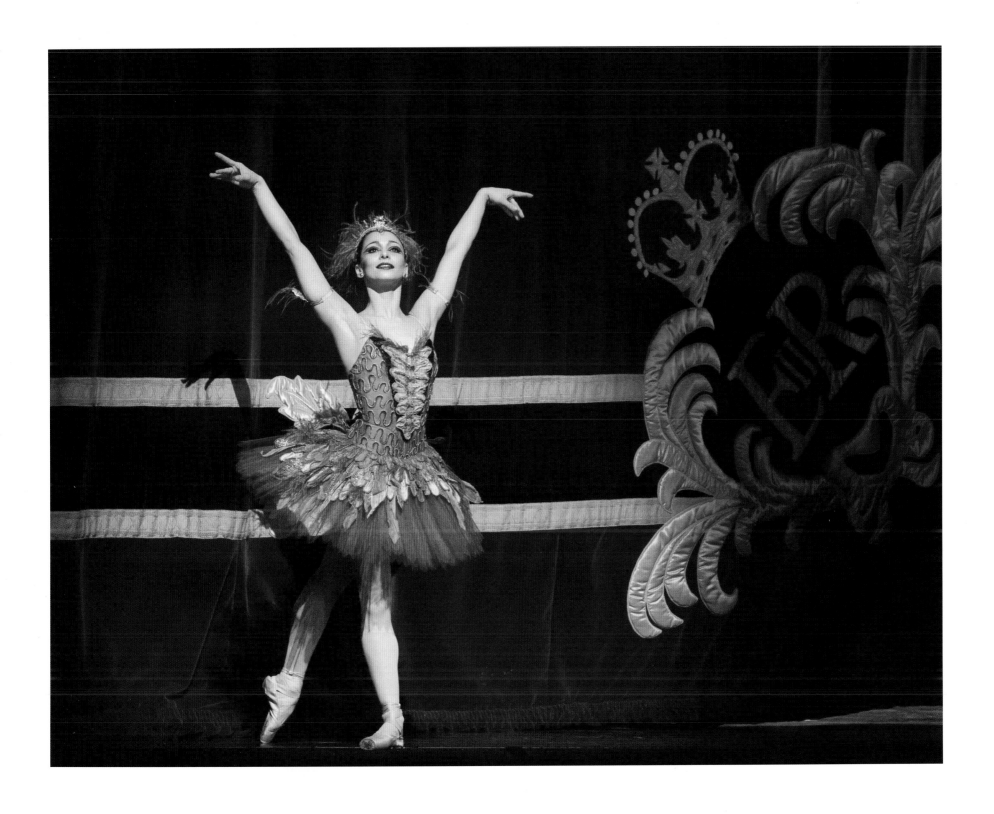

Roberta Marquez

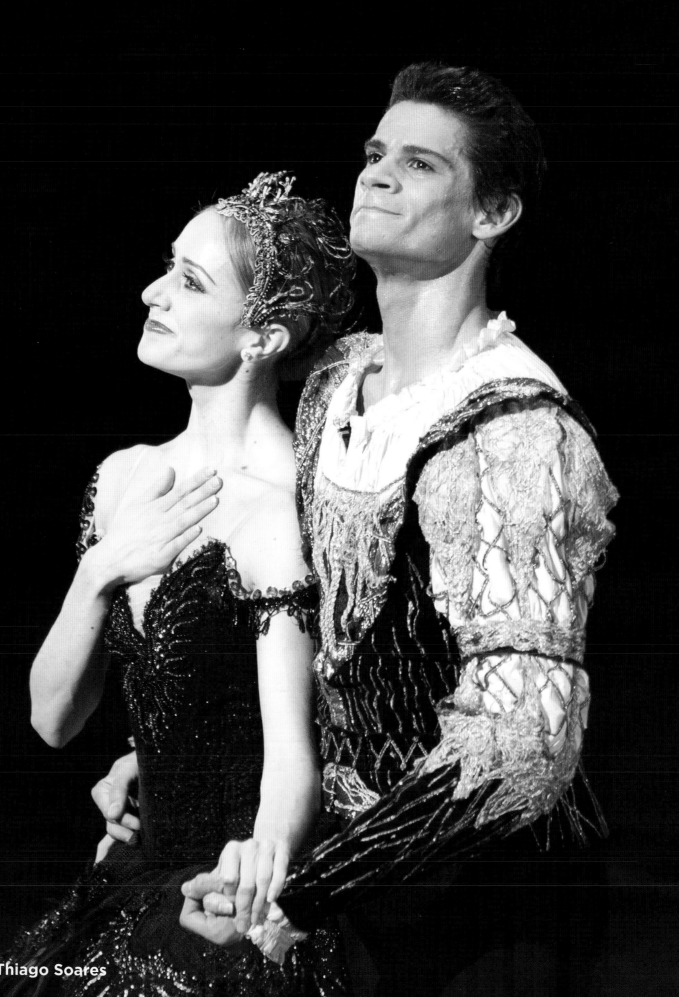

Marianela Nuñez and **Thiago Soares**
Swan Lake Curtain call